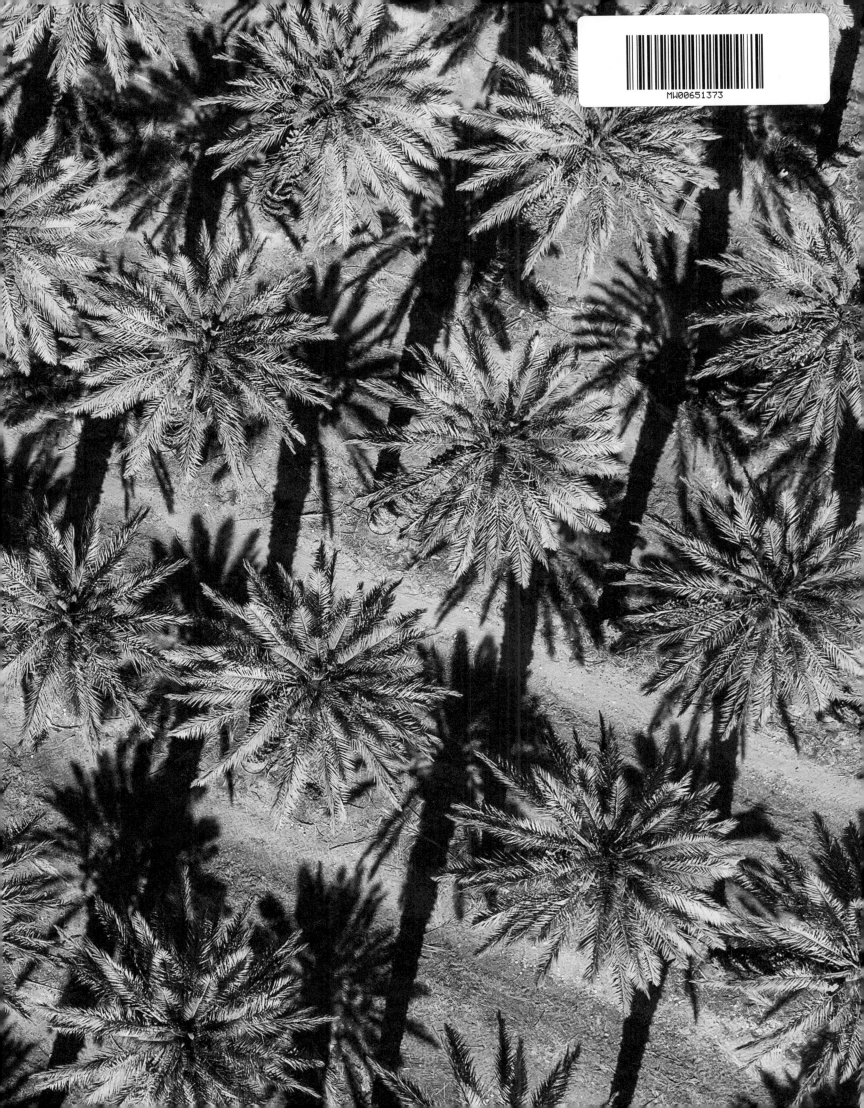

ISRAEL

ALSO BY TARA-LEIGH COBBLE

*The Bible Recap: A One-Year Guide to Reading
and Understanding the Entire Bible*

*The Bible Recap Study Guide: Daily Questions to Deepen
Your Understanding of the Entire Bible*

*The Bible Recap Journal: Your Daily Companion
to the Entire Bible*

*The Bible Recap Discussion Guide: Weekly Questions
for Group Conversation on the Entire Bible*

*The God Shot: 100 Snapshots of God's Character
in Scripture*

He's Where the Joy Is

He's Where the Joy Is, Teen Edition

ISRAEL

BEAUTY, LIGHT, AND LUXURY

TARA-LEIGH COBBLE

PHOTOGRAPHY BY
RICHARD VAN DE WATER

BETHANYHOUSE
a division of Baker Publishing Group
Minneapolis, Minnesota

© 2023 by Tara-Leigh Cobble

Published by Bethany House Publishers
Minneapolis, Minnesota
www.bethanyhouse.com

Bethany House Publishers is a division of
Baker Publishing Group, Grand Rapids, Michigan

Printed in China

Library of Congress Cataloging-in-Publication Data
Names: Cobble, Tara-Leigh, author.
Title: Israel : beauty, light, and luxury / Tara-Leigh Cobble.
Description: Minneapolis : Bethany House Publishers, a division of Baker Publishing Group, 2023.
Identifiers: LCCN 2022034442 | ISBN 9780764240348 (cloth) | ISBN 9781493440801 (ebook)
Subjects: LCSH: Israel—Pictorial works. | Jerusalem—Pictorial works.
Classification: LCC DS108.5 .C63 2023 | DDC 956.94022/2—dc23/eng/20220726
LC record available at https://lccn.loc.gov/2022034442

Scripture quotations are from The Holy Bible, English Standard Version® (ESV®), copyright © 2001 by Crossway, a publishing ministry of Good News Publishers. Used by permission. All rights reserved. ESV Text Edition: 2016

Interior design by William Overbeeke

Cover design by Dan Pitts

Cover and interior photographs by Richard Van De Water, www.richardvandewater.com, with exceptions noted on page 255.

The author is represented by Alive Literary Agency, www.aliveliterary.com.

Baker Publishing Group publications use paper produced from sustainable forestry practices and post-consumer waste whenever possible.

23 24 25 26 27 28 29 7 6 5 4 3 2 1

TO MY SISTER GINA:

I'm grateful we had the chance to walk
through this beautiful country together,
and I can't wait to do it again
in the New Jerusalem.

TO MY MOM:

For giving me your love of people and travel.
Your kindness radiates
through every corner of the world.

TO MY DAD:

For giving me your passion
for Israel and the Word of God.
I'm honored to carry on your legacy.

CONTENTS

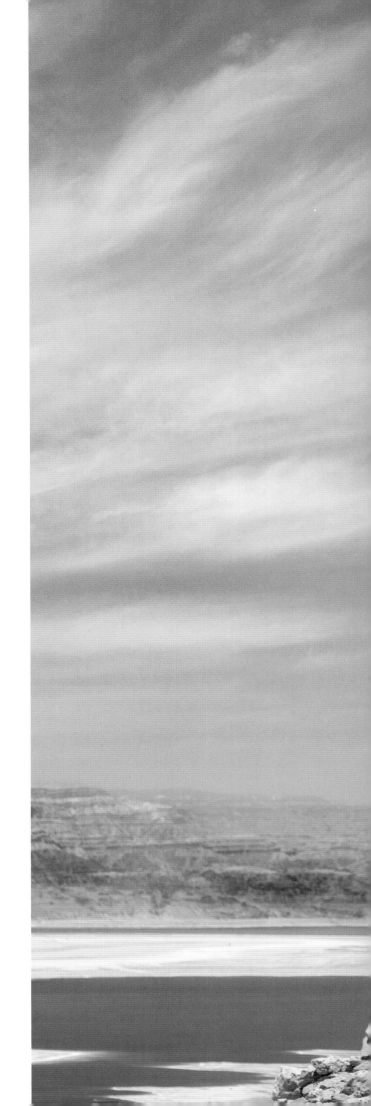

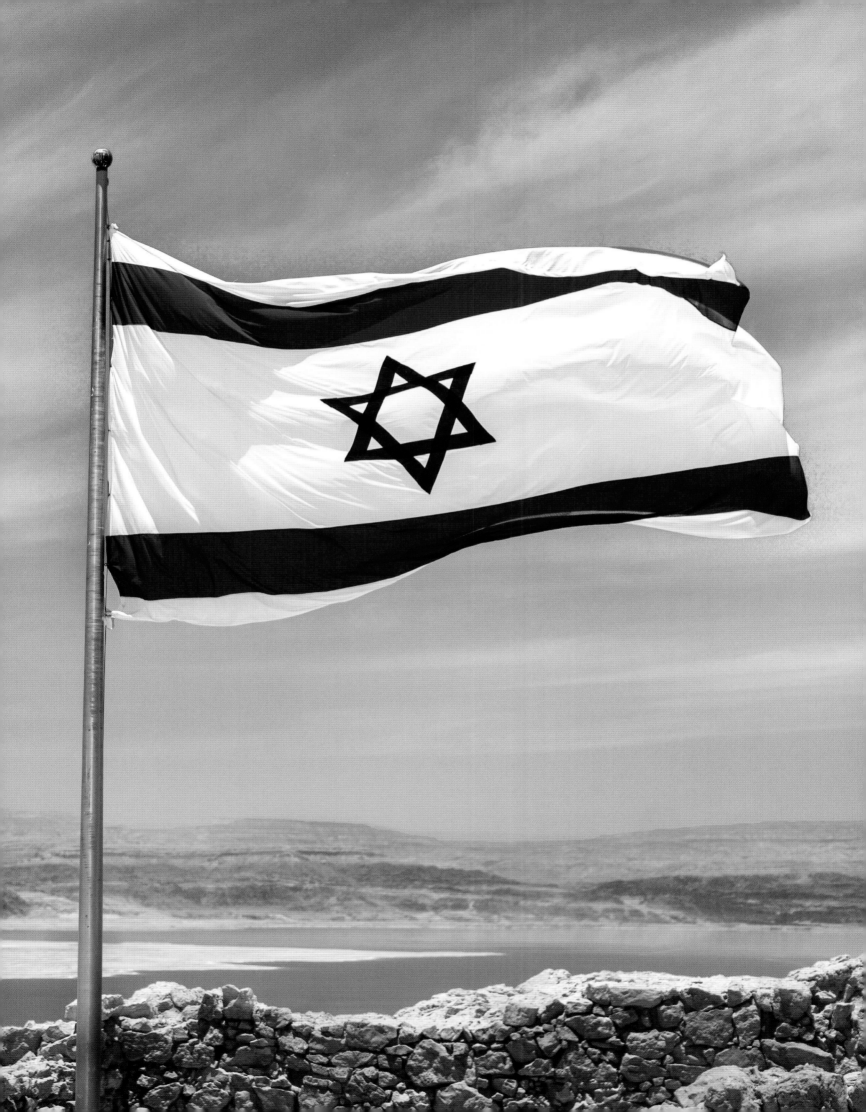

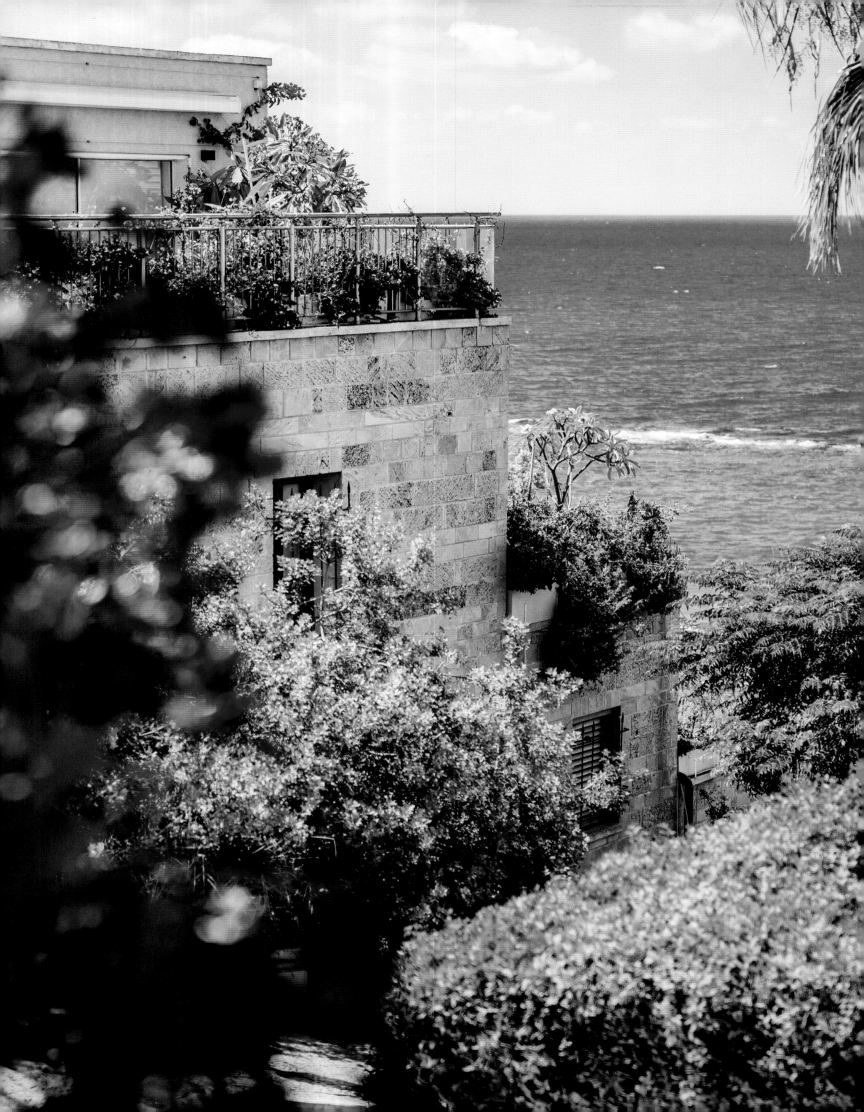

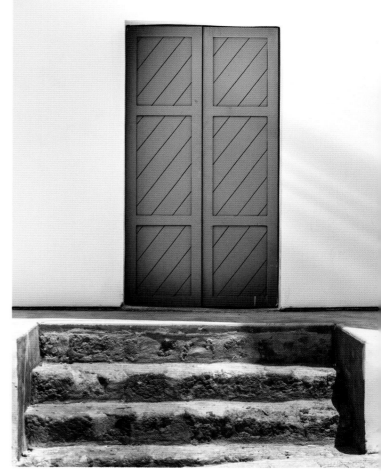

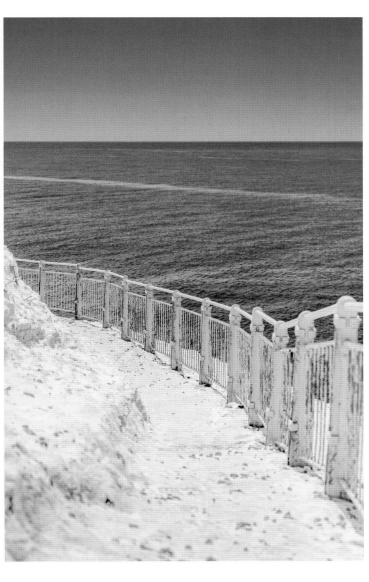

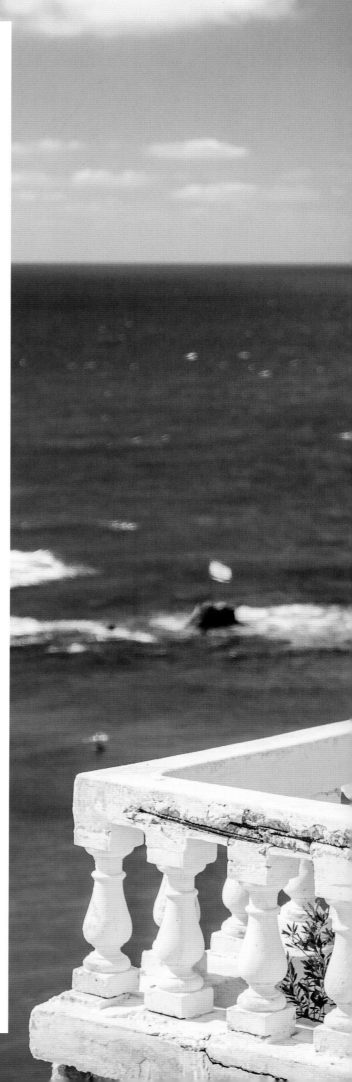

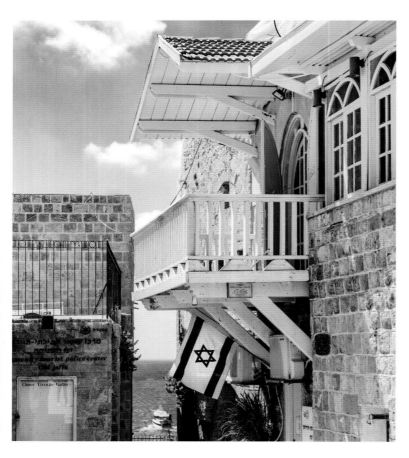

Joppa

Acts 10:1–23

FIRST-CENTURY ROMAN CENTURIONS were known for many things, but faith in God wasn't among them. Primarily, they were known for ruling the vast Roman Empire with an iron fist, torturing or killing anyone who dared oppose it. Although Cornelius was steeped in Roman culture, his life stood in stark contrast. He was focused on looking for God in the midst of a pagan city.

God sent an angel to Caesarea to prompt Cornelius toward the truth. Meanwhile, about thirty miles south in Joppa, Peter had a vision during prayer. The vision's message was that Peter shouldn't only share the message of Jesus with the Jews, but with the Gentiles (non-Jews) too. God's plan to save people through Jesus is extended to people of all nations!

As God worked out His detailed plan to get His message to the Gentiles, He called His people to overcome the preferences of two opposing cultures—the pagans and the religious, the Gentiles and the Jews. Neither Cornelius nor Peter had fully grasped what God was doing, but He worked in them separately and simultaneously to unite them as a force for His kingdom!

ABOVE: Stone houses line the shores of the Mediterranean Sea near the port of Old Jaffa. The neighborhood boasts a lively scene where ancient beauty meets with modern arts, culture, and cuisine. SPREAD: Modern fishermen still fish in the port of Jaffa, where the prophet Jonah caught a boat to Tarshish before being swallowed by the big fish and spit out in Nineveh.

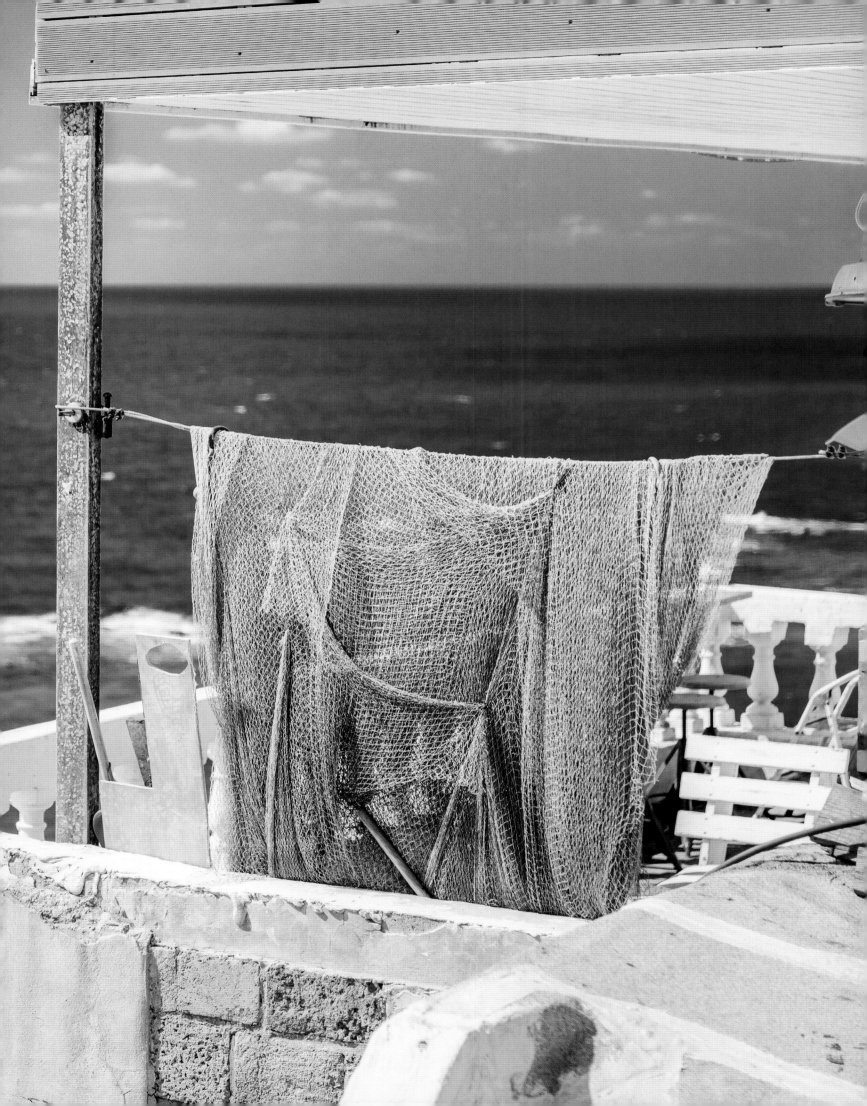

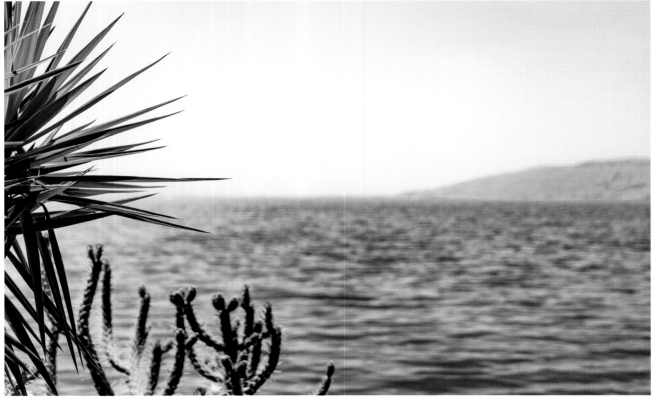

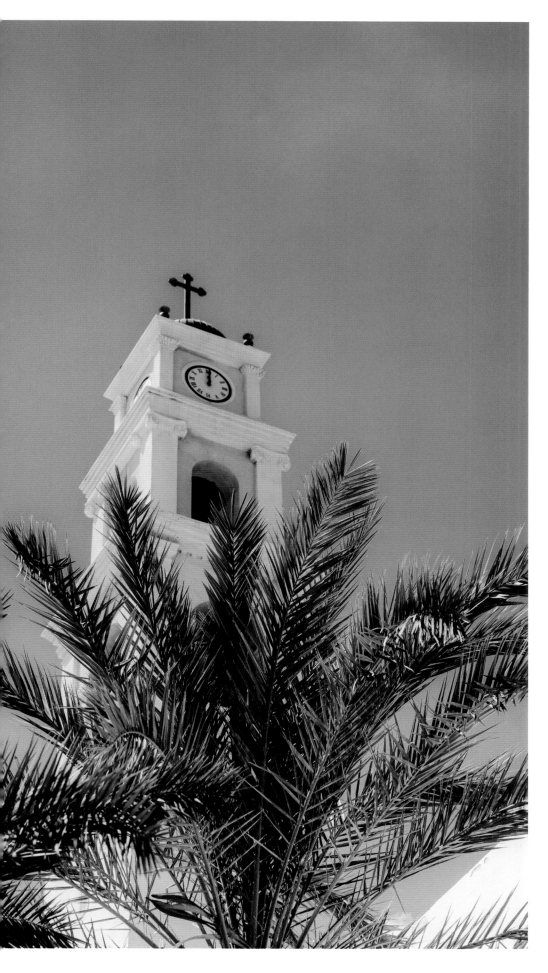

THE WILDERNESS
AND THE DRY
LAND SHALL BE
GLAD; THE DESERT
SHALL REJOICE
AND BLOSSOM
LIKE THE CROCUS;
IT SHALL BLOSSOM
ABUNDANTLY AND
REJOICE WITH JOY
AND SINGING.

ISAIAH 35:1–2

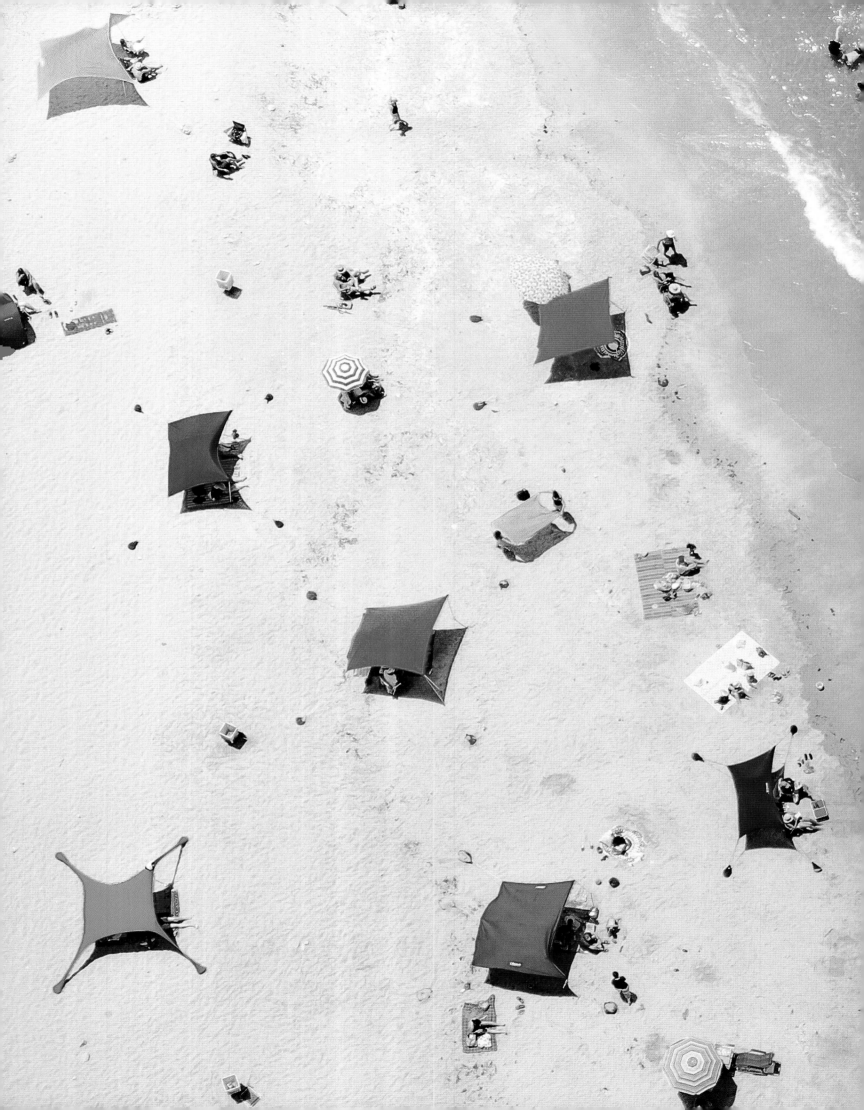

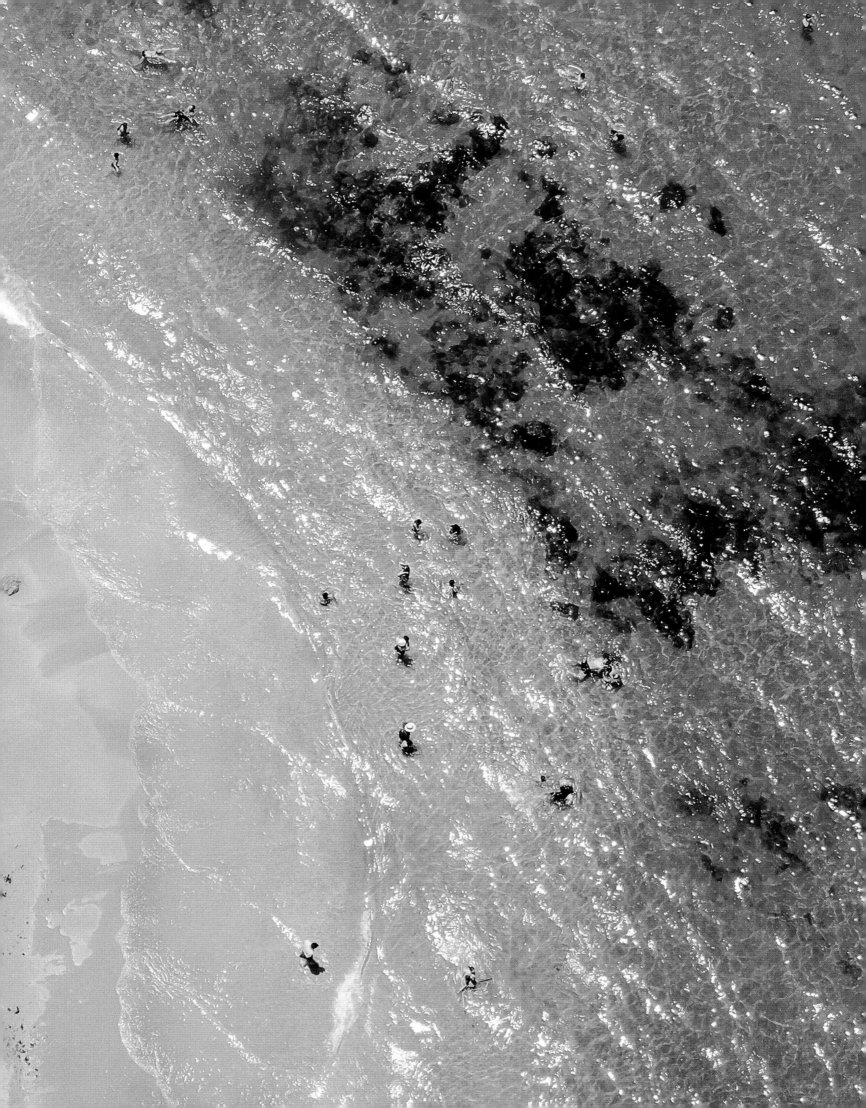

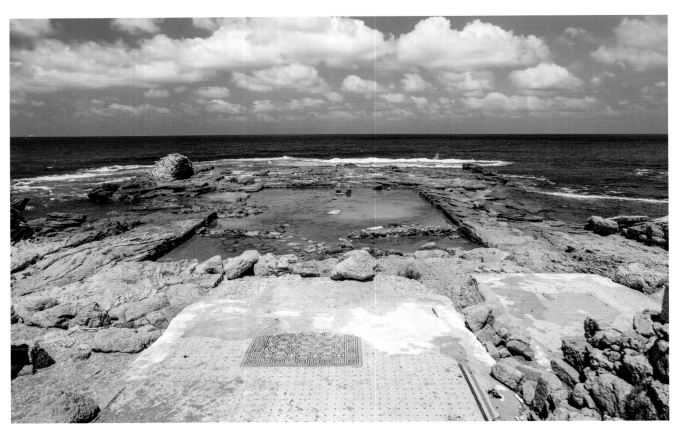

Caesarea Maritima

Acts 10:23–45

To him all the prophets bear witness that everyone who believes in him receives forgiveness of sins through his name.
—ACTS 10:43

PETER WAS A JEWISH DISCIPLE of Jesus. Cornelius was a centurion in the Roman army that carried out Jesus's execution. By all accounts, they should have been enemies, but God had different plans.

God gave Peter a vision to share the message of Jesus with people who weren't Jews, people Peter had spent his whole life avoiding. And as he spoke to a house full of Gentiles, God's Spirit impacted them all. They believed his words, and even the Gentiles received the gift of God's salvation.

But make no mistake—this wasn't a new plan. This was always the plan. Extending the gospel to other nations didn't start with Peter. And it didn't start with the ministry of Jesus. Eight hundred years earlier, the prophets Hosea and Isaiah told the Jewish people that belonging in God's family wasn't simply a matter of biological heritage. And even before that, God entered into a relationship with Gentiles like Rahab, Ruth, and Jethro.

Whether Jew or Gentile, God has always been rescuing His enemies and turning them into His family!

ABOVE: The long-buried ruins of King Herod's Palace have been excavated in recent years, revealing what was once an indoor pool surrounded by a mosaic tile floor. RIGHT: King Herod was a brilliant builder, as shown by this ancient city ruled by Rome. To increase trade, he created a port in an area of the Mediterranean where there was no bay. The port city included an amphitheater, hippodrome, and other Roman features like bath houses. Roman governors Felix and Festus imprisoned the apostle Paul here for two years, likely in a prison cell under the palace.

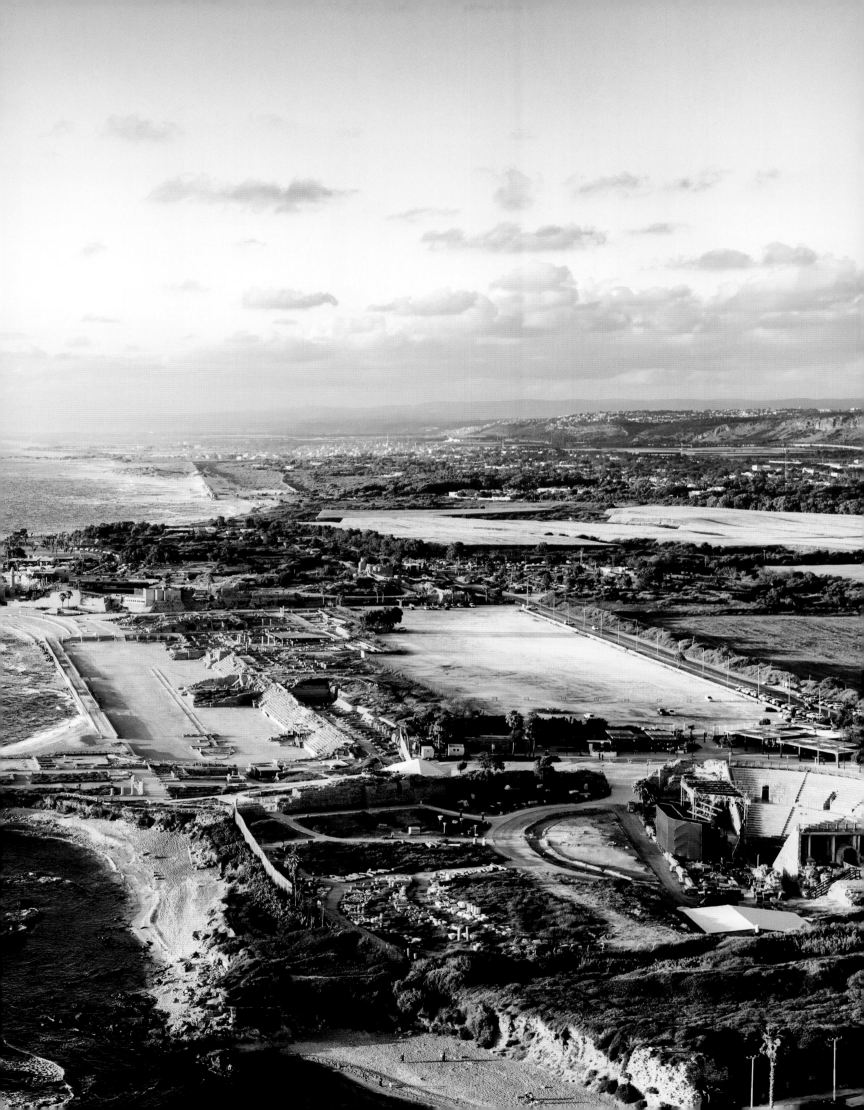

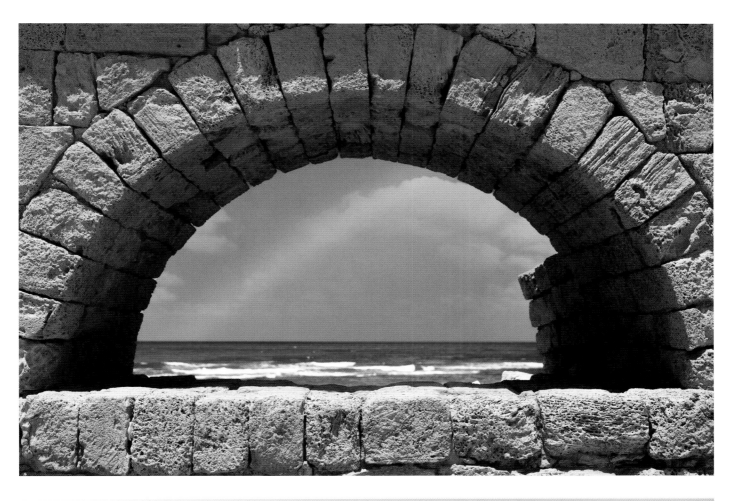

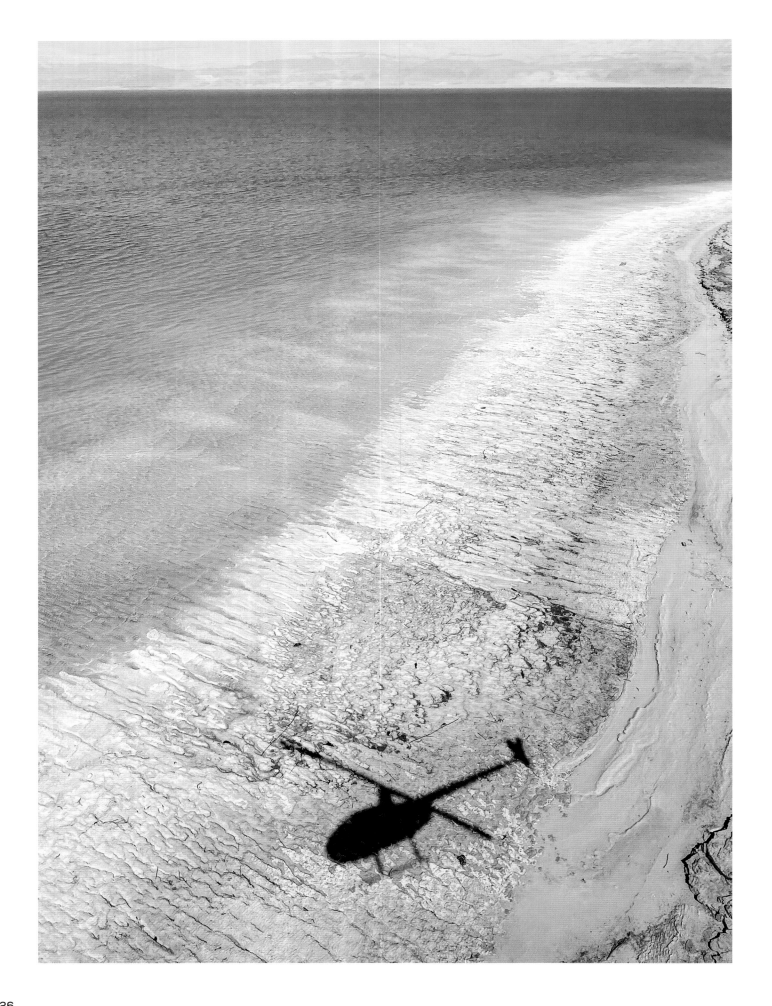

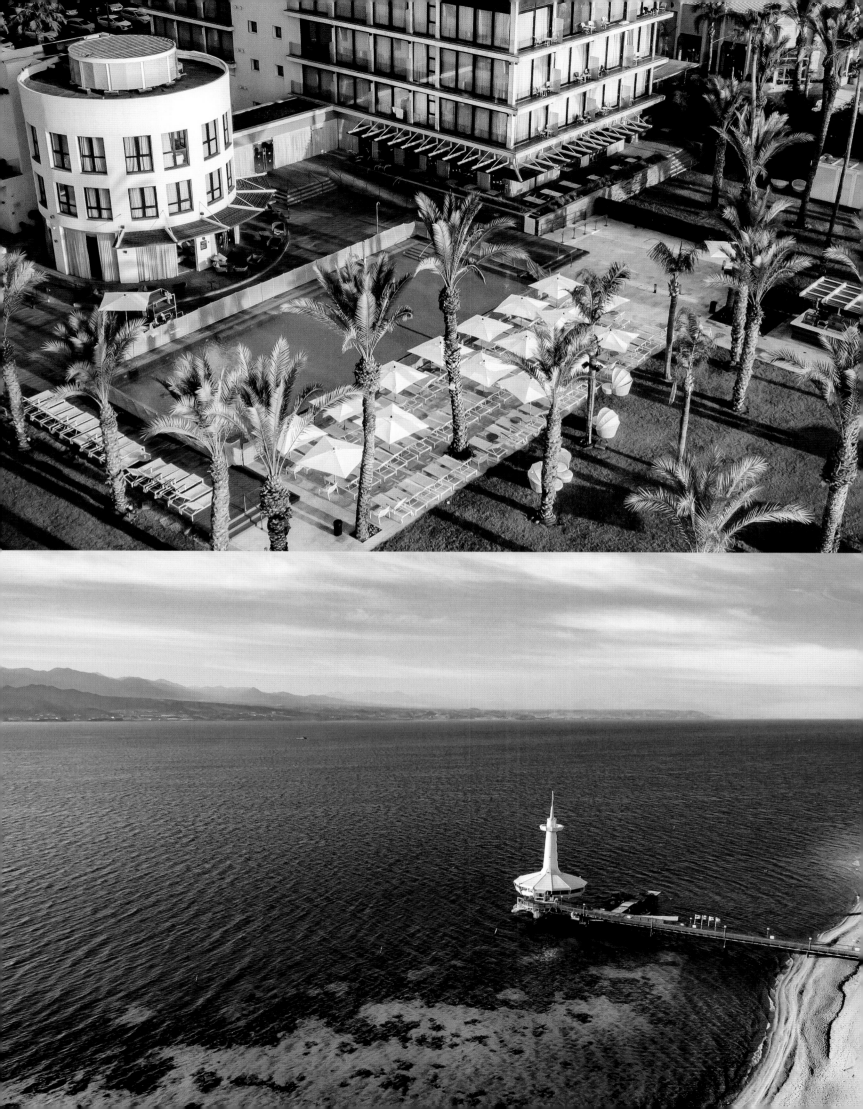

ELIJAH'S FAITH WAS
IN THE ONE TRUE GOD,
MAKER OF HEAVEN
AND EARTH, COMMANDER
OF FIRE AND RAIN.

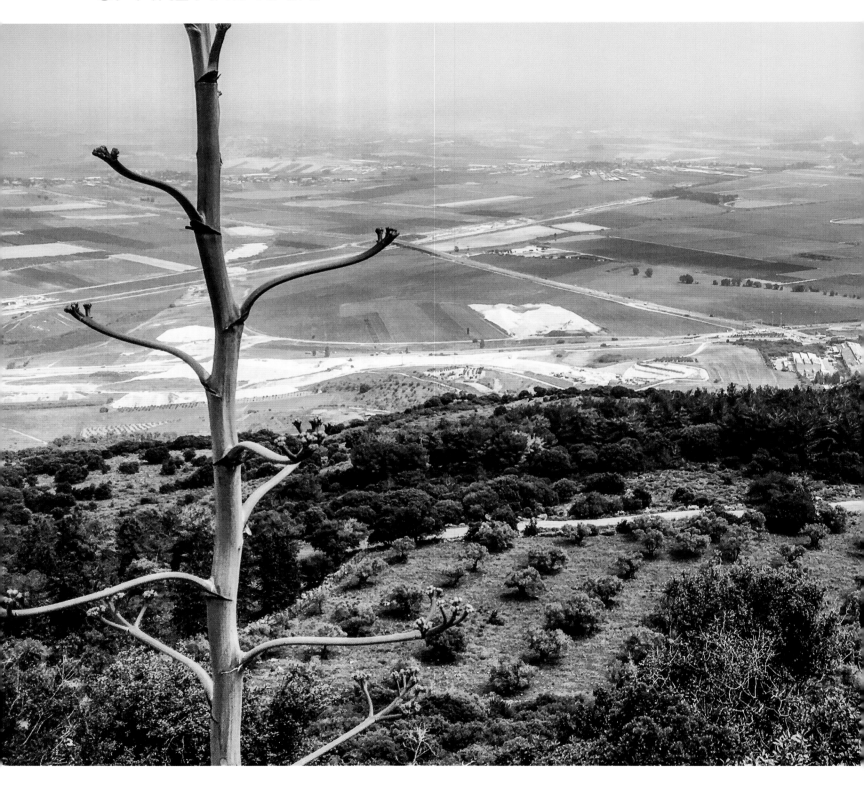

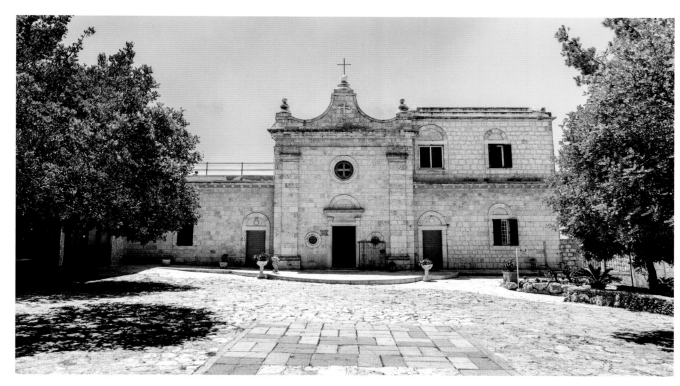

Mount Carmel

First Kings 18:1–2, 17–46

WHEN ELIJAH STOOD on this mountain to face down wicked King Ahab, Ahab was the king in Northern Israel. The people worshipped false gods and followed false prophets, so God sent the prophet Elijah to tell them to repent.

At the time, there was a drought in the land. Elijah used that as an opportunity to show God's power over all creation and His superiority over the false gods. The god who could prove his power by sending fire would be acknowledged as the one true God.

The false prophets cried out to Baal, who remained silent. Then Elijah made two moves that were counterintuitive given the drought. He poured gallons of water on the ground—water they needed. Then he called for a fire—something they'd want to *avoid* in a drought. God sent a scorching fire; it burned the offering, the stones, and the dust!

Afterward, God brought the rain Elijah prayed for! Elijah knew God would answer that prayer with a yes because God had promised rain before Elijah ever met with King Ahab. Elijah's faith was in the one true God, Maker of heaven and earth, Commander of fire and rain.

THEY SHALL COME AND SING
ALOUD ON THE HEIGHT OF ZION.

JEREMIAH 31:11

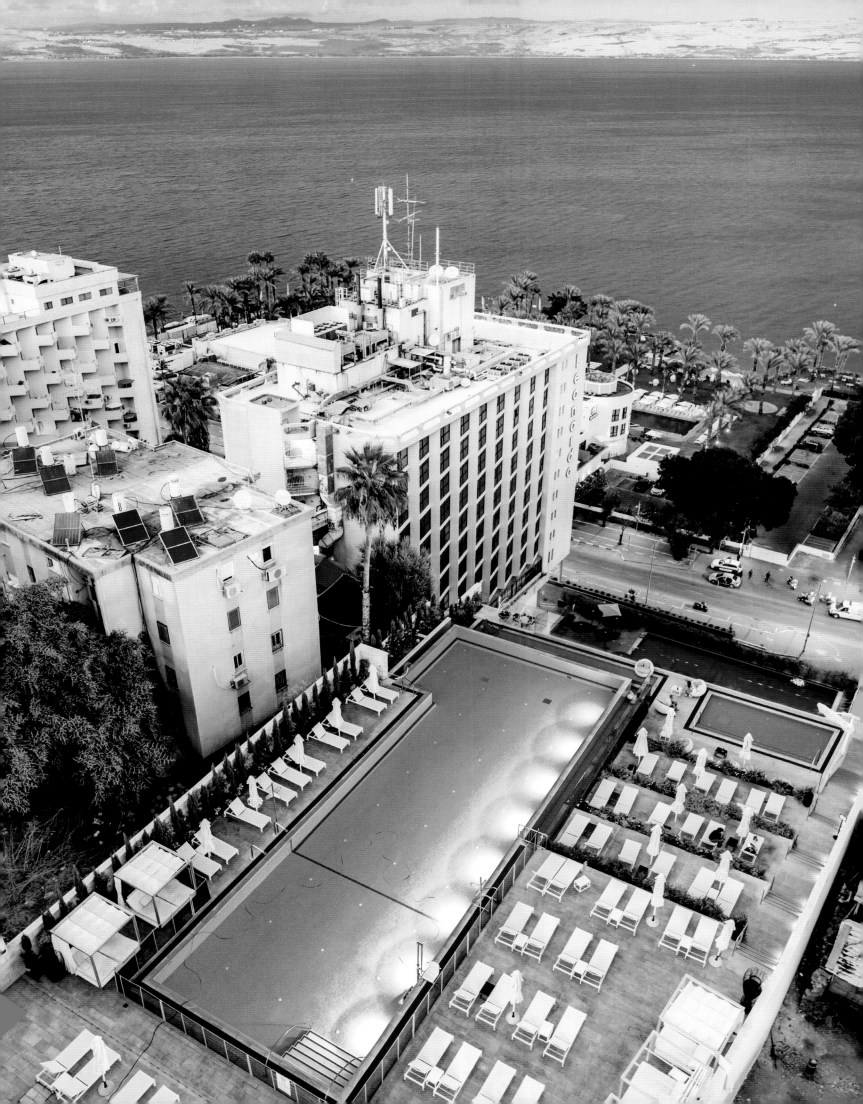

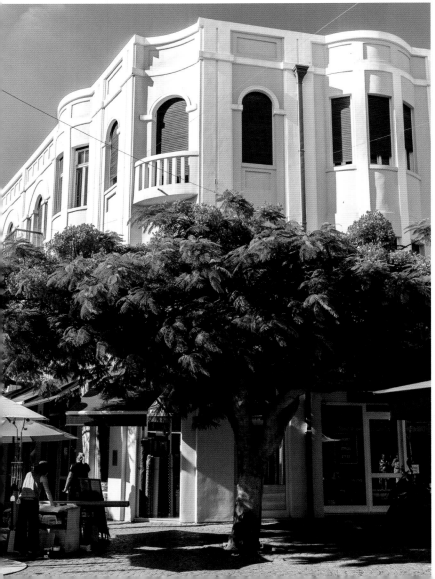

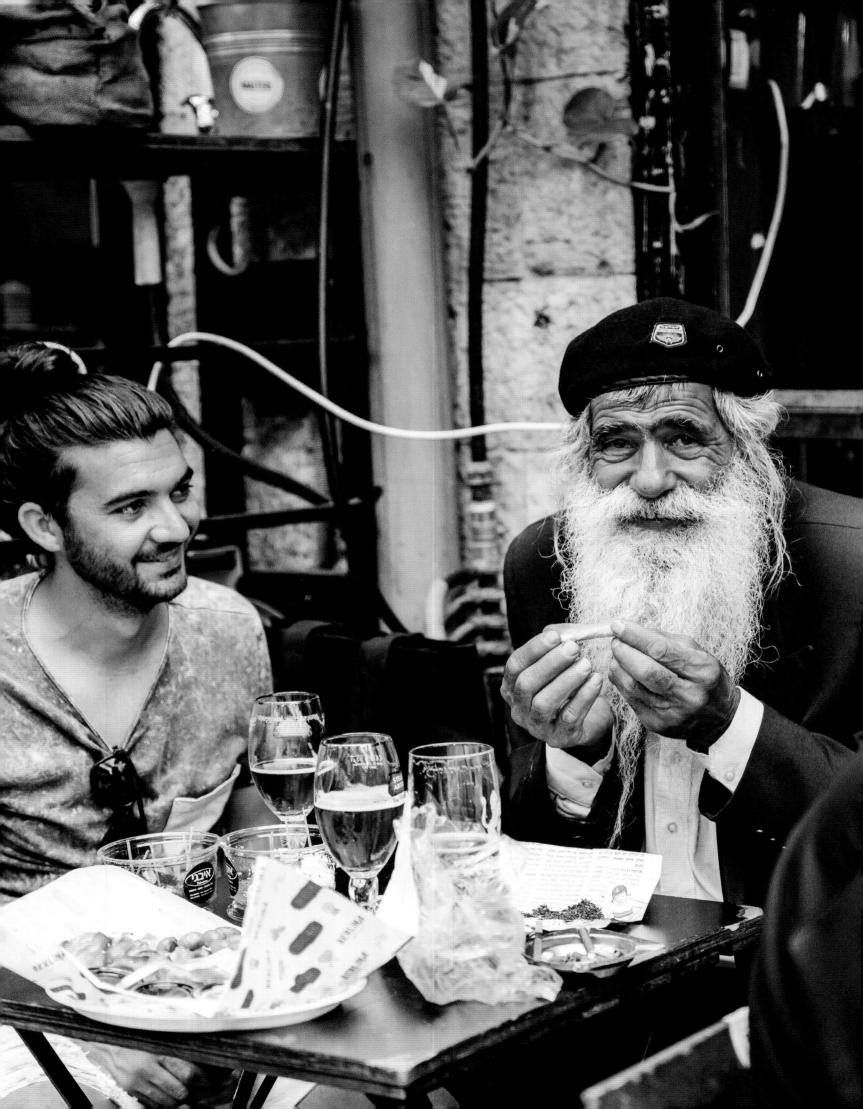

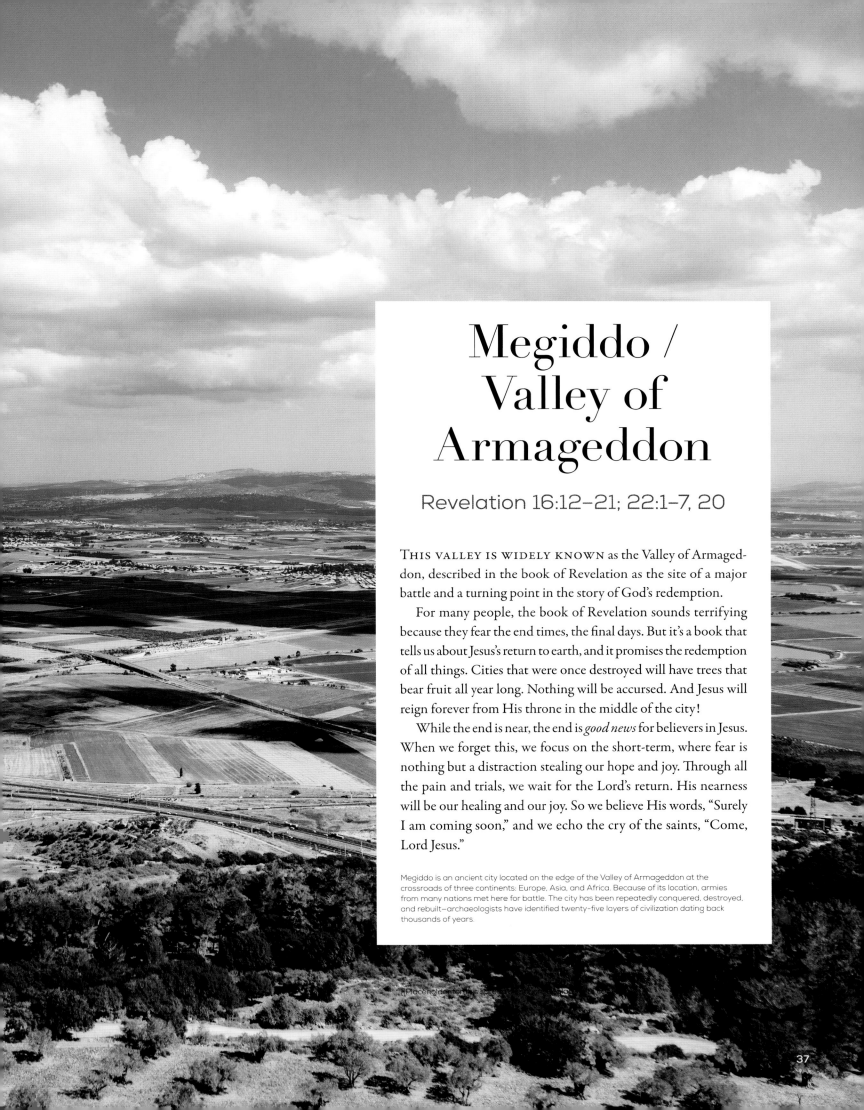

Megiddo / Valley of Armageddon

Revelation 16:12–21; 22:1–7, 20

THIS VALLEY IS WIDELY KNOWN as the Valley of Armageddon, described in the book of Revelation as the site of a major battle and a turning point in the story of God's redemption.

For many people, the book of Revelation sounds terrifying because they fear the end times, the final days. But it's a book that tells us about Jesus's return to earth, and it promises the redemption of all things. Cities that were once destroyed will have trees that bear fruit all year long. Nothing will be accursed. And Jesus will reign forever from His throne in the middle of the city!

While the end is near, the end is *good news* for believers in Jesus. When we forget this, we focus on the short-term, where fear is nothing but a distraction stealing our hope and joy. Through all the pain and trials, we wait for the Lord's return. His nearness will be our healing and our joy. So we believe His words, "Surely I am coming soon," and we echo the cry of the saints, "Come, Lord Jesus."

Megiddo is an ancient city located on the edge of the Valley of Armageddon at the crossroads of three continents: Europe, Asia, and Africa. Because of its location, armies from many nations met here for battle. The city has been repeatedly conquered, destroyed, and rebuilt—archaeologists have identified twenty-five layers of civilization dating back thousands of years.

HAGIA SION
COENACULUM DORMITION ABBEY

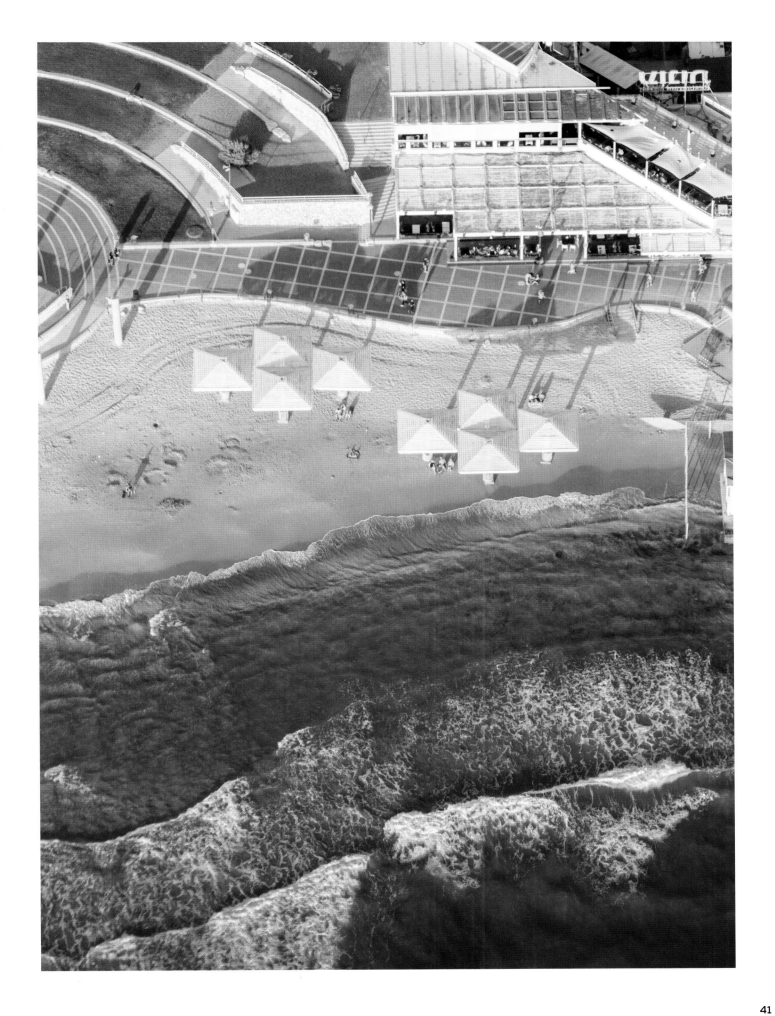

Tel Dan

First Kings 12:25–33

ISRAEL'S FIRST THREE KINGS were Saul, David, and Solomon. After Solomon's reign, the kingdom of Israel split into two kingdoms: the Northern Kingdom of Israel, which included ten tribes, and the Southern Kingdom of Judah.

The Southern Kingdom had access to Jerusalem and the temple, where God had commanded His people to bring sacrifices. But the Northern Kingdom didn't. Jeroboam was the first king of the Northern Kingdom, and he feared that his people would leave him to worship in Jerusalem. So he hatched a plan to defy God's laws and build his own temple, setting up his own altars for sacrifice.

We're all wired to worship something; if we don't worship God, we'll worship the false gods we set up for ourselves, like Jeroboam did. We worship things like wealth, beauty, power, success, and approval. And our fear drives us to compromise, which leads us to sin and control—just like it did with Jeroboam. Despite all his efforts, his plans failed.

In God's kingdom, success looks like trust and surrender. By trusting Him, our hearts find rest instead of striving.

ABOVE: In the north of Israel, the Tel Dan Nature Reserve offers hiking trails, wading pools, and lots of history. RIGHT: Located at the foot of Mount Hermon, Tel Dan benefits from snow melt that feeds the Dan River.

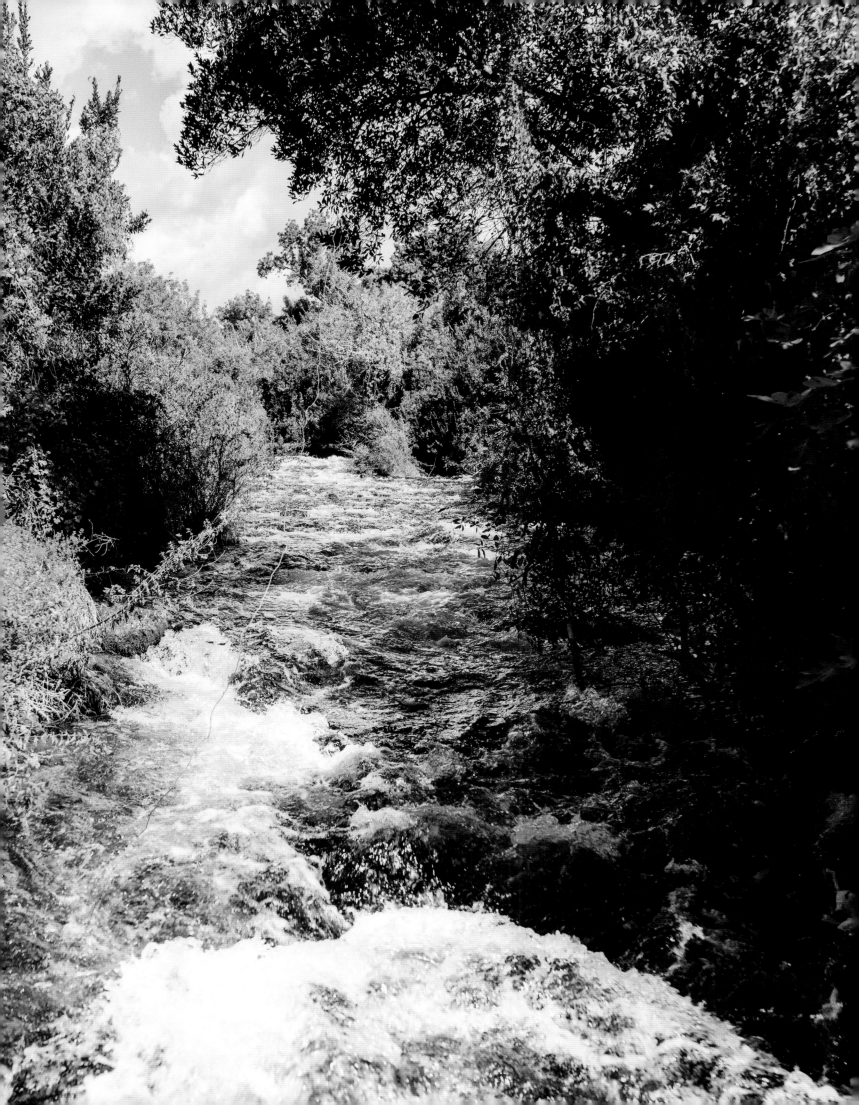

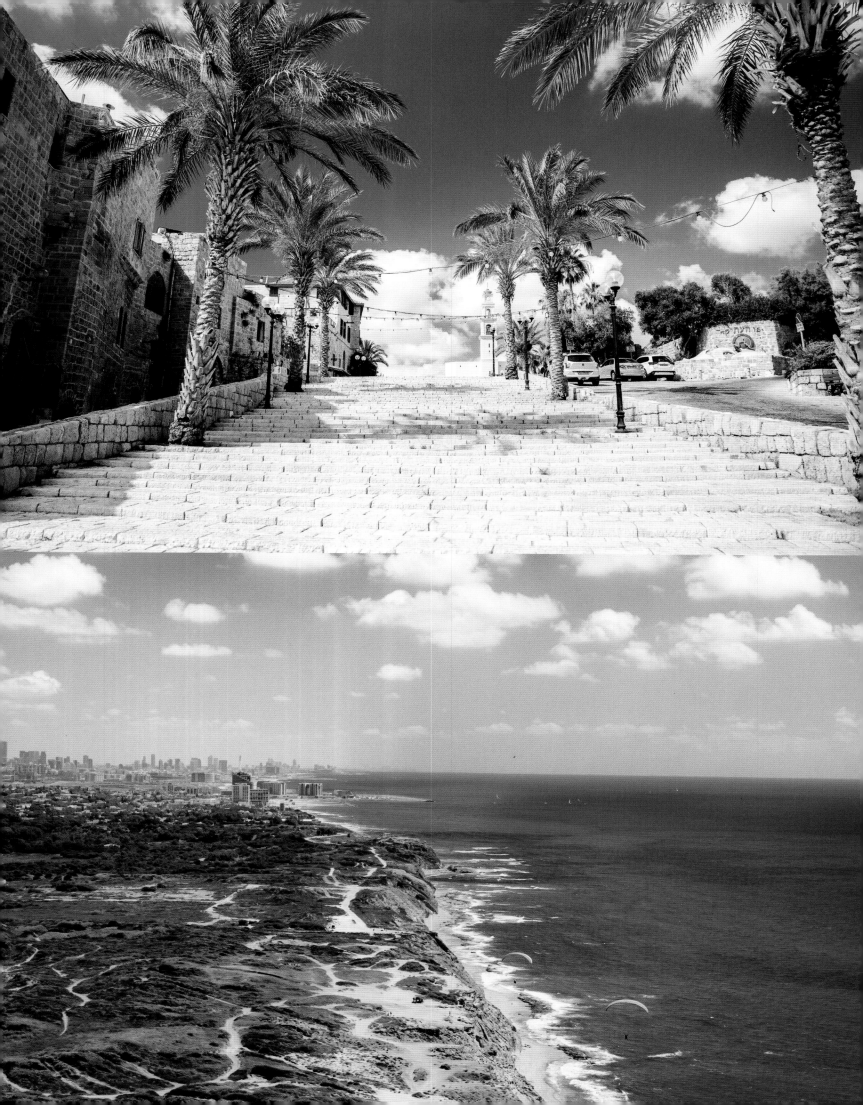

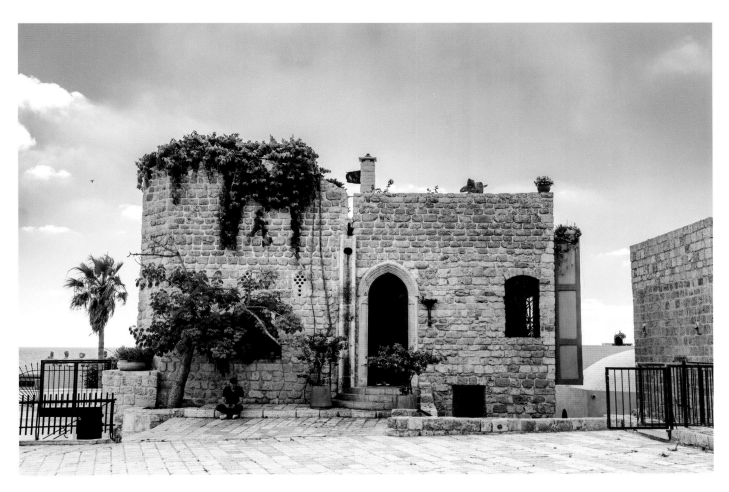

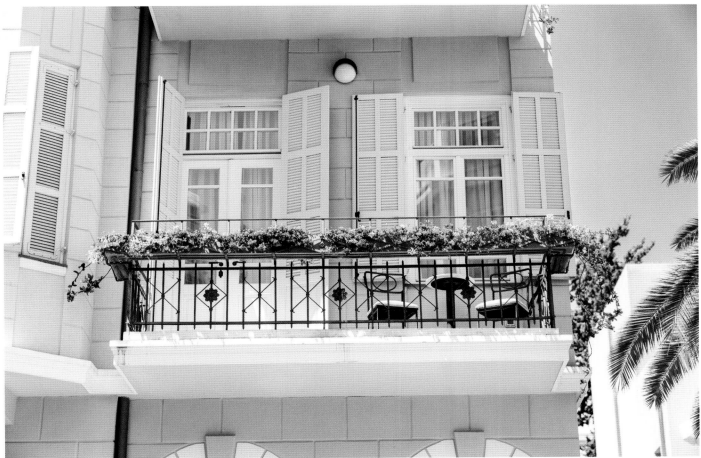

THE VINE
SHALL GIVE
ITS FRUIT, AND
THE GROUND
SHALL GIVE ITS
PRODUCE, AND
THE HEAVENS
SHALL GIVE
THEIR DEW.

ZECHARIAH 8:12

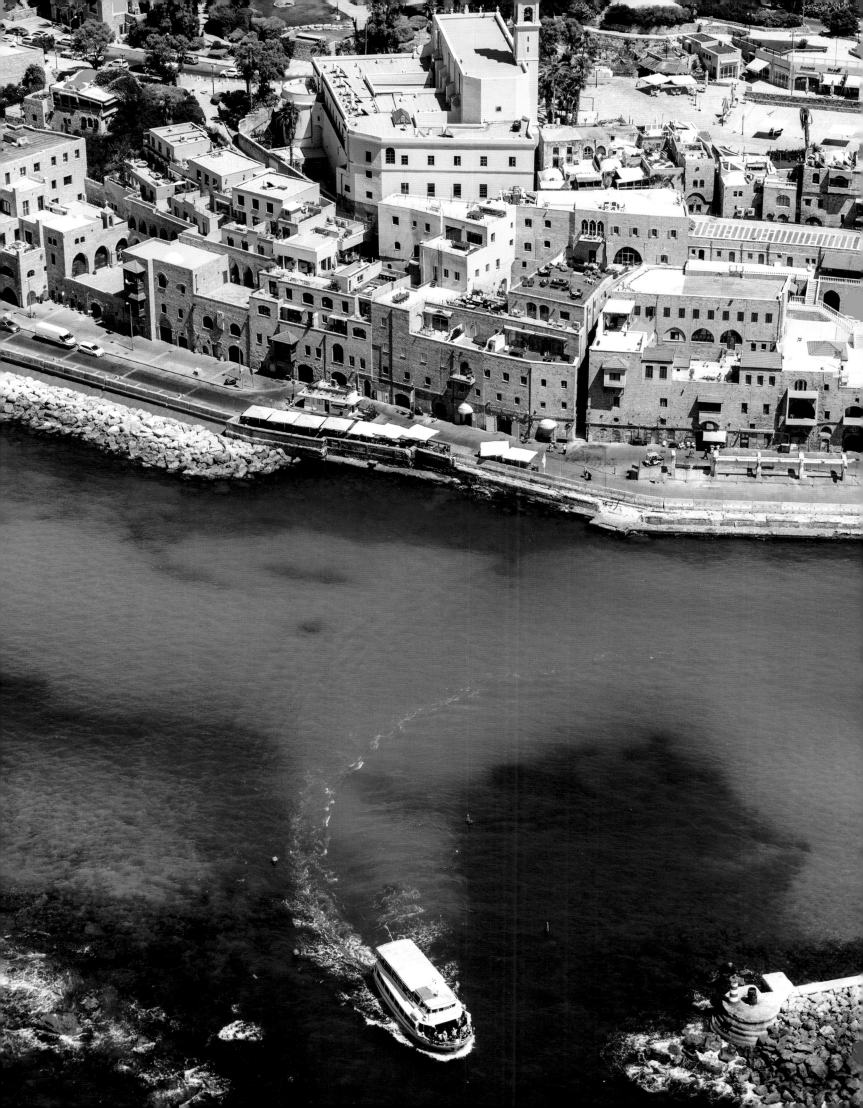

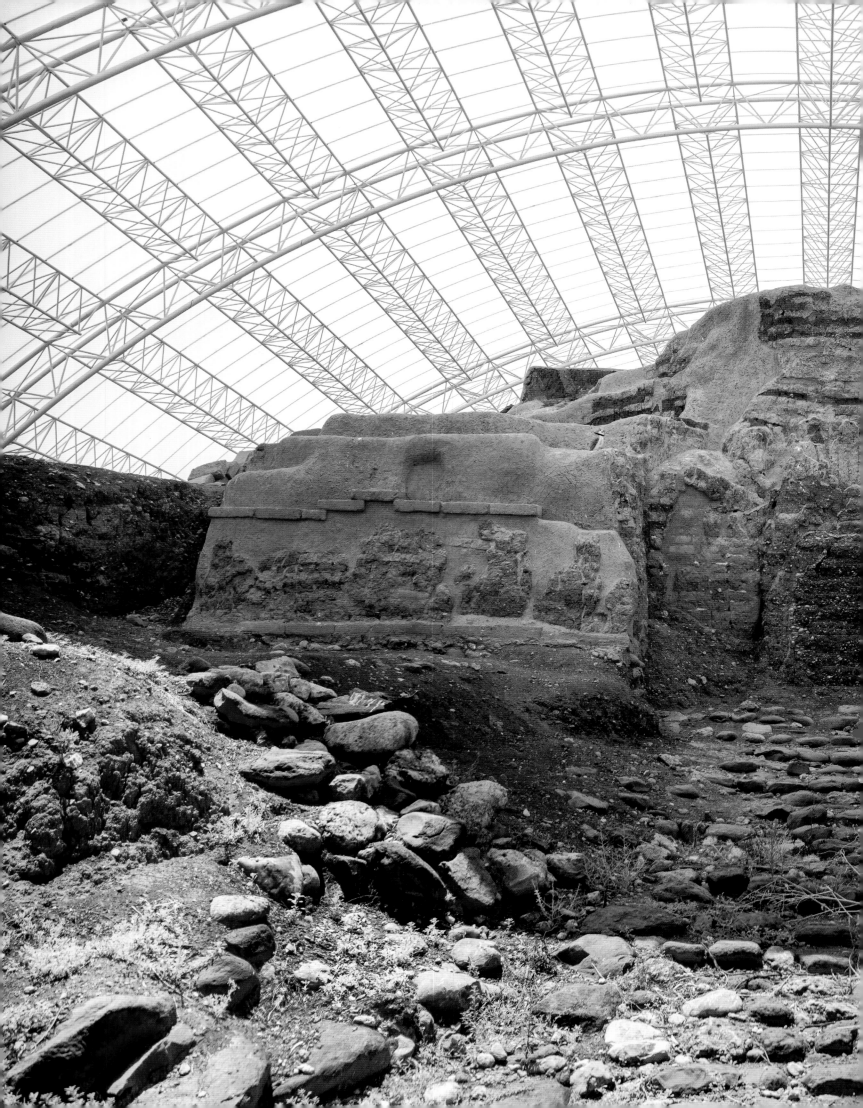

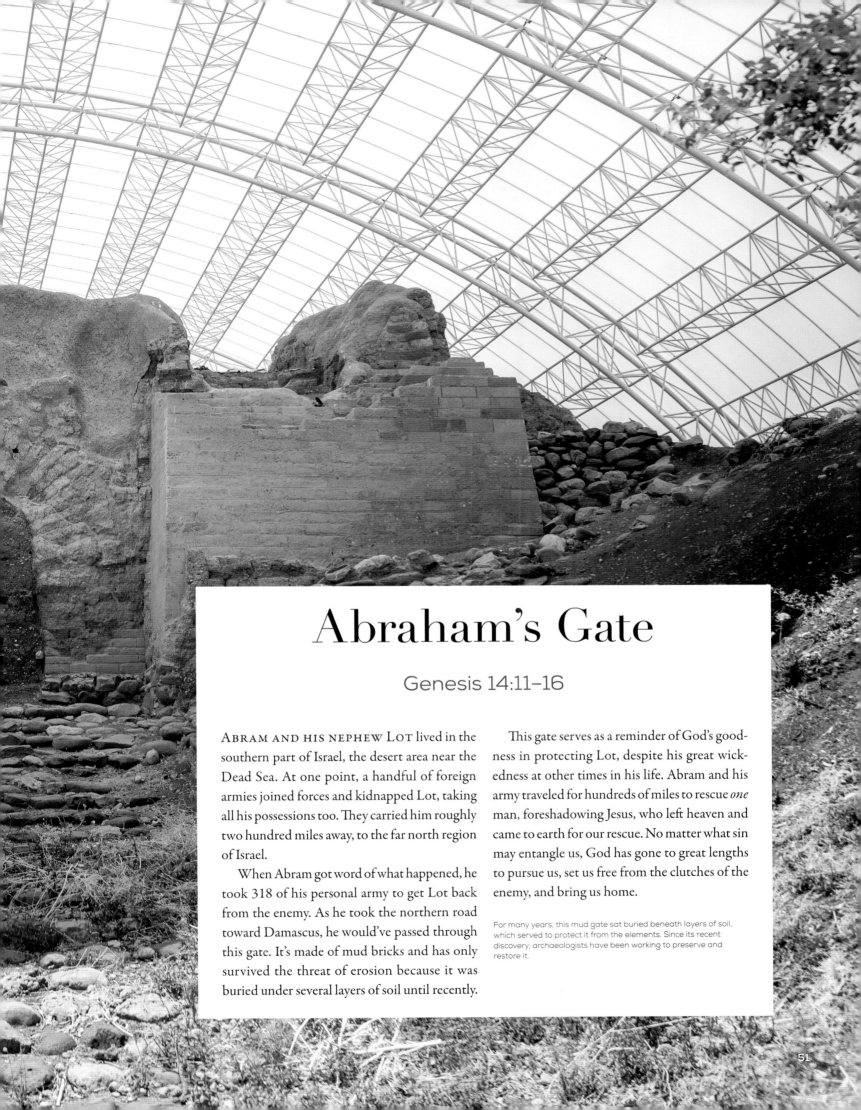

Abraham's Gate

Genesis 14:11–16

ABRAM AND HIS NEPHEW LOT lived in the southern part of Israel, the desert area near the Dead Sea. At one point, a handful of foreign armies joined forces and kidnapped Lot, taking all his possessions too. They carried him roughly two hundred miles away, to the far north region of Israel.

When Abram got word of what happened, he took 318 of his personal army to get Lot back from the enemy. As he took the northern road toward Damascus, he would've passed through this gate. It's made of mud bricks and has only survived the threat of erosion because it was buried under several layers of soil until recently.

This gate serves as a reminder of God's goodness in protecting Lot, despite his great wickedness at other times in his life. Abram and his army traveled for hundreds of miles to rescue *one* man, foreshadowing Jesus, who left heaven and came to earth for our rescue. No matter what sin may entangle us, God has gone to great lengths to pursue us, set us free from the clutches of the enemy, and bring us home.

For many years, this mud gate sat buried beneath layers of soil, which served to protect it from the elements. Since its recent discovery, archaeologists have been working to preserve and restore it.

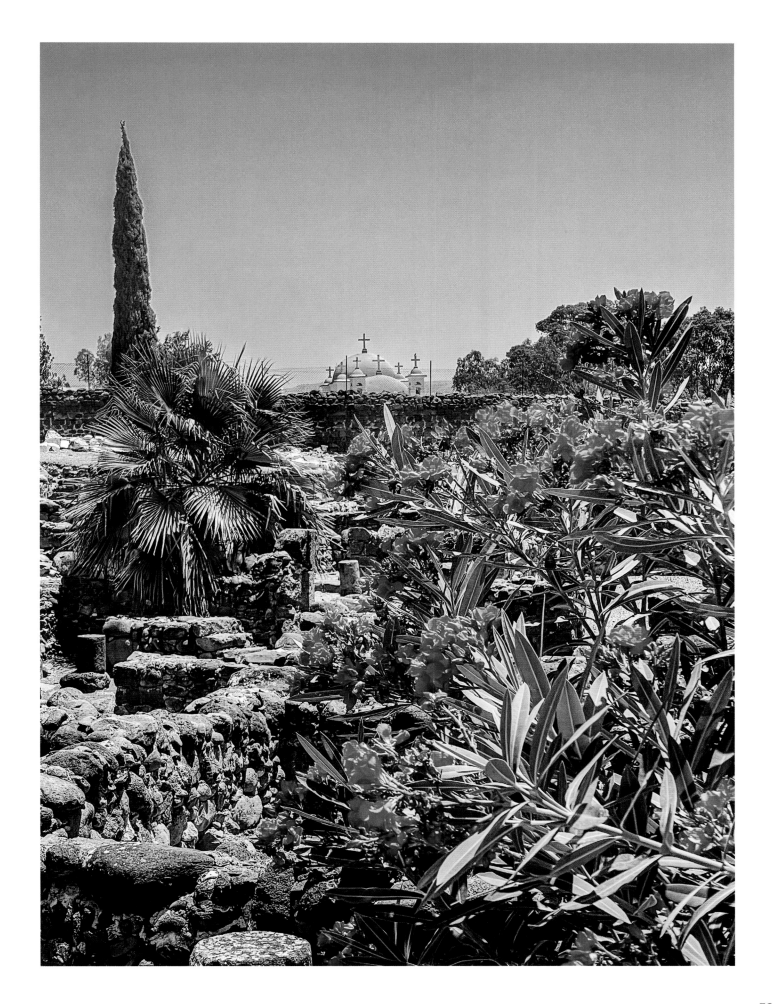

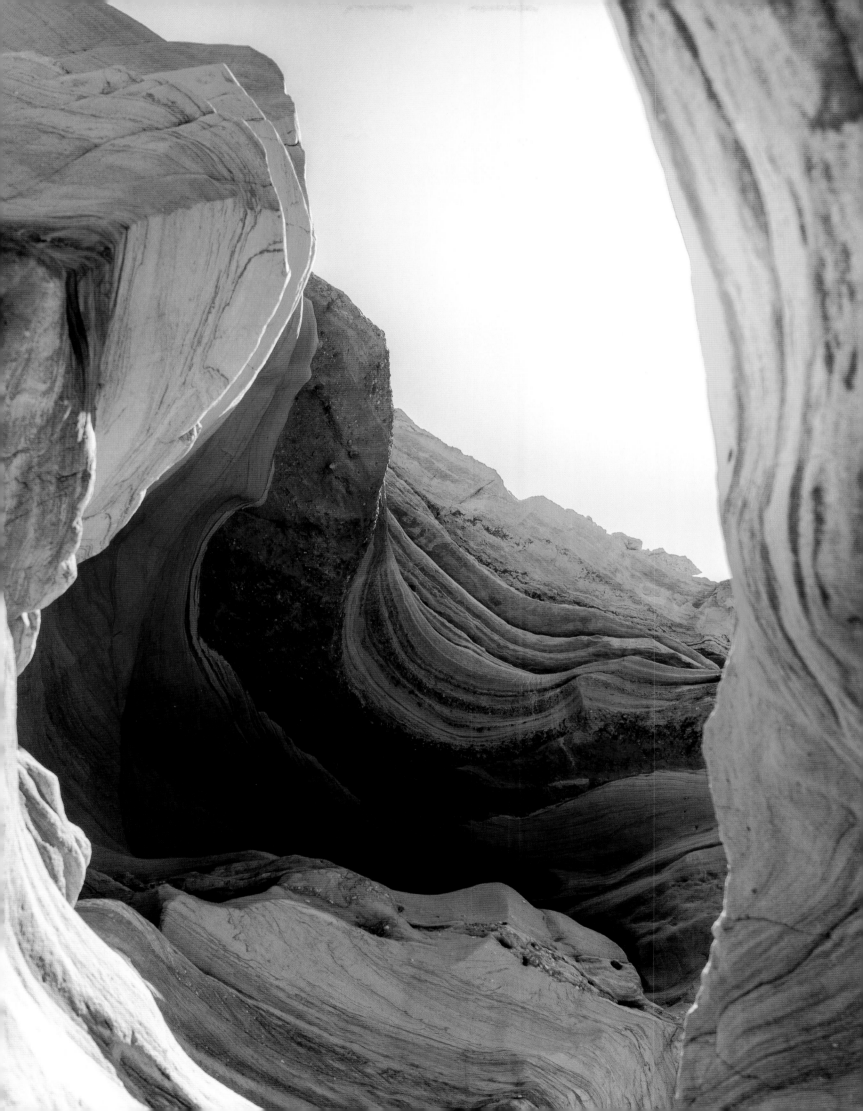

Caesarea Philippi

Matthew 16:13–18

CAESAREA PHILIPPI was a center of pagan worship. Jesus took His disciples here to ask them, "Who do you say I am?"

> Simon Peter replied, "You are the Christ, the Son of the living God." And Jesus answered him, "Blessed are you, Simon Bar-Jonah! For flesh and blood has not revealed this to you, but my Father who is in heaven. And I tell you, you are Peter, and on this rock I will build my church, and the gates of hell shall not prevail against it."
>
> —Matthew 16:16–18

Jesus refers back to Peter's statement about His identity, connecting it to life of the church: Since Jesus is the Messiah and the church is built on Him, it will outlast everything. Jesus is the foundation of the church. Matthew 21:42, Ephesians 2:20, and Acts 4:11 speak to this as well. And 1 Corinthians 3:11 says, "*No one can lay a foundation other than that which is laid, which is Jesus Christ.*"

In stone masonry, the cornerstone is the most important piece. If it's removed, everything collapses. But since Jesus is the cornerstone, nothing is a threat to the church. No matter what evils you encounter today, they cannot stop His kingdom!

In Jesus's day, Caesarea Philippi was the site of horrific pagan worship rituals, including child sacrifice. The mouth of this cave served as their sacrificial spot; they referred to it as "the gates of hell" because they believed it was the opening to the underworld where their gods resided. Jesus referenced this spot in His conversation with Peter in Matthew 16. He comforted His followers by reminding them His kingdom of light is more powerful than all the evil and darkness of the world.

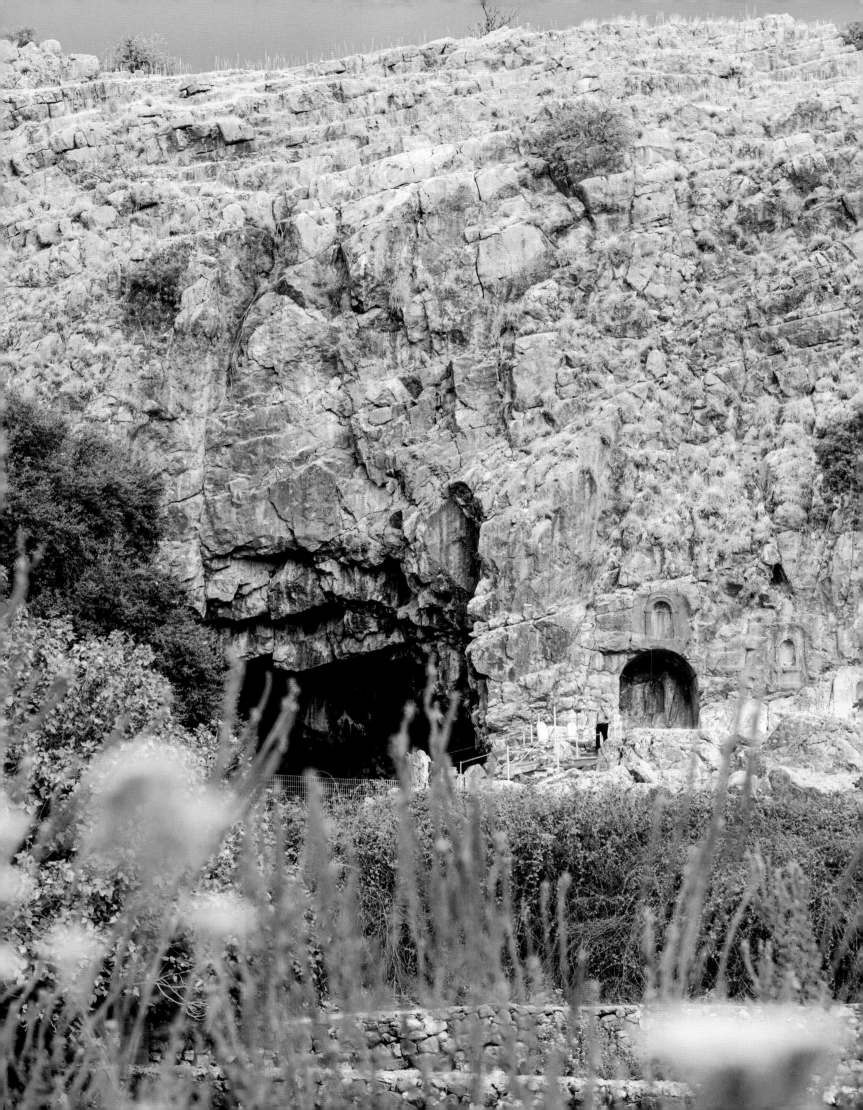

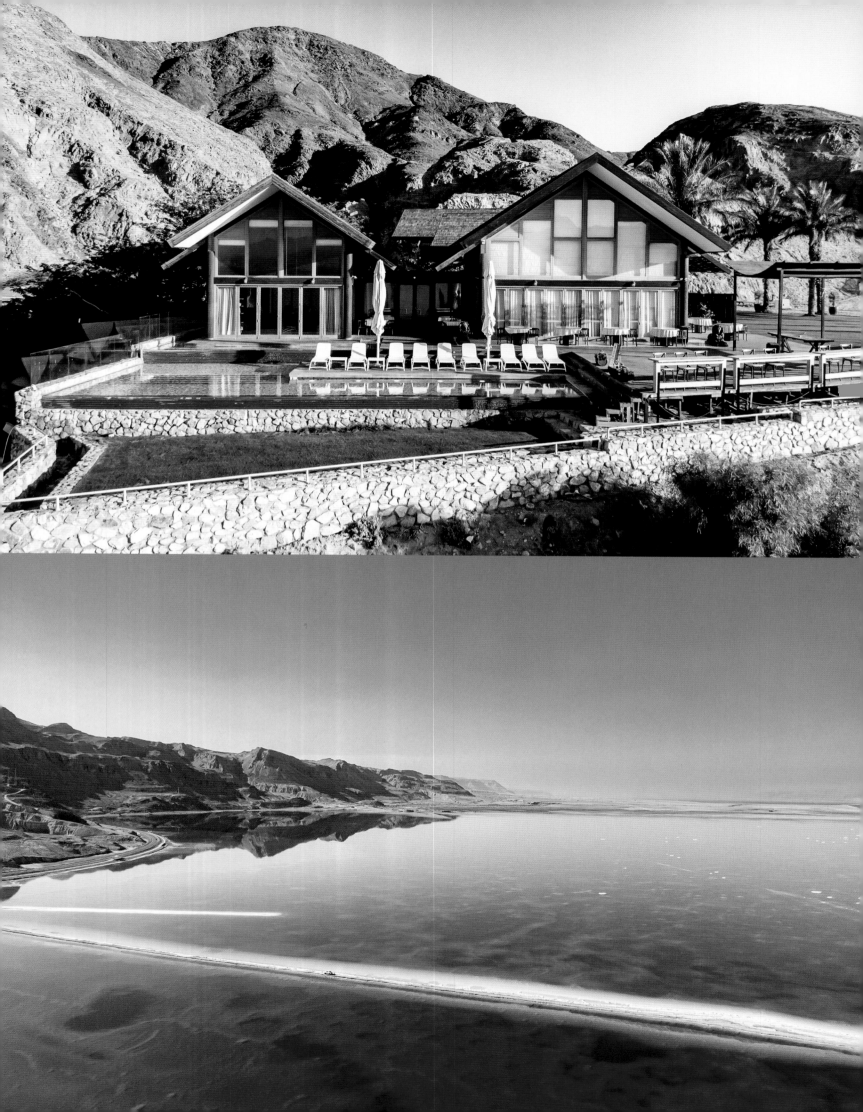

A LAND IN WHICH YOU WILL EAT BREAD WITHOUT SCARCITY, IN WHICH YOU WILL LACK NOTHING.

DEUTERONOMY 8:9

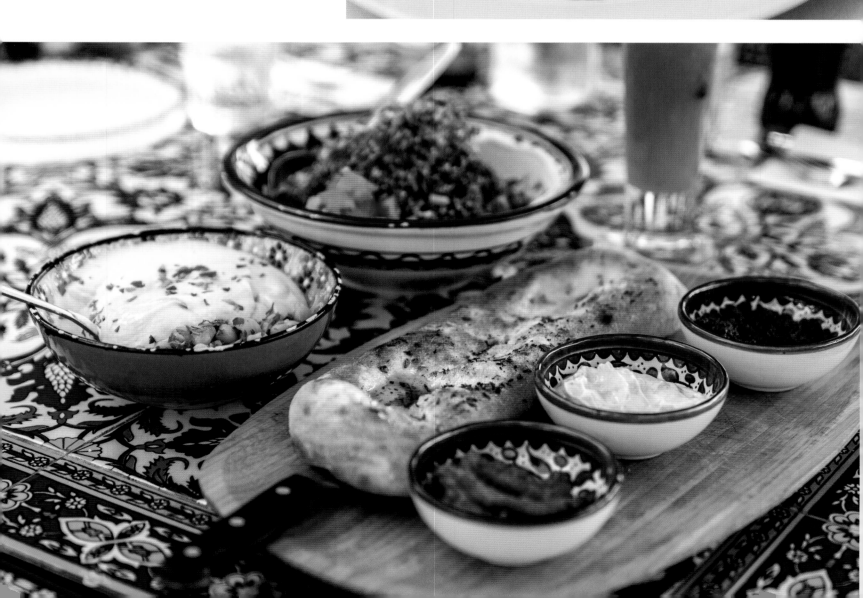

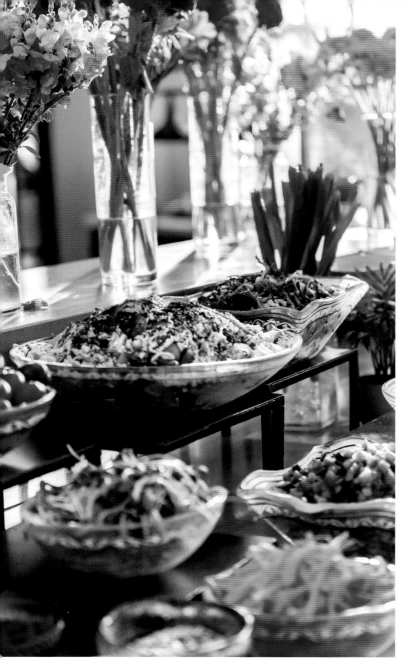

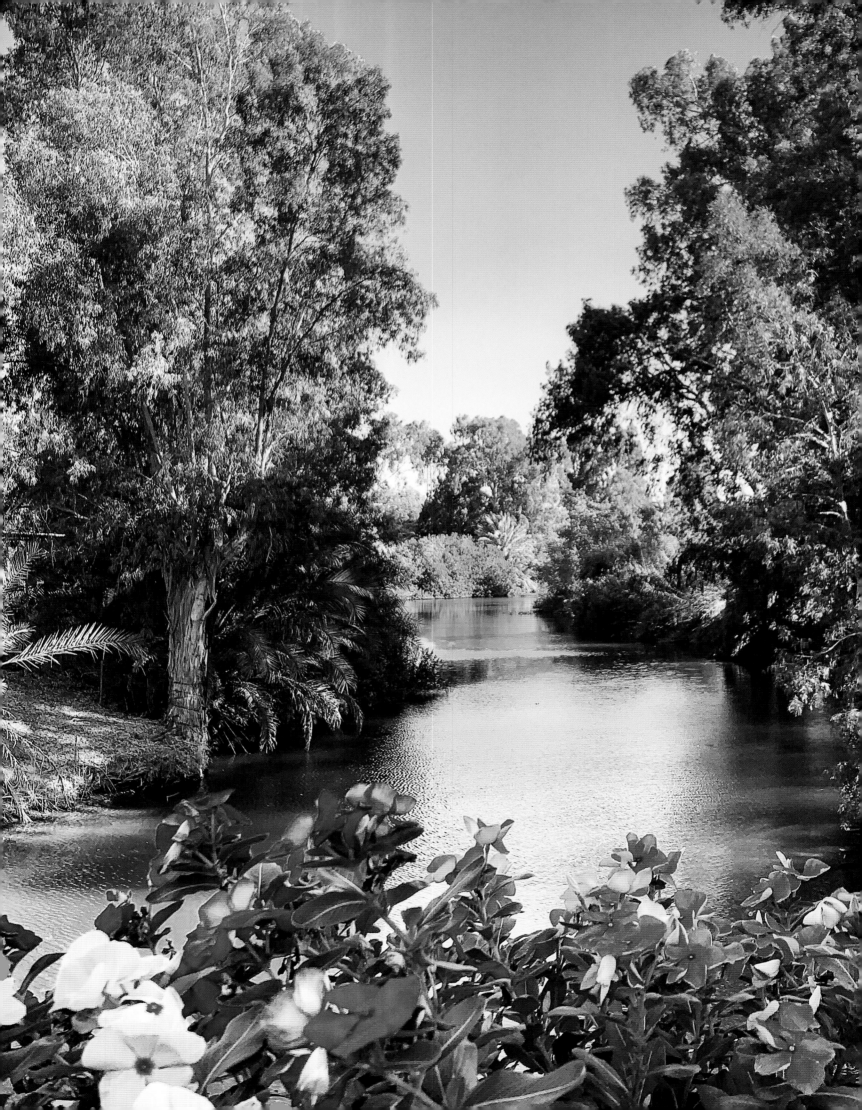

Jordan River

Matthew 3:13–17

JESUS'S BAPTISM is one of the few places in Scripture where we see all three persons of the Trinity referenced. Jesus (God the Son) was in the water, God the Spirit descended like a dove, and God the Father spoke from heaven, identifying Jesus as the Son, voicing His approval for all to hear.

This scene is reminiscent of the creation story. In creation, the Father spoke the Word (who is the Son), and the Spirit descended on creation, hovering, as the Son completed the manual labor of creation (Colossians 1:16).

Creation occurred at the beginning of the earthly kingdom, and Jesus's baptism occurred at the beginning of the eternal kingdom— the initiation of His public ministry. In these two events, Scripture shows us how the Father, Spirit, and Son work in unity and diversity toward our creation and our re-creation.

Yardenit is one of the two primary sites where Christian pilgrims conduct baptisms in the Jordan River. Here, the river flows out of the south end of the Sea of Galilee and continues southward to the Dead Sea.

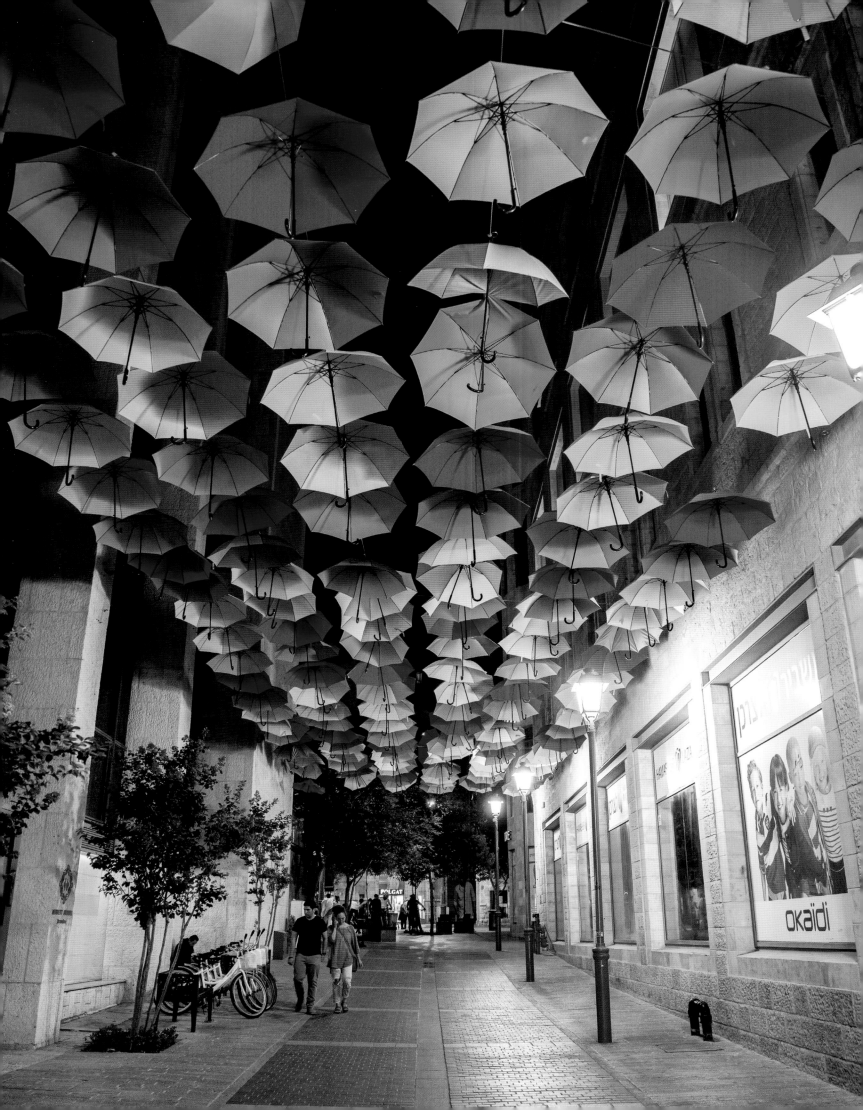

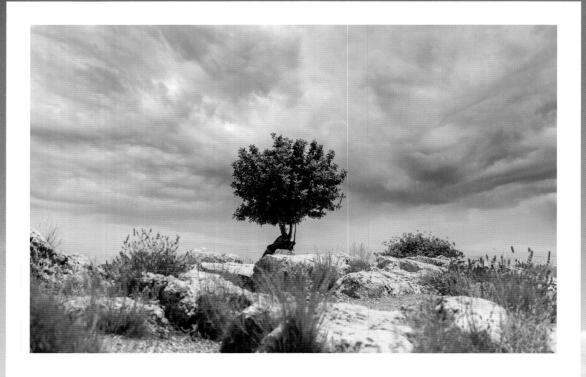

Golan Heights

Deuteronomy 4:41–43

GOD ESTABLISHED SIX CITIES of refuge in Israel—places chosen for accidental murderers to live. These people were regarded as *manslayers* since their apparent motive wasn't to kill the victim. The Levite priests oversaw these places of refuge.

In these cities, the manslayer was safe from anyone who might want to seek revenge for the death he caused. Even though the manslayer's actions were accidental, he still committed a sin; however, God protected him from the consequences of his actions. The manslayers had to live in the city of refuge until the high priest died, at which point his death counted as payment for their sins (Romans 6:23) since their sins had occurred on his watch.

Both the high priest and these cities foreshadow Jesus for us—He is our city of refuge, our hiding place, where we're protected against the ultimate consequences of our sins. And as our great High Priest, His death atoned for those sins. Not only did Jesus make a way for us to be spared the punishment we deserve forever, but He grants us the peaceful protection of His refuge!

This elevated area sits on the borders of Israel, Syria, and Jordan. Because of its location, it serves as an important military conquest. Most recently, Israel won the Golan Heights in the Six Days War (1967).

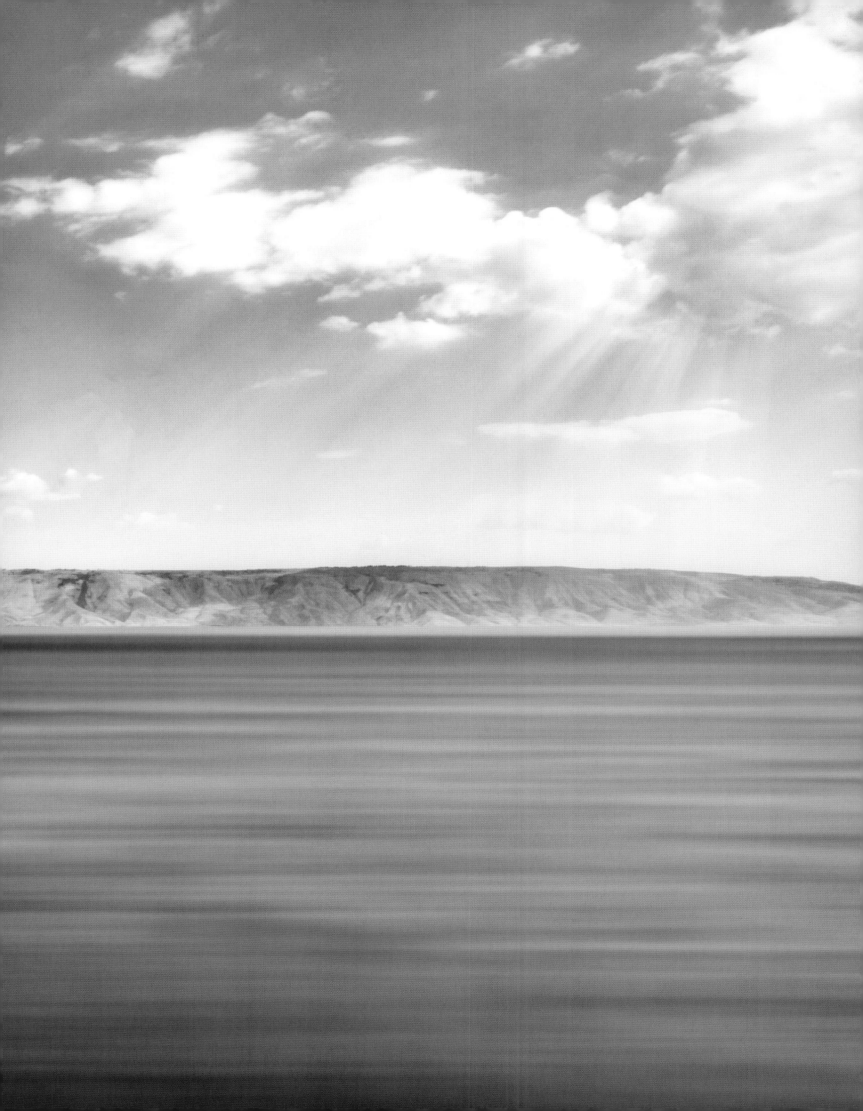

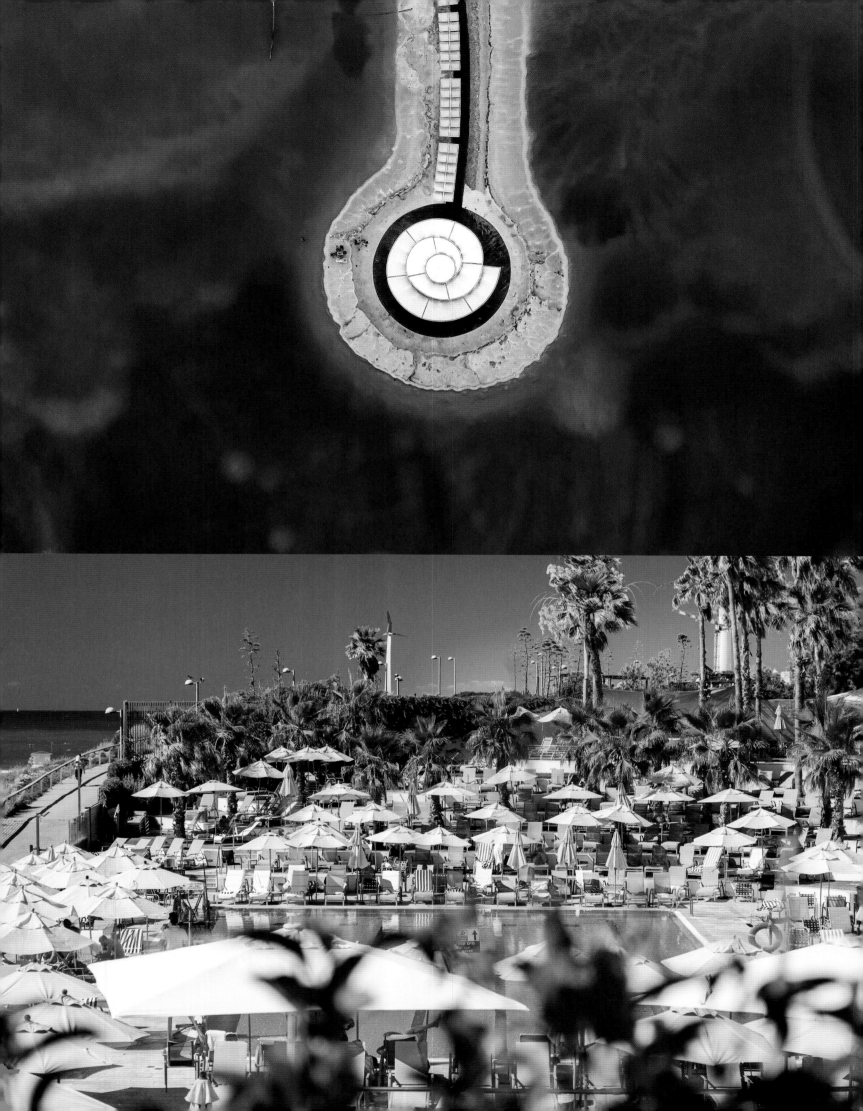

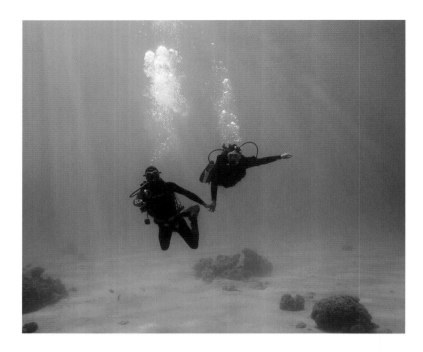

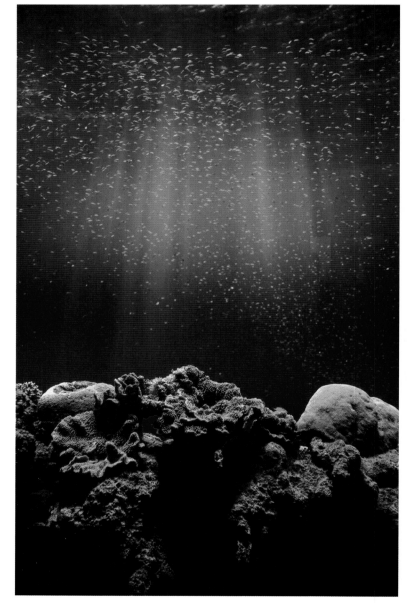

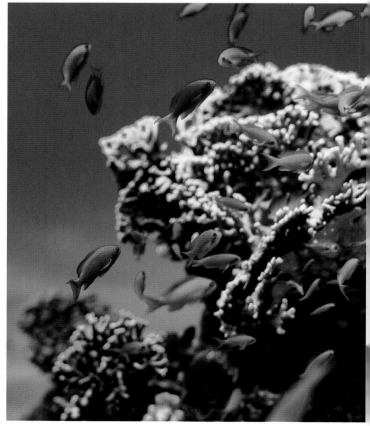

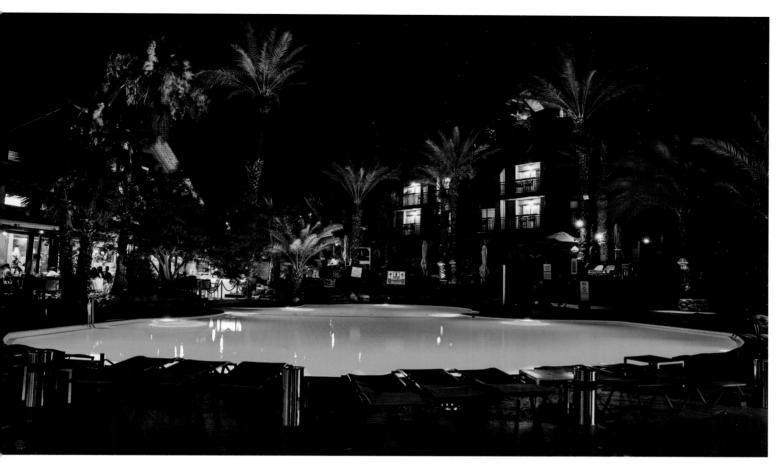

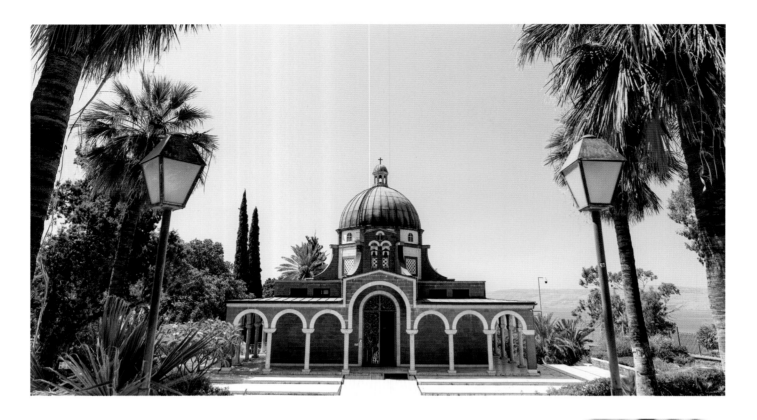

Mount Beatitudes

Matthew 6:19–21, 25–34

THERE ARE FOUR "DO NOT" COMMANDS in this passage: "do not store up treasures" and "do not be anxious," which shows up three times. If we obeyed the first command and refused to store up treasures, the other commands would likely be harder to follow—our anxieties would *increase* since we'd have less to find our security in.

But the message of Jesus has more to do with what's in our hearts than in our bank accounts. He's not interested in an empty wallet if it's adjacent to an anxious heart. He's interested in a heart that is anchored in Him. He's focused on *eternal* treasures.

Jesus knows that anxiety usurps our allegiance to His kingdom. It takes our eyes off the eternal things and fixes them on the temporary things. He's serious about teaching us to trust Him and not to fear. He's deeply invested in our hearts. If our hearts are attached to the fleeting, temporary things of life, anxiety is a natural response. But if our hearts are invested in the eternal things of His kingdom, they'll be unshakable! If our hearts trust Him, we have nothing to fear!

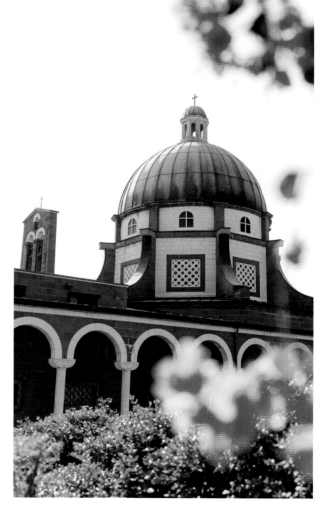

During the three years of Jesus's ministry, He lived in the Jewish region of Galilee, in a town called Capernaum. Not too far from His town, there's a hill surrounded by wide, flat fields. Many believe this site was where Jesus fed the five thousand and where He preached His most famous sermon, the Sermon on the Mount (Matthew 5–7). On this lush hilltop, a beautiful octagonal church represents the eight beatitudes listed in the sermon.

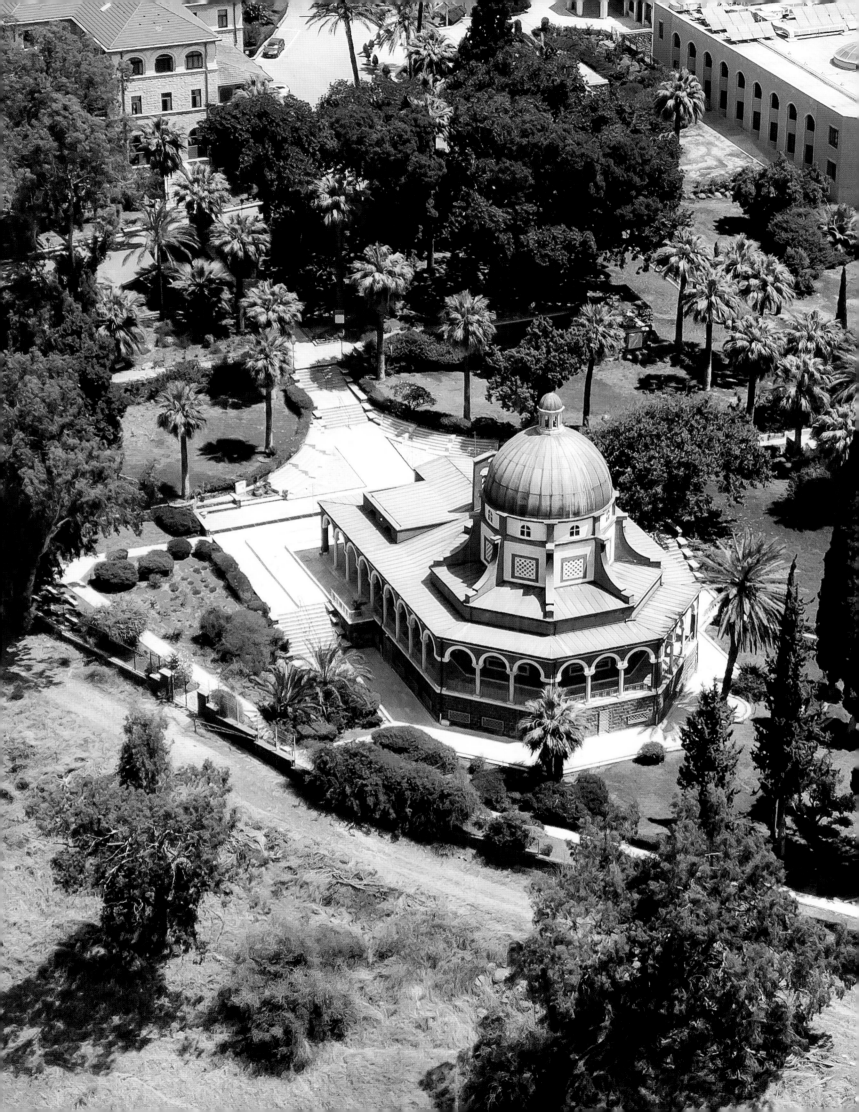

EVERY PLACE
THAT THE SOLE
OF YOUR FOOT
WILL TREAD
UPON I HAVE
GIVEN TO YOU.

JOSHUA 1:3

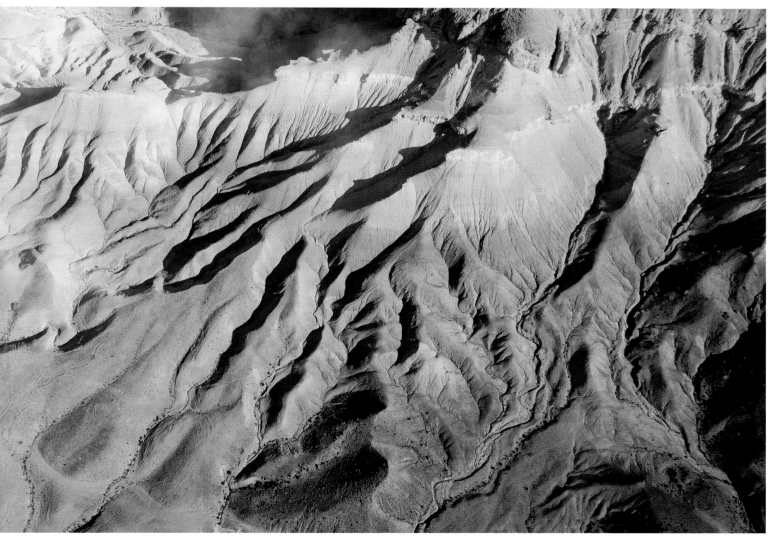

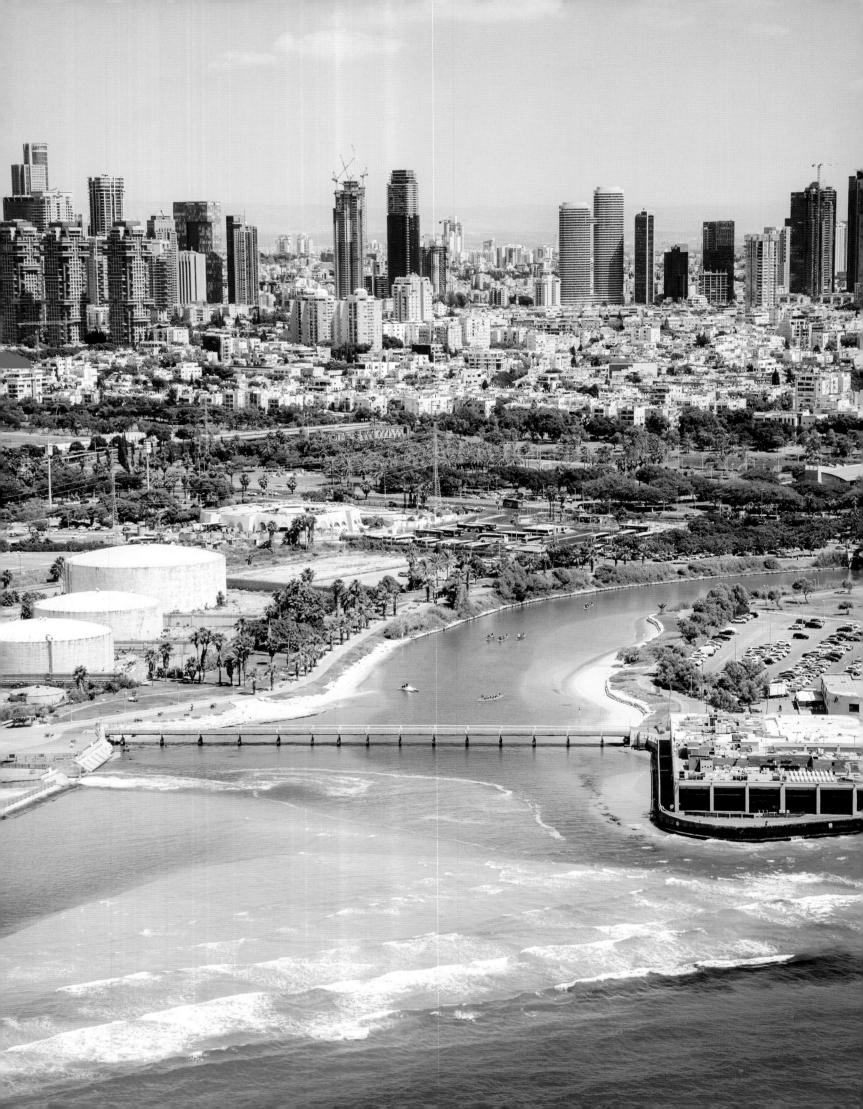

DWELL IN THE LAND AND
BEFRIEND FAITHFULNESS.

PSALM 37:3

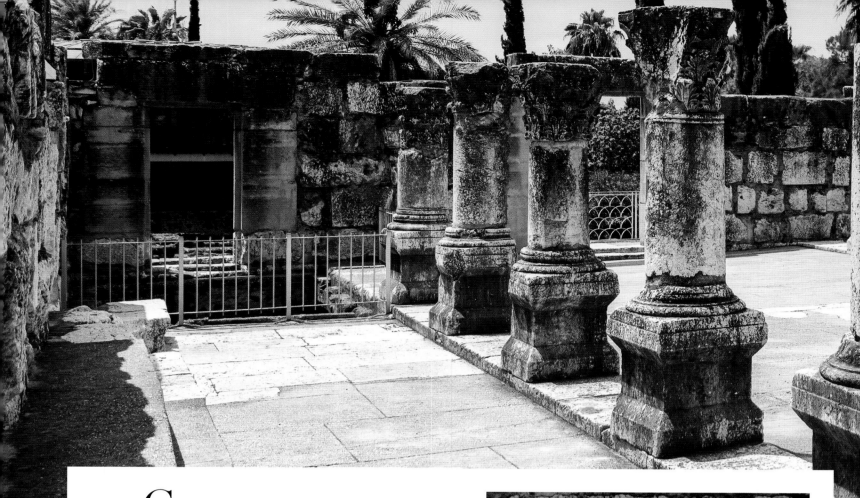

Capernaum

Matthew 8:5–13

CAPERNAUM LOCALS KNEW JESUS—they passed Him on the street and saw Him in the synagogue. It was His home during His years of ministry. Rome's army kept watch over the locals and tourists there—oppressing, jailing, and even murdering them—and centurions were leaders in this ruling army.

Jesus performed roughly 90 percent of His miracles in Capernaum. But even after seeing His power displayed repeatedly, the locals doubted. So when a Roman centurion asked Him for help, it was scandalous on every level. Not only was the person ostensibly in power asking for help from someone "beneath" him, but the centurion believed in His power and authority even when the locals didn't. Perhaps most scandalous of all, Jesus helped him and used him as an example of faith.

God's plan has always involved reaching across enemy lines to save those far from Him. After Jesus's resurrection, He said, "Repentance for the forgiveness of sins should be proclaimed in his name to all nations" (Luke 24:47). No matter our nationality or status, we all started out as God's enemies, children of wrath by birth. But by the finished work of Christ, God has made a way to rescue us into His family!

Capernaum stood as one of the most influential cities in the Galilee region during Jesus's time. Today, visitors can walk in the ruins of the first-century synagogue where Jesus taught. The original synagogue was made of black volcanic rock (visible in the photo on the right), and in the fourth century a limestone synagogue was built atop it.

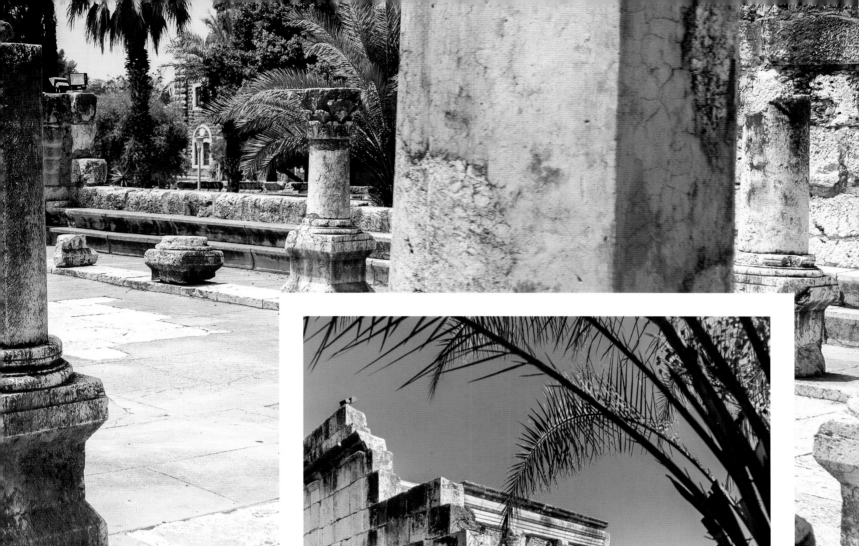

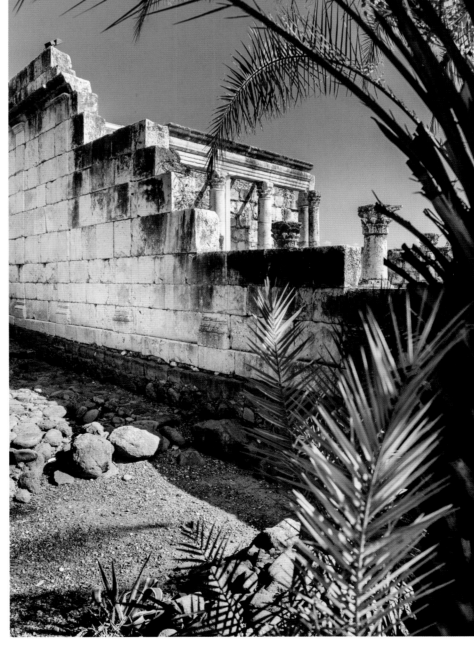

REPENTANCE
FOR THE
FORGIVENESS
OF SINS
SHOULD BE
PROCLAIMED
IN HIS NAME TO
ALL NATIONS.

LUKE 24:47

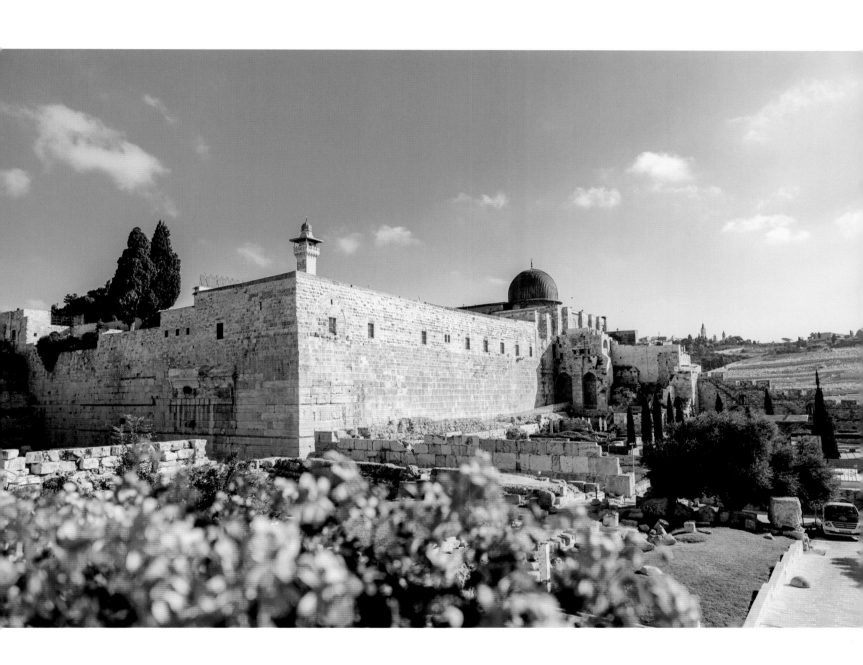

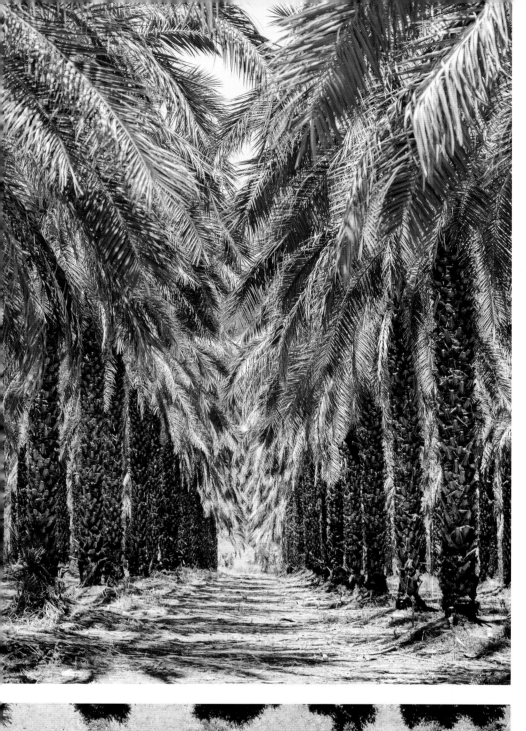

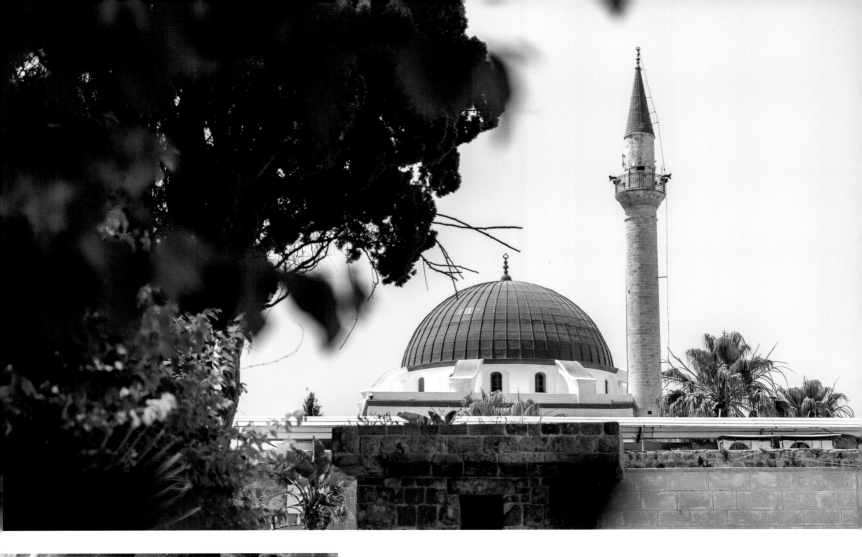

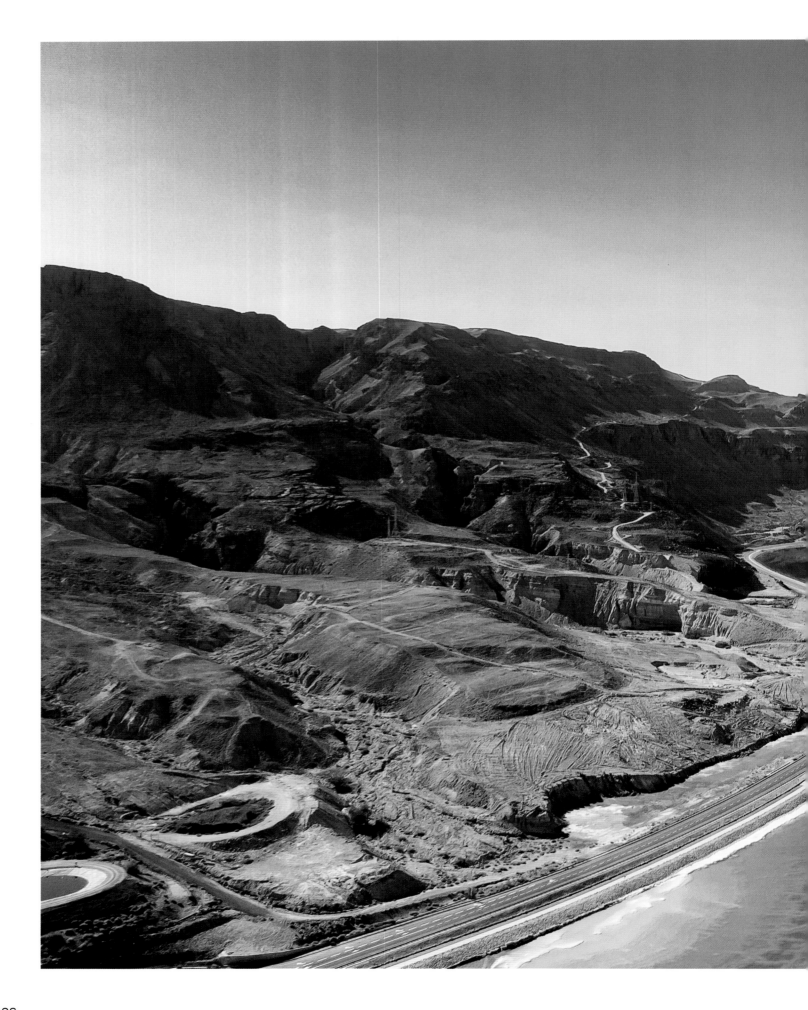

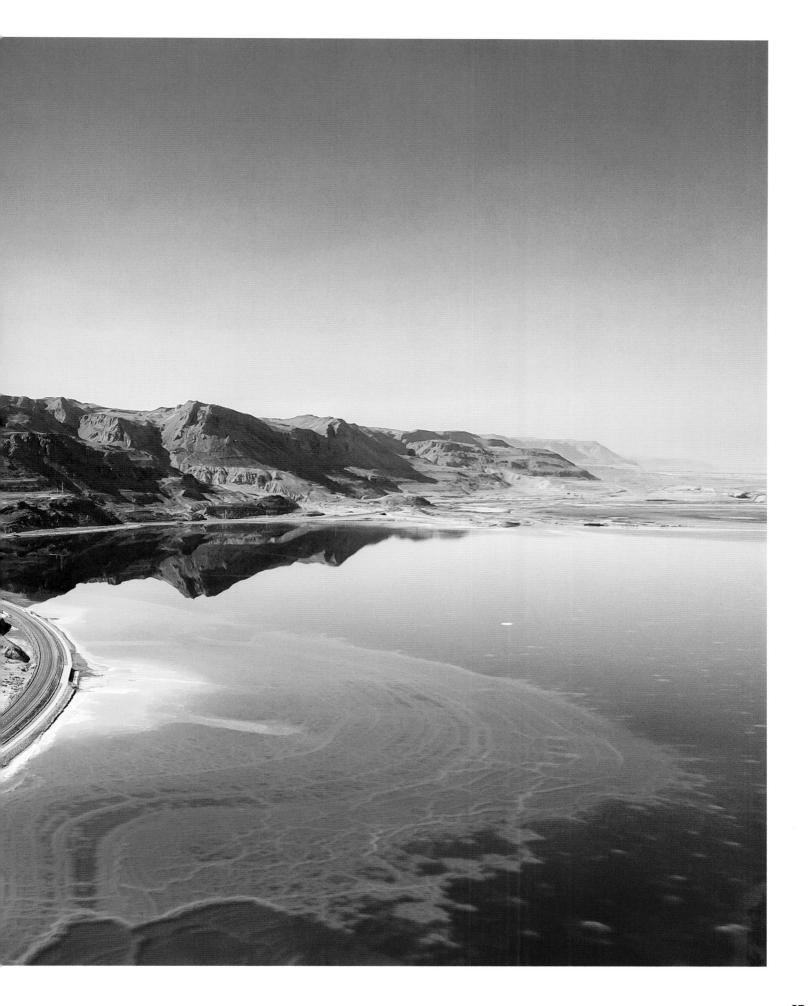

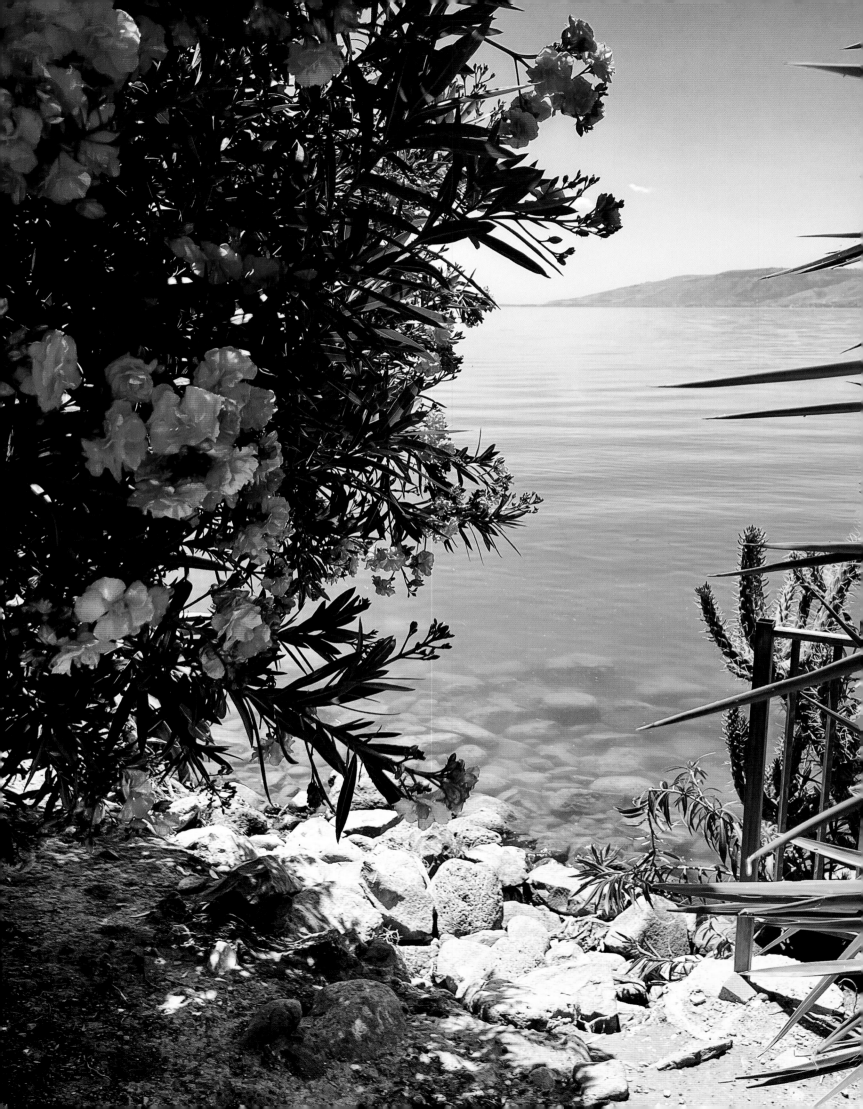

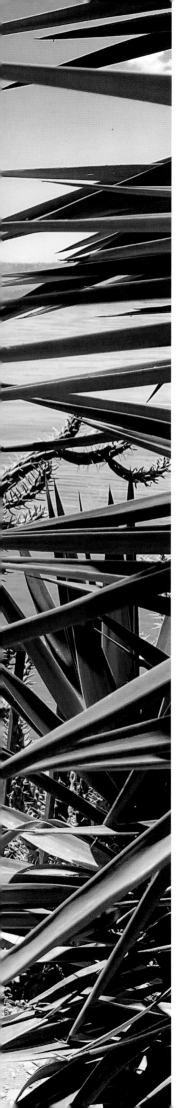

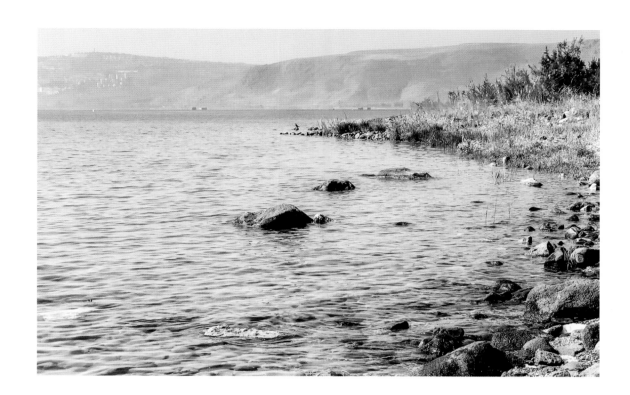

Galilee Shoreline

Luke 5:1–11

IN FIRST-CENTURY ISRAEL, most followers of a rabbi were selected by age twelve, but Jesus's disciples were likely a few years older, probably in their early-to-mid teens. Most didn't have families of their own and were working in their fathers' businesses. For some, that was the business of fishing on the Sea of Galilee. On the western shores of Galilee outside Capernaum, there's one natural harbor; there's reason to believe this would've been the spot where they docked their boats—and where the story of Jesus calling some of His first disciples took place.

When he had finished speaking, he said to Simon, "Put out into the deep and let down your nets for a catch." And Simon answered, "Master, we toiled all night and took nothing! But at your word I will let down the nets." And when they had done this, they enclosed a large number of fish, and their nets were breaking. They signaled to their partners in the other boat to come and help them. And they came and filled both the boats, so that they began to sink. . . . And when they had brought their boats to land, they left everything and followed him.

—Luke 5:4–7, 11

First-time visitors to Israel often find themselves shocked by the small size of the Sea of Galilee. From the north and south ends, the entire sea is visible at once. Jesus and His disciples lived and ministered primarily on the northwest shore. The shoreline has remained the same over the past two thousand years, making it easier to find and confirm biblical sites as they're discovered through continued excavation.

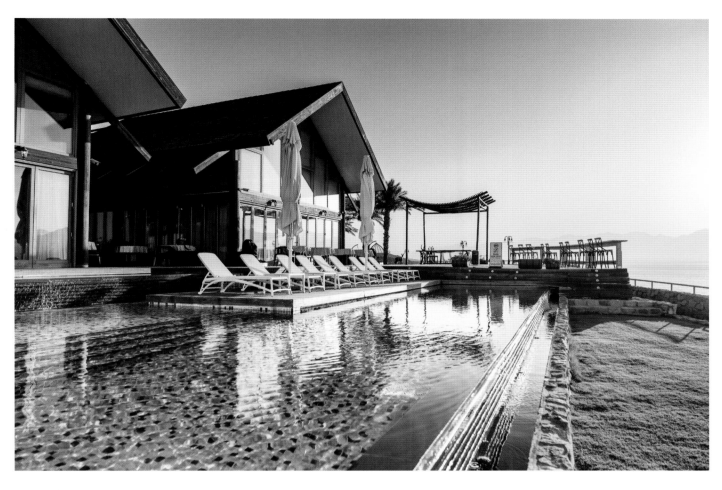

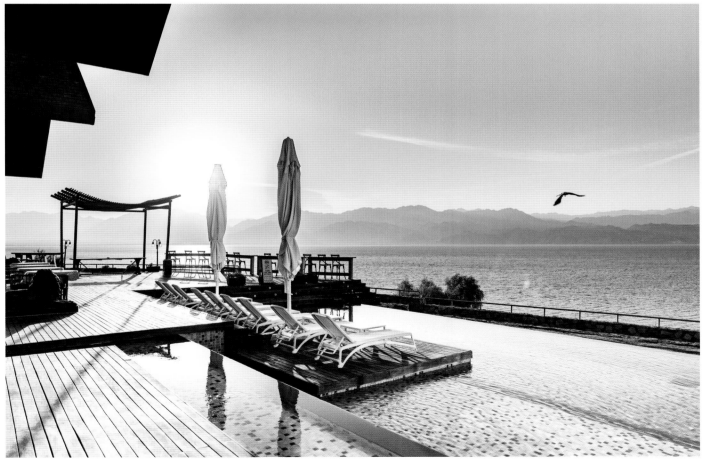

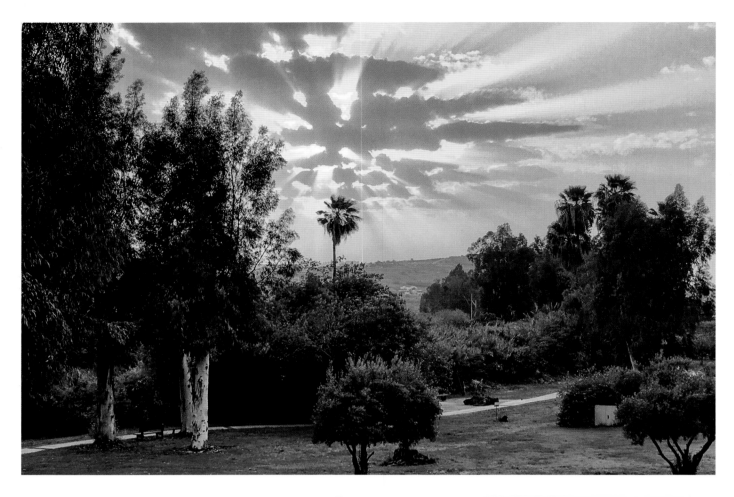

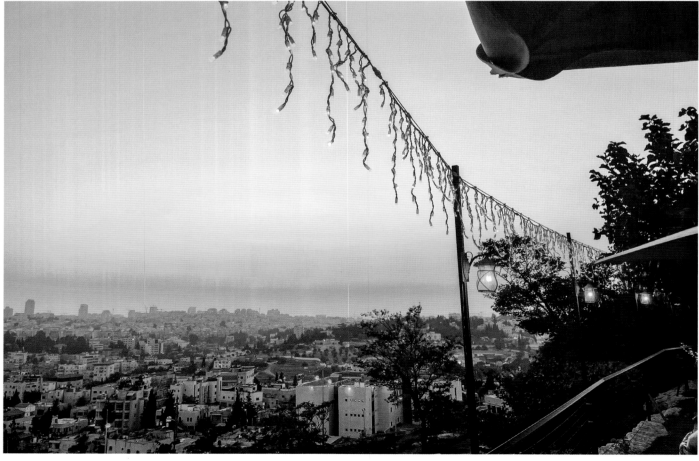

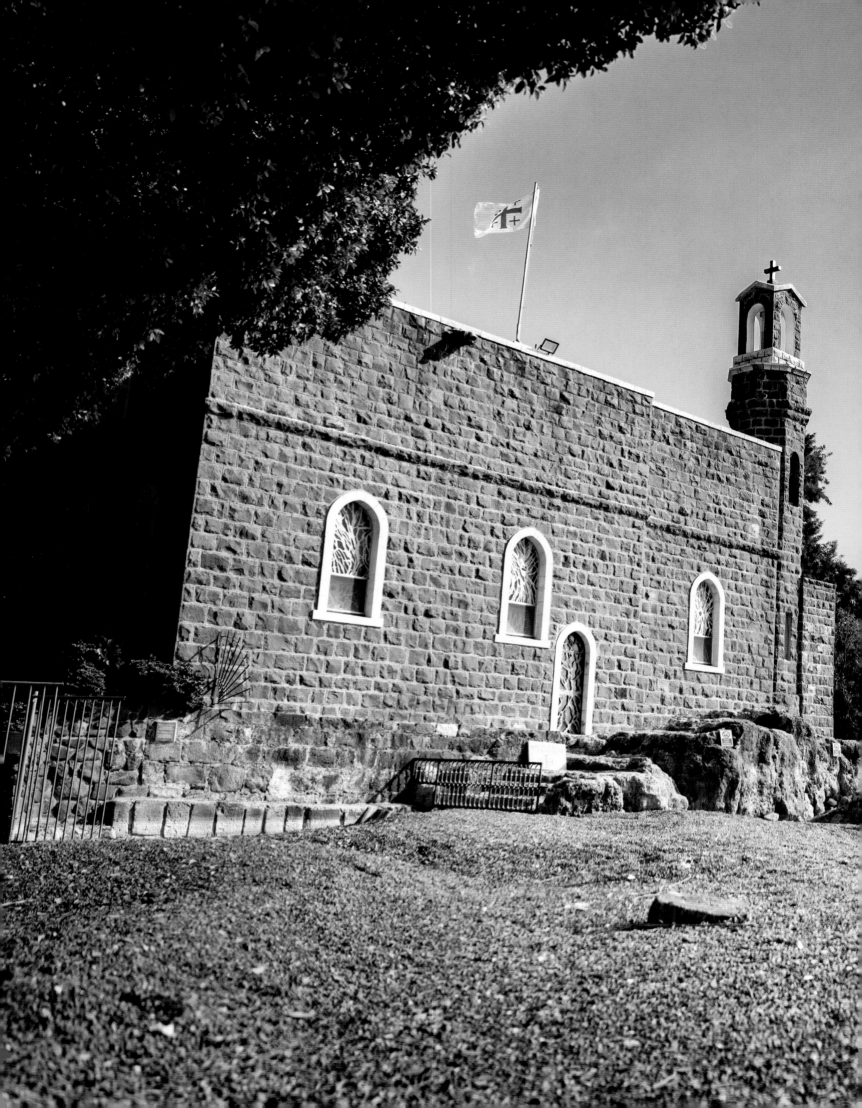

Mensa Christi
Part 1 of 3

John 21:2-8

Just as day was breaking, Jesus stood on the shore; yet the disciples did not know that it was Jesus. Jesus said to them, "Children, do you have any fish?" They answered him, "No." He said to them, "Cast the net on the right side of the boat, and you will find some." So they cast it, and now they were not able to haul it in, because of the quantity of fish.
—JOHN 21:4–6

AFTER JESUS'S RESURRECTION, His disciples went back to what they knew: fishing. But after a night in the boat, they came up empty-handed. Fortunately, a man on the shore offered some guidance; he suggested they cast their nets on the other side of the boat, and they made a massive catch.

This was a callback—an inside joke with His boys. By repeating the same directions and results as when He first called them, Jesus was tipping His hand—*He* was the man on the shoreline. These two fishing stories serve as bookends for Jesus's time with His disciples. They reveal how He stayed with them after their denial and desertion. We wander, but He stays. He never leaves you to fend for yourself.

Mensa Christi, also known as the site of Peter's primacy, is likely where Jesus first called many of His disciples while they were fishing. This natural port sits just outside of Capernaum, where many of the local fishermen disciples lived.

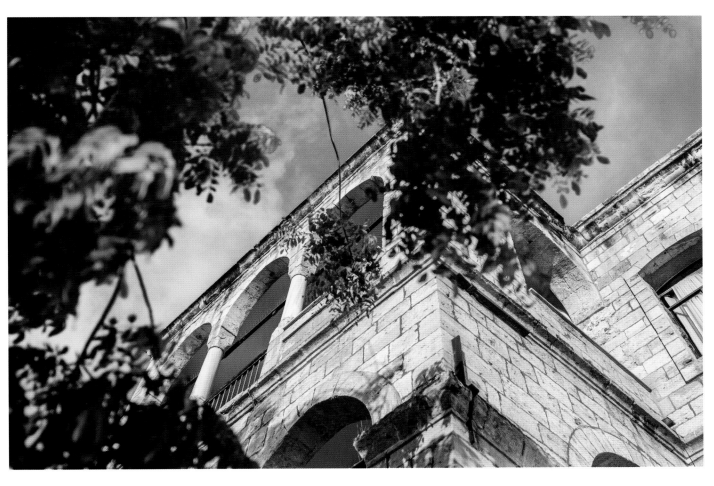

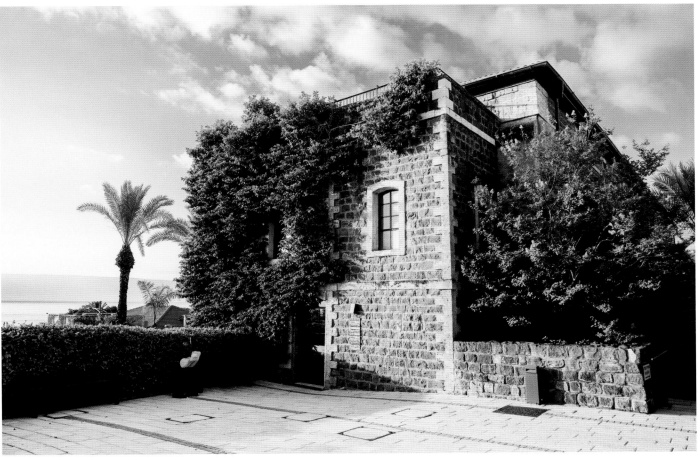

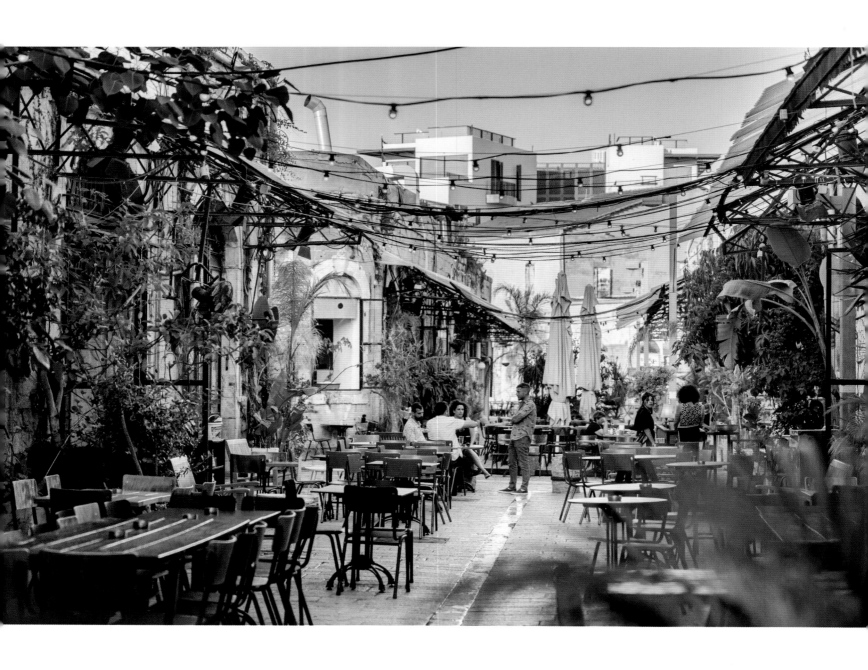

MY CITIES SHALL AGAIN OVERFLOW WITH PROSPERITY.

ZECHARIAH 1:17

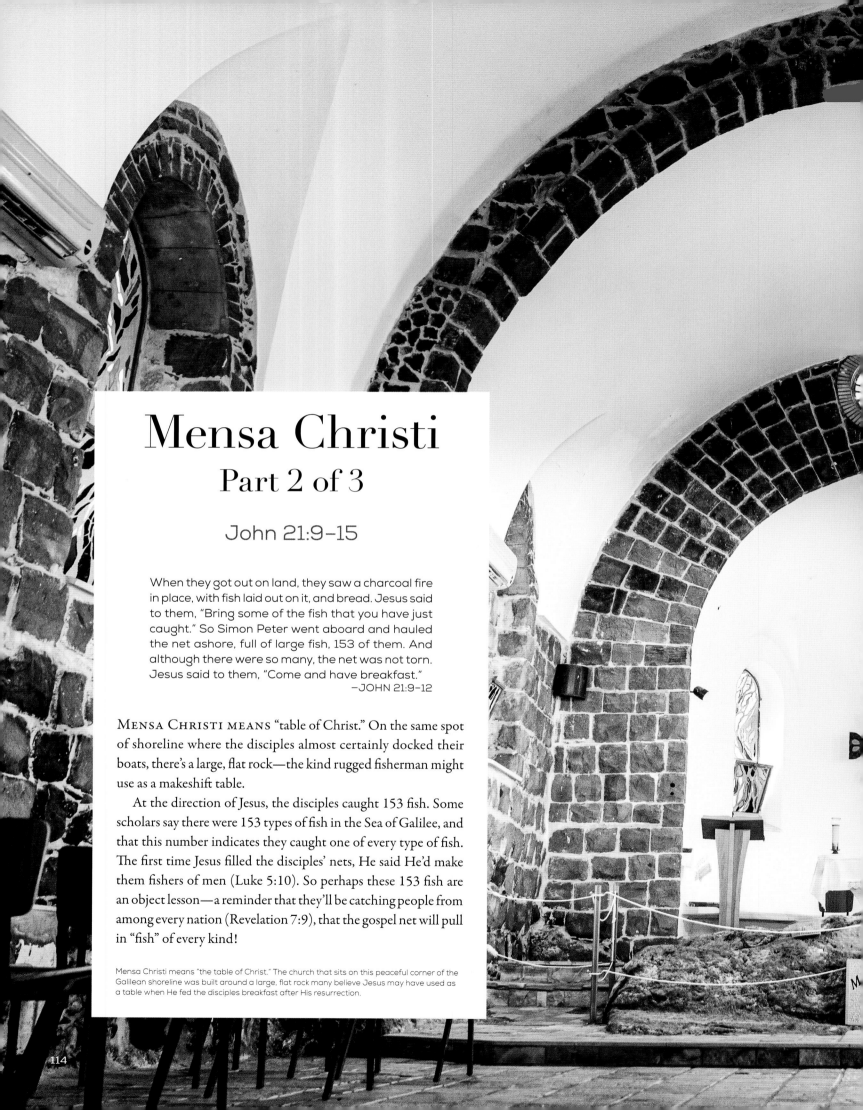

Mensa Christi
Part 2 of 3

John 21:9–15

When they got out on land, they saw a charcoal fire in place, with fish laid out on it, and bread. Jesus said to them, "Bring some of the fish that you have just caught." So Simon Peter went aboard and hauled the net ashore, full of large fish, 153 of them. And although there were so many, the net was not torn. Jesus said to them, "Come and have breakfast."
—JOHN 21:9–12

MENSA CHRISTI MEANS "table of Christ." On the same spot of shoreline where the disciples almost certainly docked their boats, there's a large, flat rock—the kind rugged fisherman might use as a makeshift table.

At the direction of Jesus, the disciples caught 153 fish. Some scholars say there were 153 types of fish in the Sea of Galilee, and that this number indicates they caught one of every type of fish. The first time Jesus filled the disciples' nets, He said He'd make them fishers of men (Luke 5:10). So perhaps these 153 fish are an object lesson—a reminder that they'll be catching people from among every nation (Revelation 7:9), that the gospel net will pull in "fish" of every kind!

Mensa Christi means "the table of Christ." The church that sits on this peaceful corner of the Galilean shoreline was built around a large, flat rock many believe Jesus may have used as a table when He fed the disciples breakfast after His resurrection.

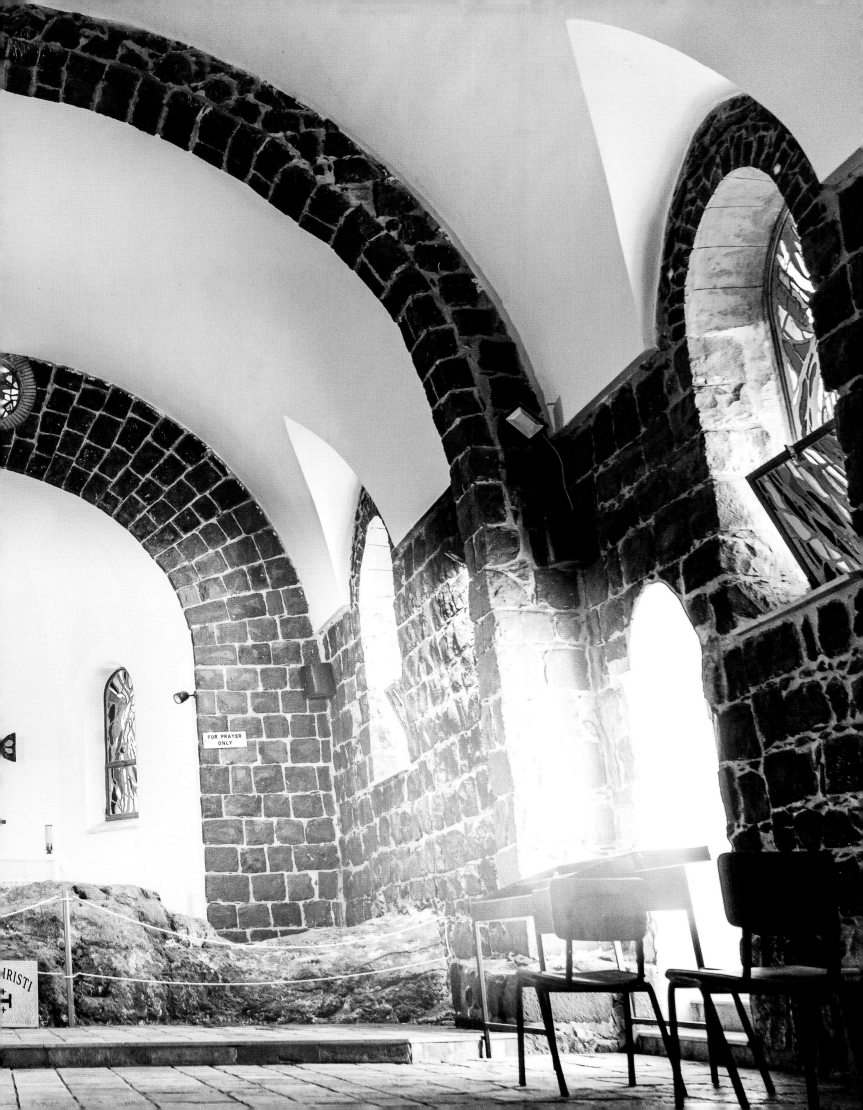

FOR PRAYER
ONLY

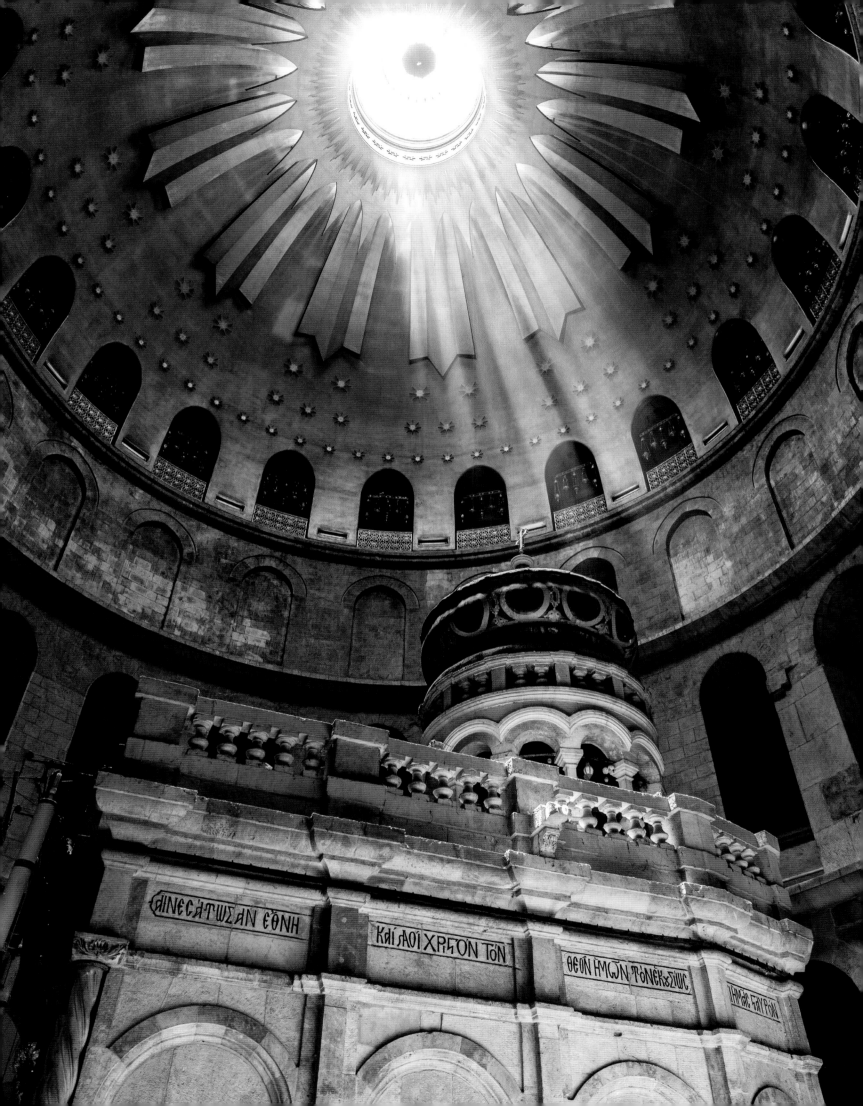

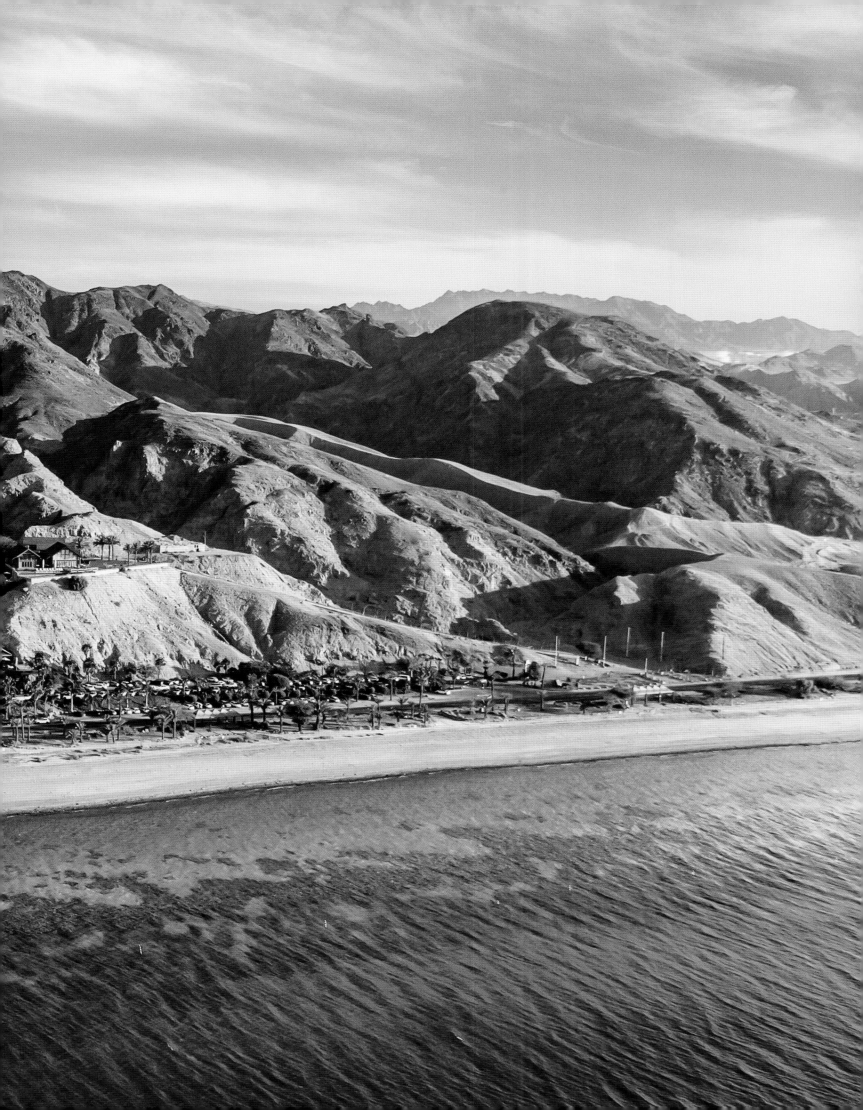

Mensa Christi
Part 3 of 3

John 21:15-23

When they had finished breakfast, Jesus said to Simon Peter, "Simon, son of John, do you love me more than these?"

—JOHN 21:15

ONE MORNING AFTER HIS RESURREC-TION, Jesus cooked His disciples breakfast over a charcoal fire like the one Peter sat around when he denied Jesus (John 18:18). With the familiar sights and smells of the fire, it's easy to imagine Peter being transported back to that moment, filled with shame and regret. But then, instead of shaming him, Jesus invites him into a beautiful moment of restoration.

In His great patience and kindness, Jesus asks Peter three times if he loves Him, paralleling Peter's three denials. Then Jesus gives him a weighty assignment—serving people. He reminds Peter that the gospel must reach the people of all nations.

Even after having this intimate, powerful exchange with Jesus, he immediately takes his eyes off Christ, comparing his assignment to John's. Peter first experienced that when he walked on water, and he experiences it here when he gets his life's assignment. Peter fails often, but always and only by taking his eyes off Christ. To love Jesus well in return, we must fix our eyes on Him, not ourselves or others.

A Franciscan monk stands outside the Church of Mensa Christi.

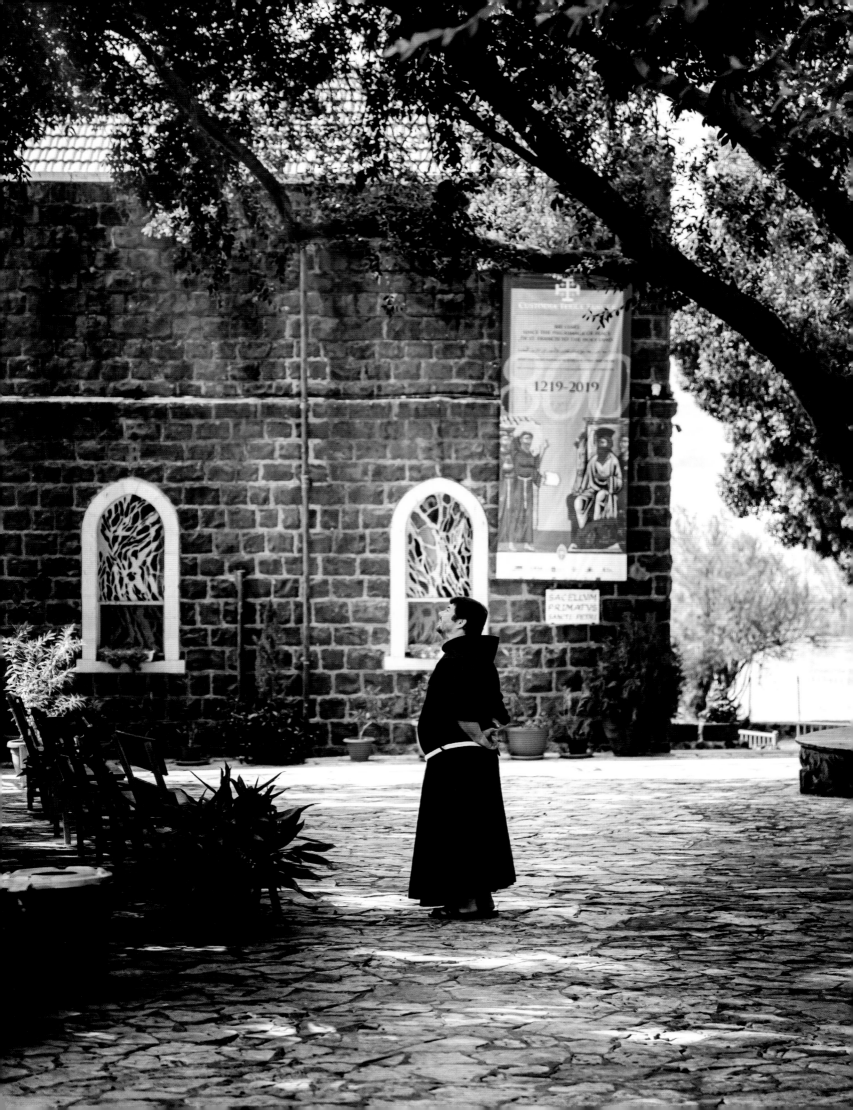

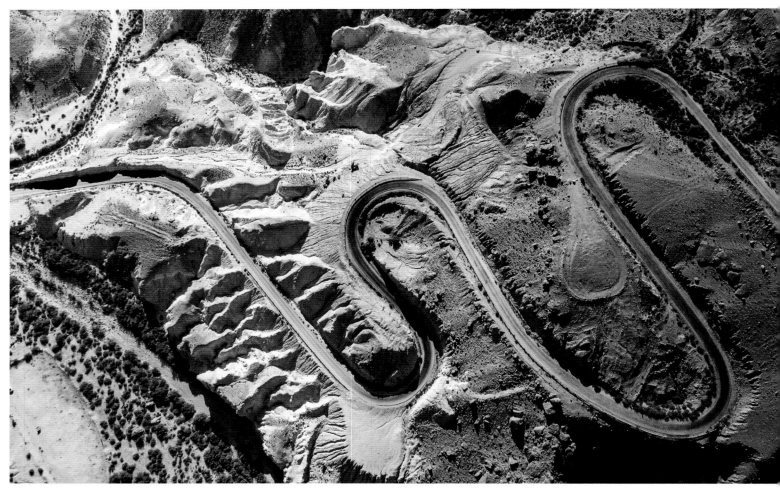

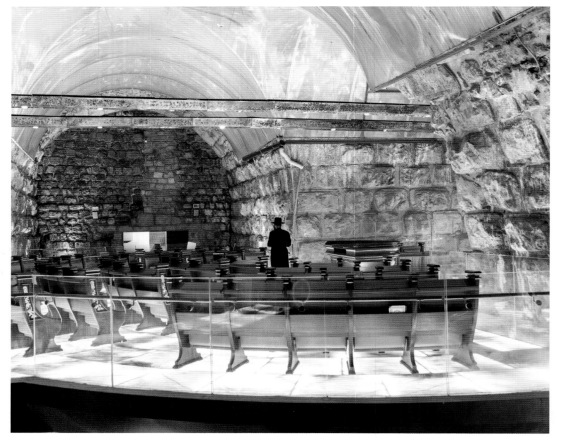

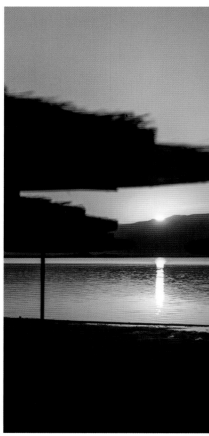

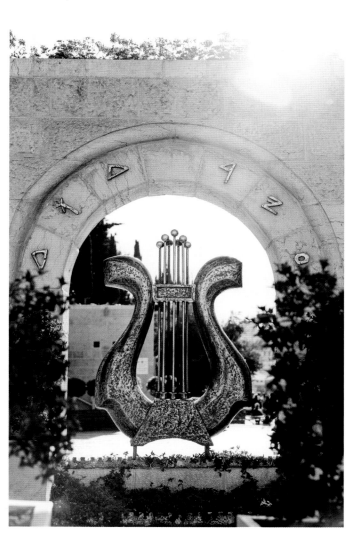

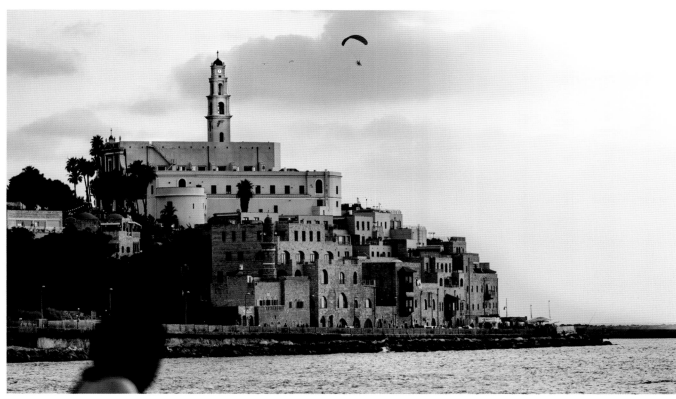

THERE WAS GREAT JOY
IN JERUSALEM.

2 CHRONICLES 30:26

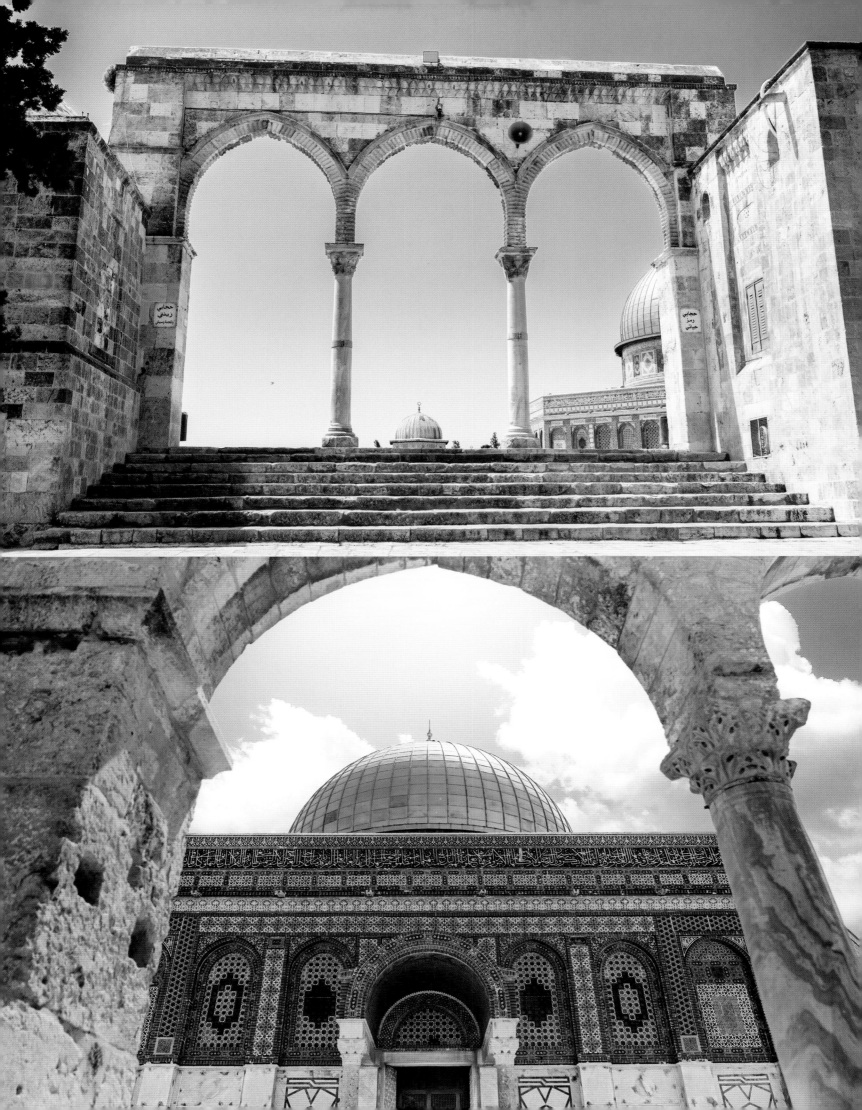

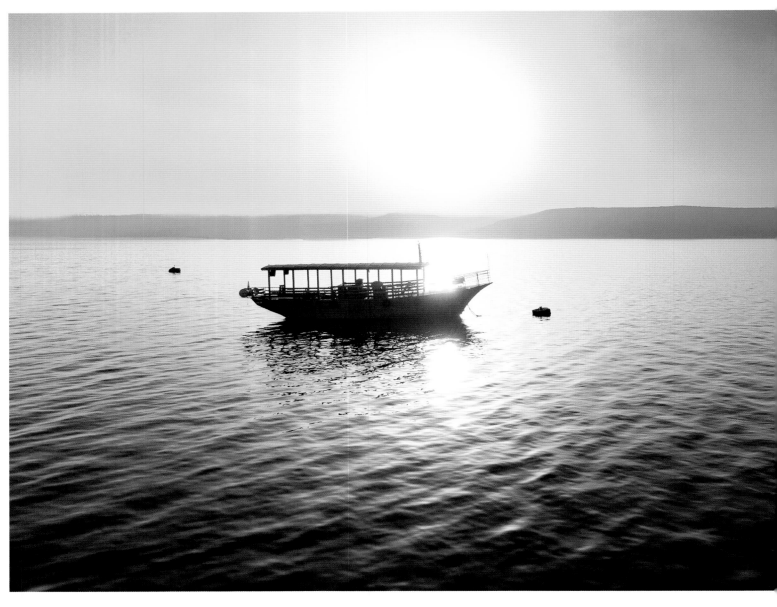

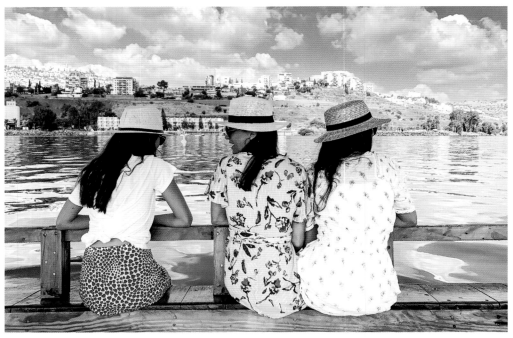

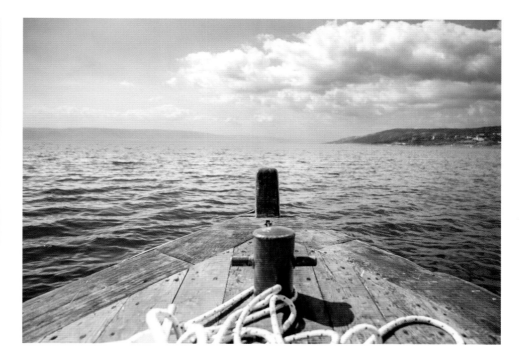

Sea of Galilee

Mark 6:45–52

JESUS SENT HIS DISCIPLES OUT on their own to "the other side," the pagan side. Law-abiding Jews spent most of their lives avoiding the eastern shores of Galilee, but Jesus sent them there *on purpose.*

He watched from a distance as they moved further into darkness. And in the midst of what surely felt scary already, they encountered a storm. Then a figure appeared walking on the water! *A ghost?* Their fears mounted as they faced danger upon danger. It's natural to think our struggles are the result of our failures or foolishness. Sometimes they are, but the disciples didn't get into this storm by running from God or rebelling—they got into it by obeying Him.

Sometimes what we perceive as tragic or scary may be God moving among us, at work to reveal His nearness and power. This wasn't an evil spirit coming to harm them—this was God Himself showing up to dispel their fears.

By the time they reached the other side, they knew something about Him that they didn't know before: He's sovereign over all creation. There's nothing beyond the reach of His power. Our trials reveal that He can calm seas *and* hearts.

The Galilee shoreline displays a wide range of plants and flowers—it's a fertile ground for agriculture. The occasional towns dotting its perimeter offer a bounty of fresh fruit and seafood. Locals fish from the banks while travelers set sail on wooden boats to traverse the waters Jesus walked on.

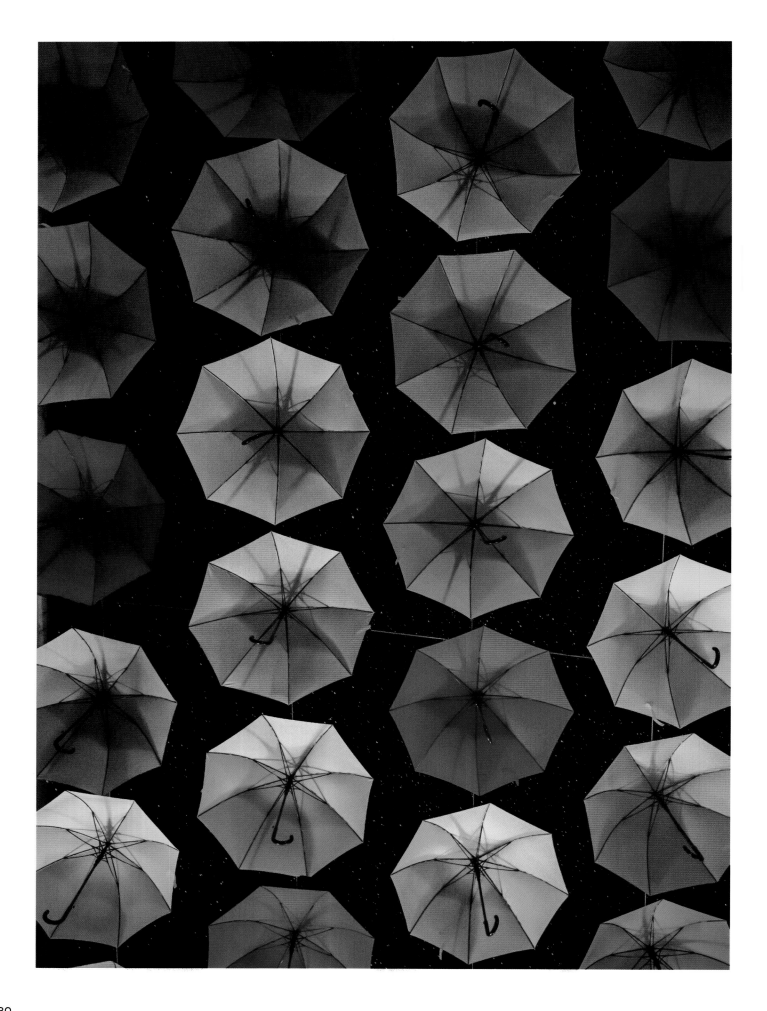

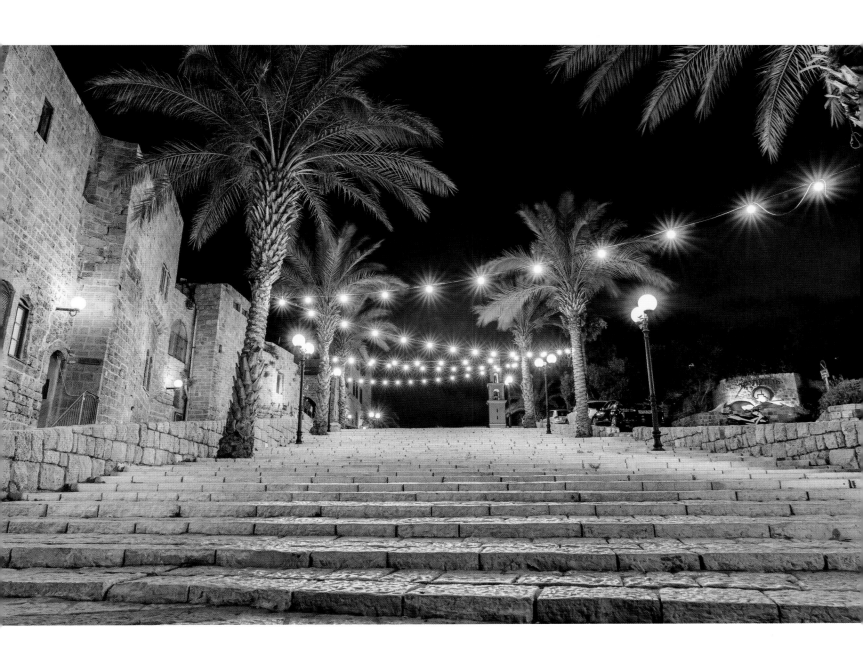

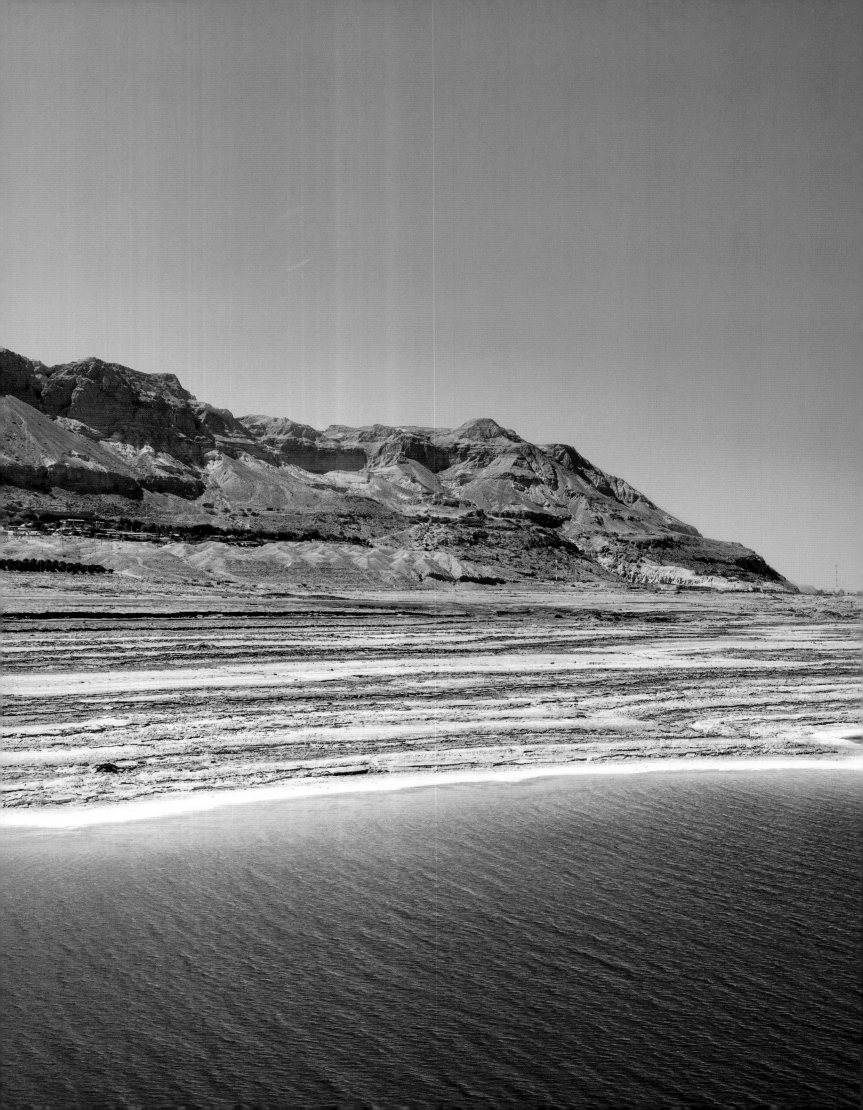

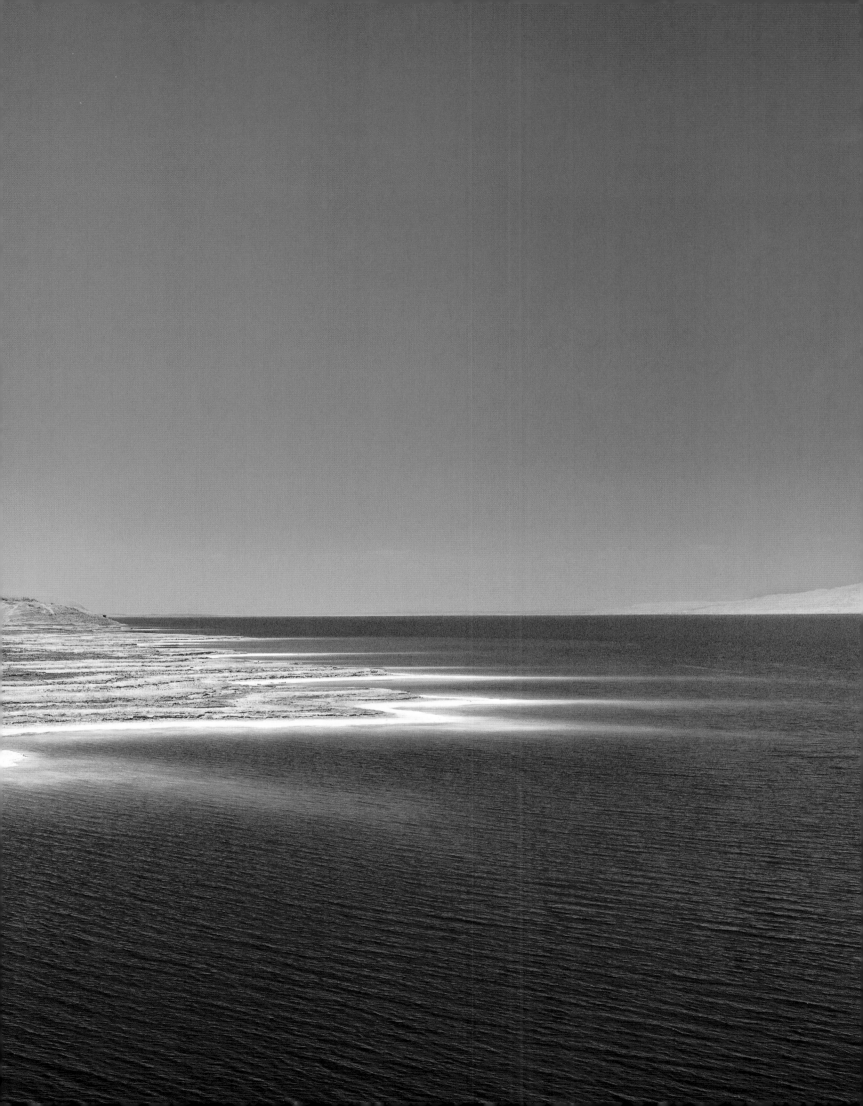

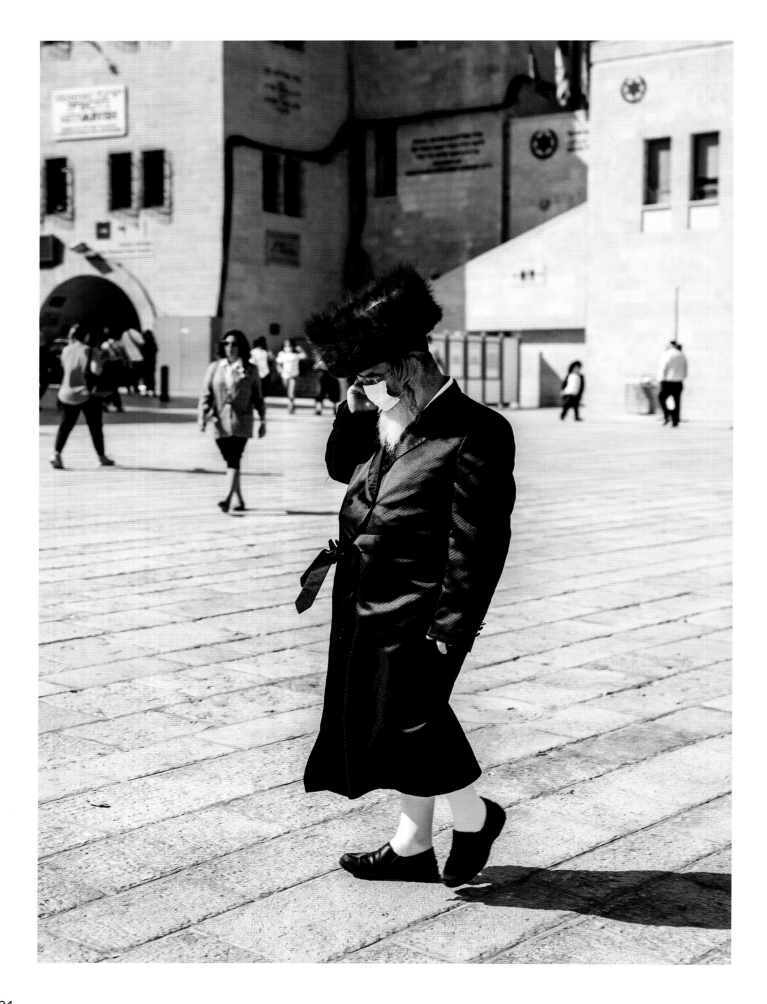

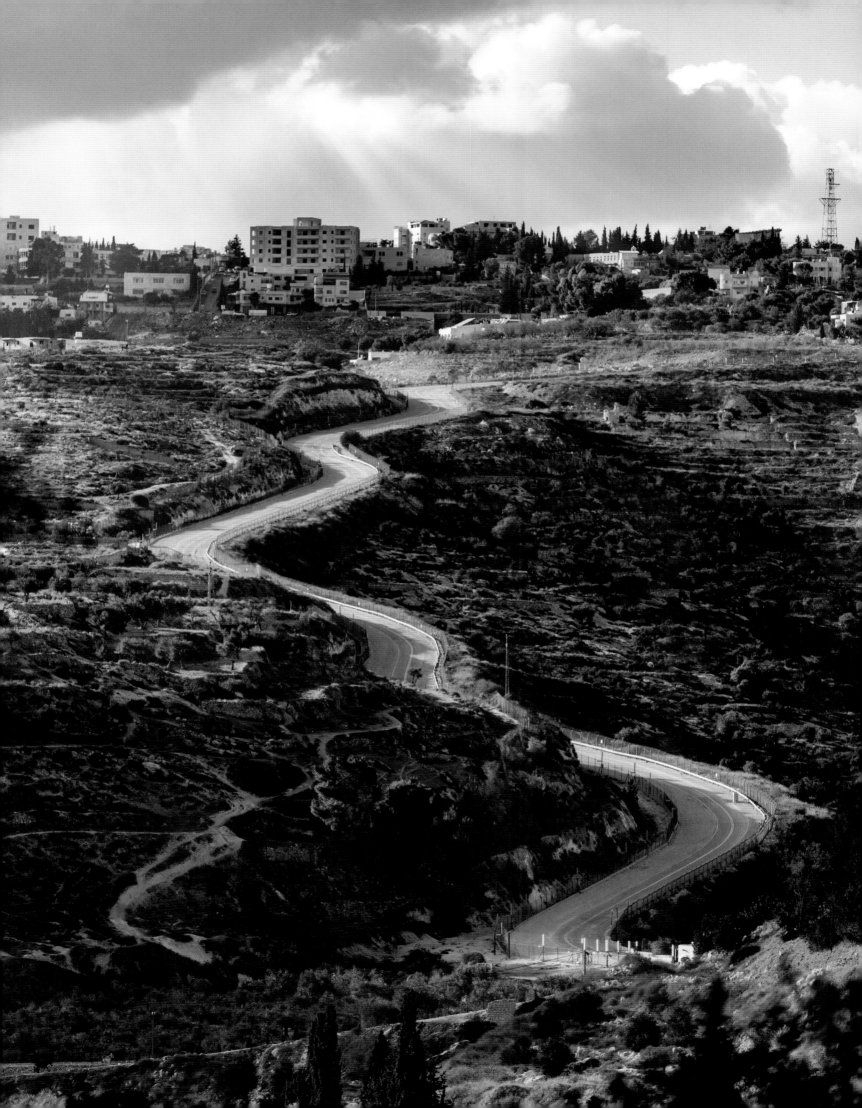

THE HANDS THAT
FORMED THESE ROCKS
WASHED IN THEM,
TAUGHT FROM THEM.

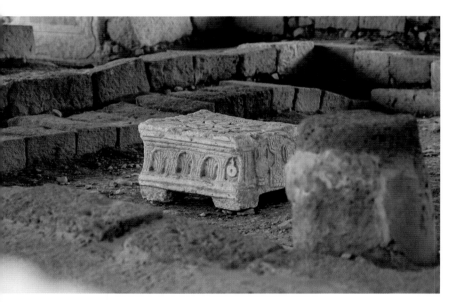

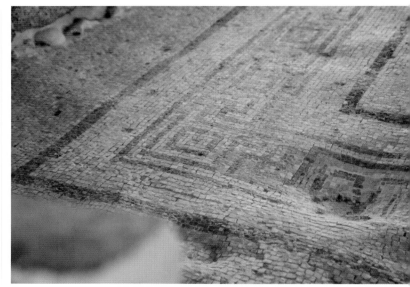

Magdala

Matthew 4:23, 9:35; John 1:3; Colossians 1:16

THIS FIRST-CENTURY SYNAGOGUE in Magdala marks the hometown of Mary Magdalene. It was uncovered by accident in 2009 while workers broke ground for a new hotel.

When the excavator first struck dirt, it made contact with a rock that turned out to be an ornately carved stone, now called the Magdala Stone. This stone was positioned in the center of the synagogue, leading scholars to believe it was used as a podium or reading desk—the flat surface where rabbis would unroll the Torah scrolls for teaching.

Outside the entrance, archaeologists found a stone wash basin. This type of basin is where Jews would wash their hands prior to entering the synagogue.

Scripture tells us Jesus taught in this synagogue, which means He likely rolled out a scroll on the Magdala Stone. And as a law-abiding Jew, He would've washed His hands in this wash basin. The hands that formed these rocks washed in them, taught from them. Archaeologists long denied the existence of the first-century synagogues that Scripture mentions, but buried underneath this soil for thousands of years, these stones testify to the truth of His Word.

For centuries, the beauty of this synagogue—the mosaic tile floor, the Magdala Stone—stayed hidden underneath layers of dirt.

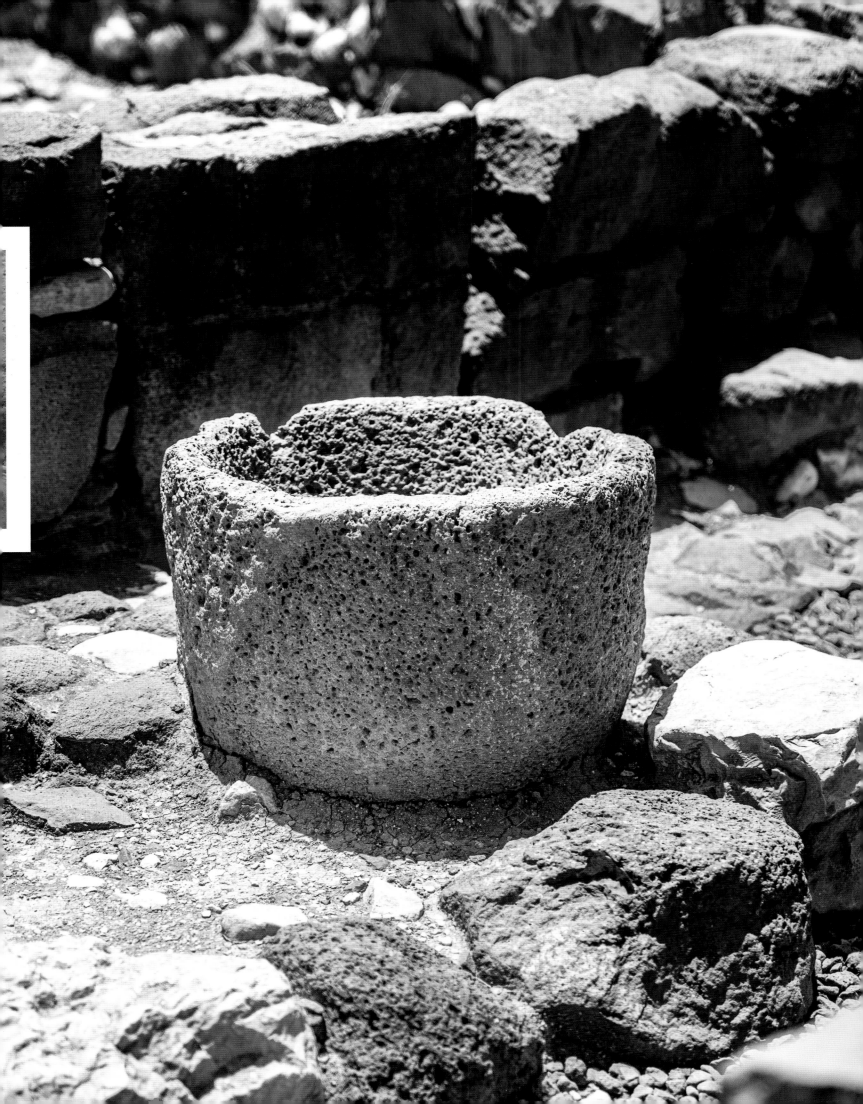

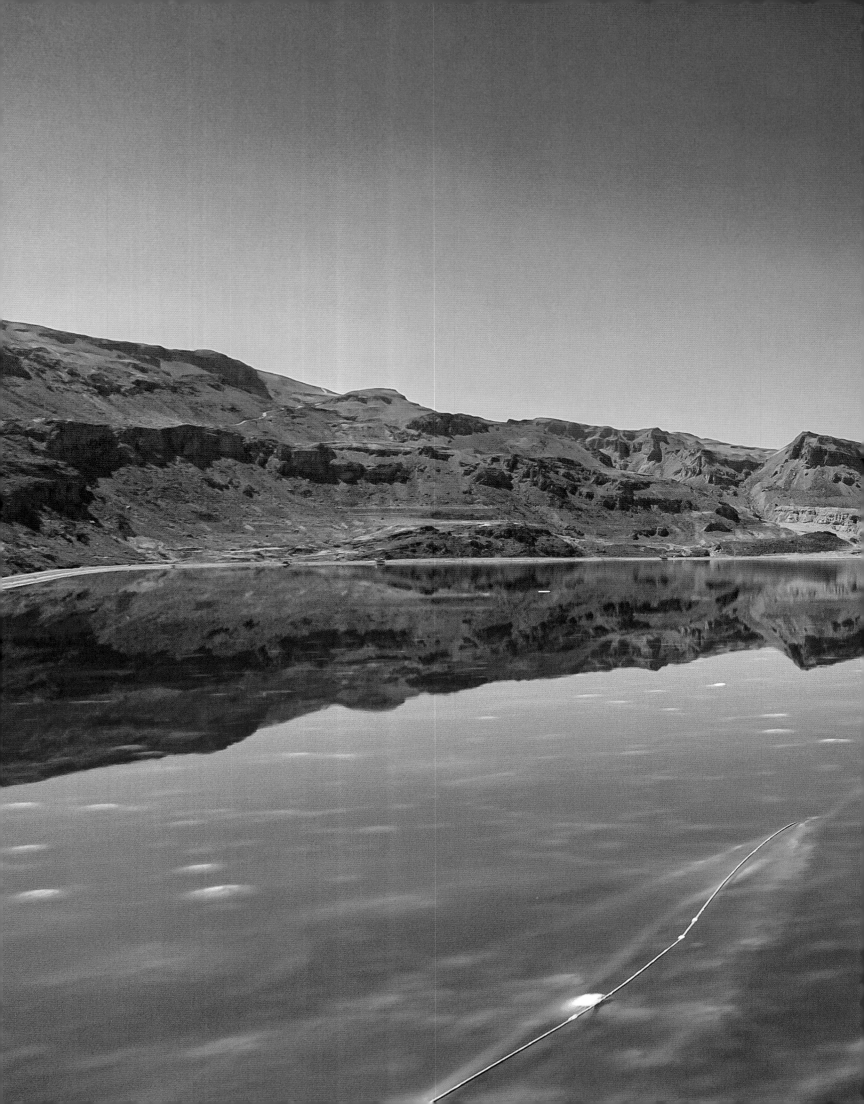

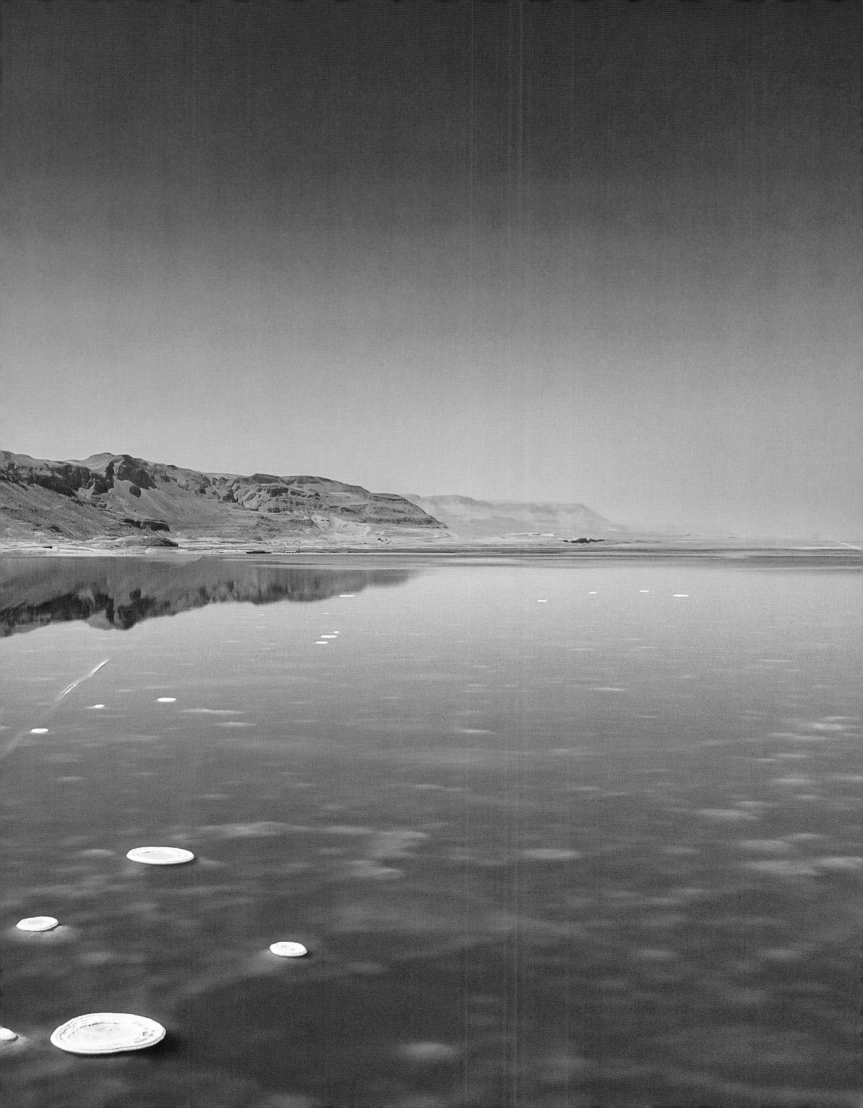

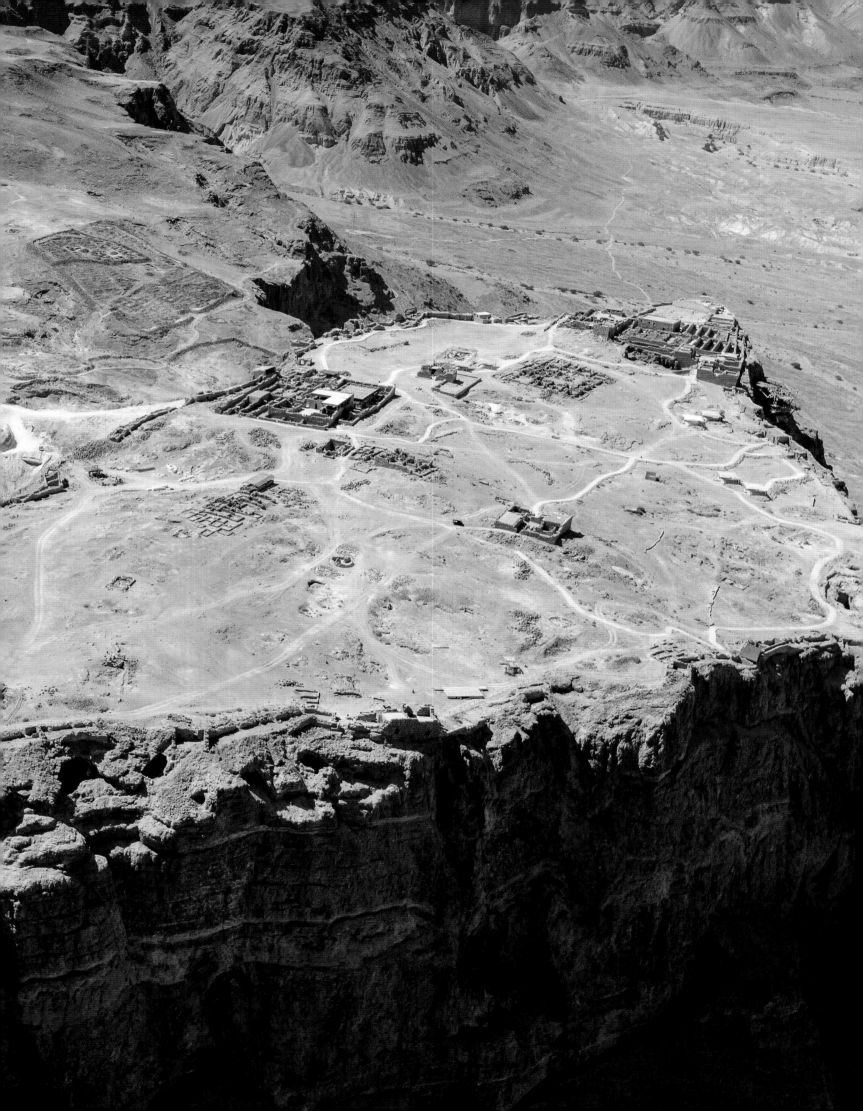

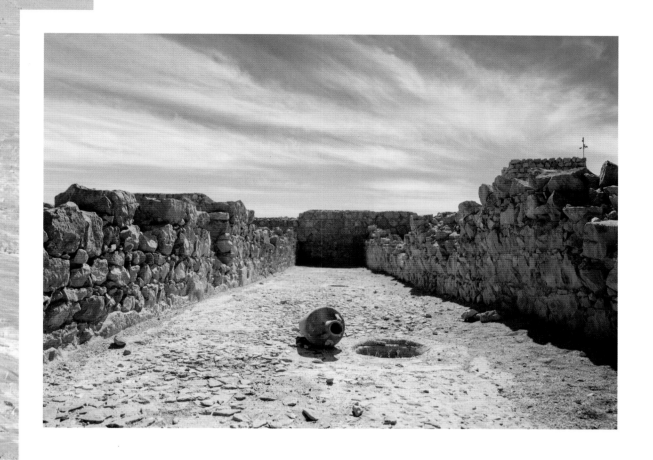

Masada

Matthew 2:1–21

Masada is the most visited tourist site in Israel. It holds vast historical and political significance for Israel. It's primarily known as the place where Jewish patriots had their last stand against the Roman army in AD 73.

King Herod the Great built this massive fortress as a safe haven where he could escape an enemy attack. It consisted of double walls, defensive towers, an aqueduct, enormous food warehouses, and cisterns that held over 200,000 gallons of water.

Herod reportedly never spent a single night at Masada. Much of what we know about him reveals that he was driven by fear. He couldn't bear the thought of losing the throne, so he sought to eliminate any apparent threats. His desire for control and paranoia led him to kill many of his family members.

Fear focuses our minds on the hypothetical, spinning scenarios that often never happen, which can lead to irrational responses. Herod was no exception. When Jesus was born, Herod heard a rumor that the new king had been born. So he plotted and manipulated to secure his position, murdering all the two-year-old boys in the region. But Jesus was never after Herod's throne. Jesus came as an eternal King to rule an eternal kingdom.

Masada is most widely known as the site of the last stand of the Jews in the First Jewish–Roman War (AD 73–74).

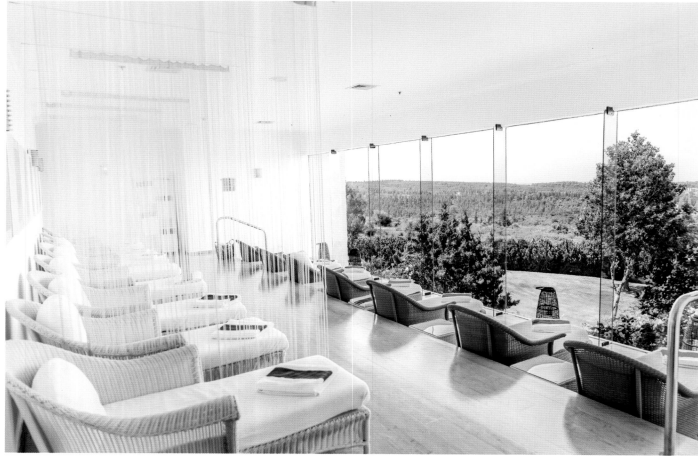

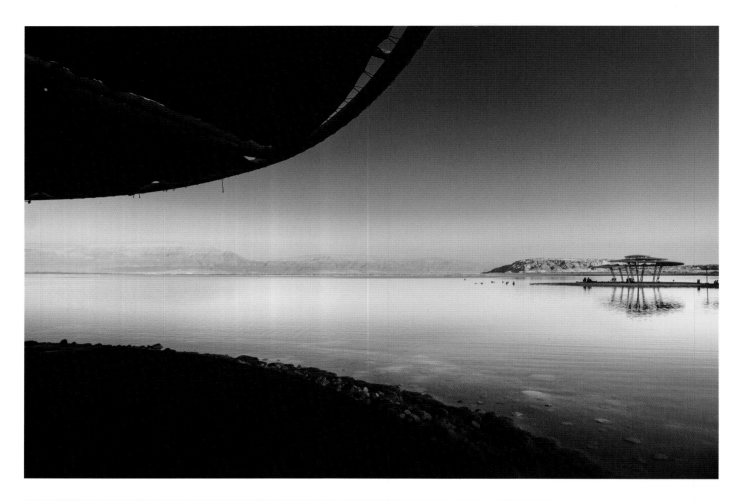

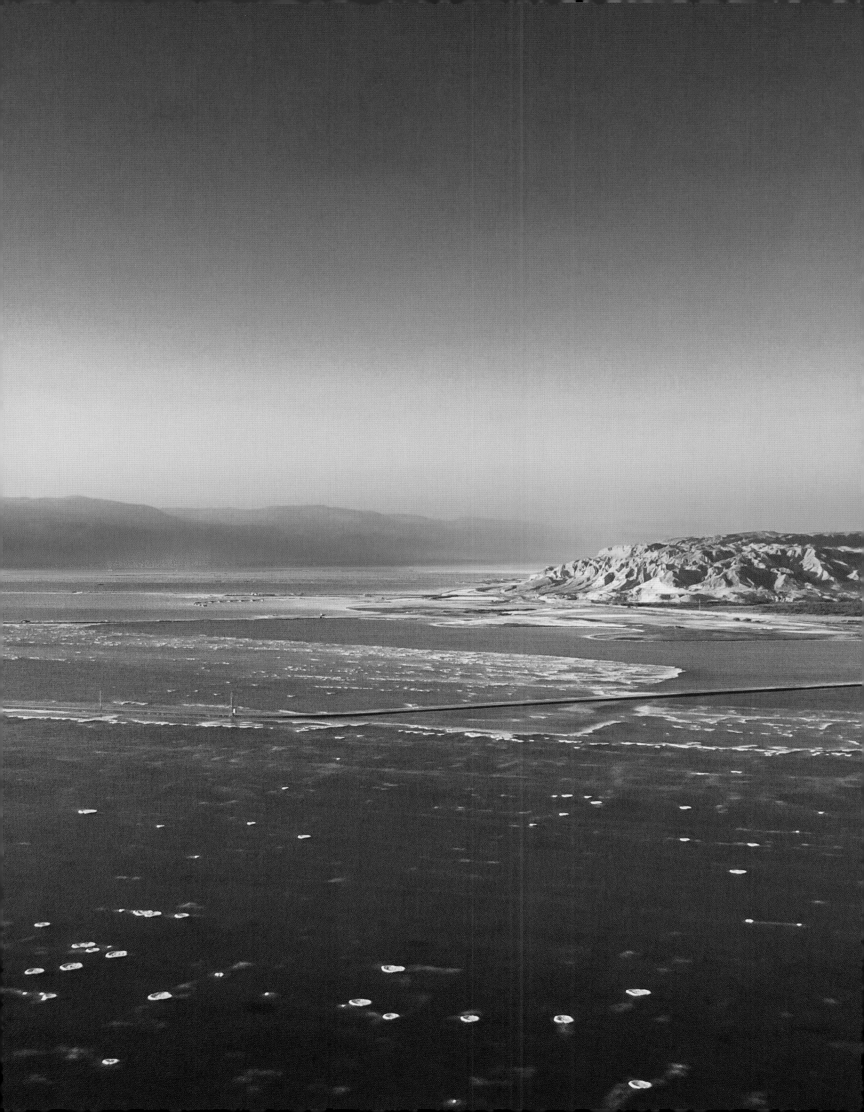

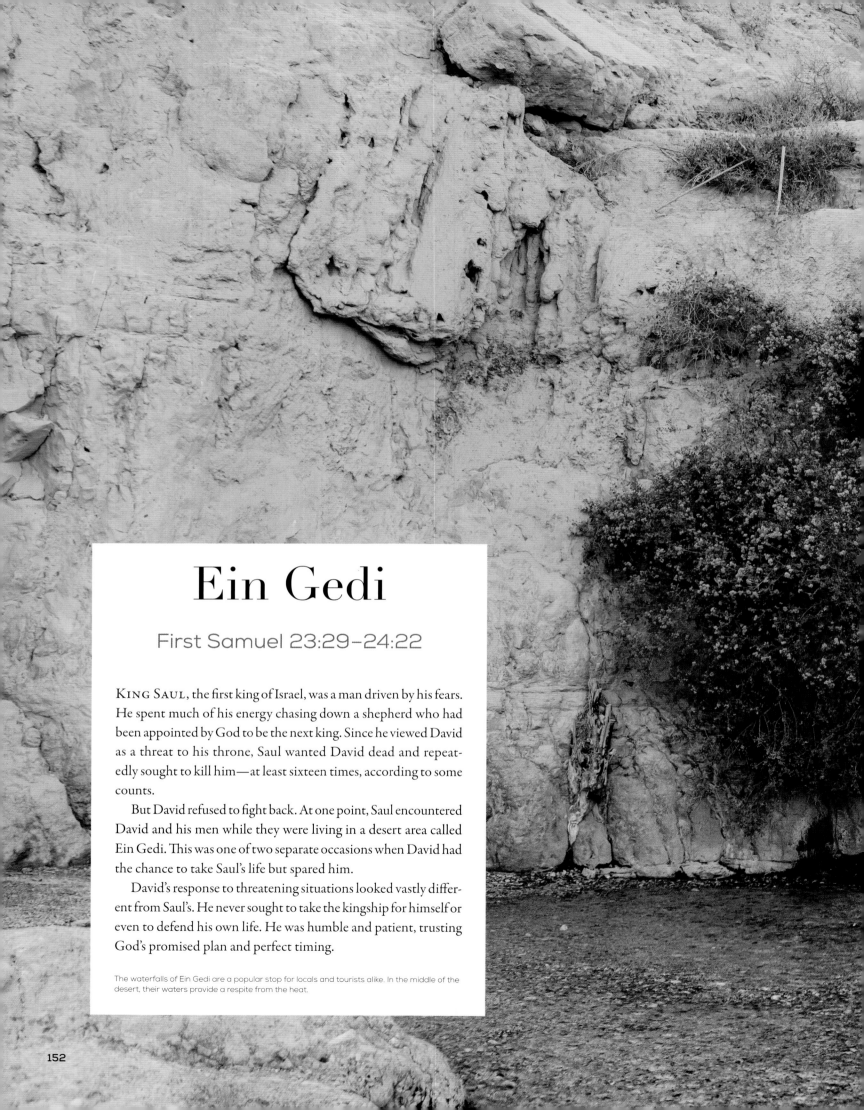

Ein Gedi

First Samuel 23:29–24:22

KING SAUL, the first king of Israel, was a man driven by his fears. He spent much of his energy chasing down a shepherd who had been appointed by God to be the next king. Since he viewed David as a threat to his throne, Saul wanted David dead and repeatedly sought to kill him—at least sixteen times, according to some counts.

But David refused to fight back. At one point, Saul encountered David and his men while they were living in a desert area called Ein Gedi. This was one of two separate occasions when David had the chance to take Saul's life but spared him.

David's response to threatening situations looked vastly different from Saul's. He never sought to take the kingship for himself or even to defend his own life. He was humble and patient, trusting God's promised plan and perfect timing.

The waterfalls of Ein Gedi are a popular stop for locals and tourists alike. In the middle of the desert, their waters provide a respite from the heat.

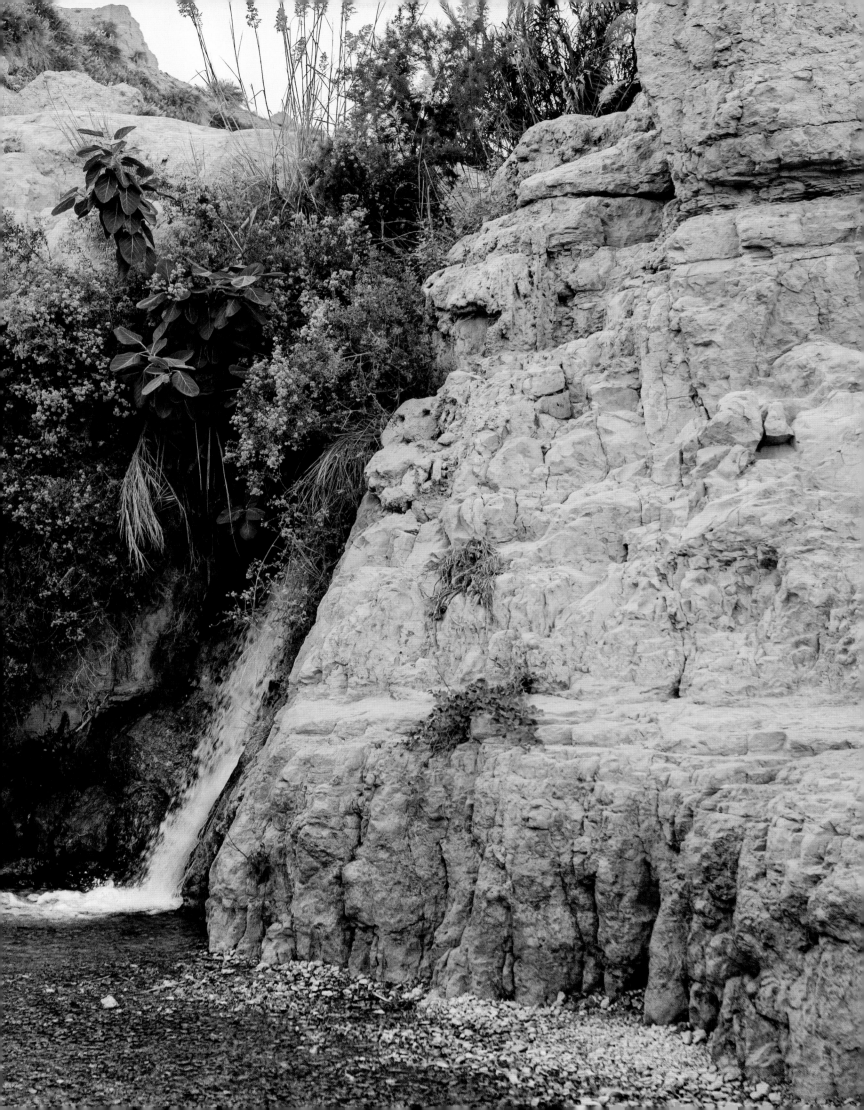

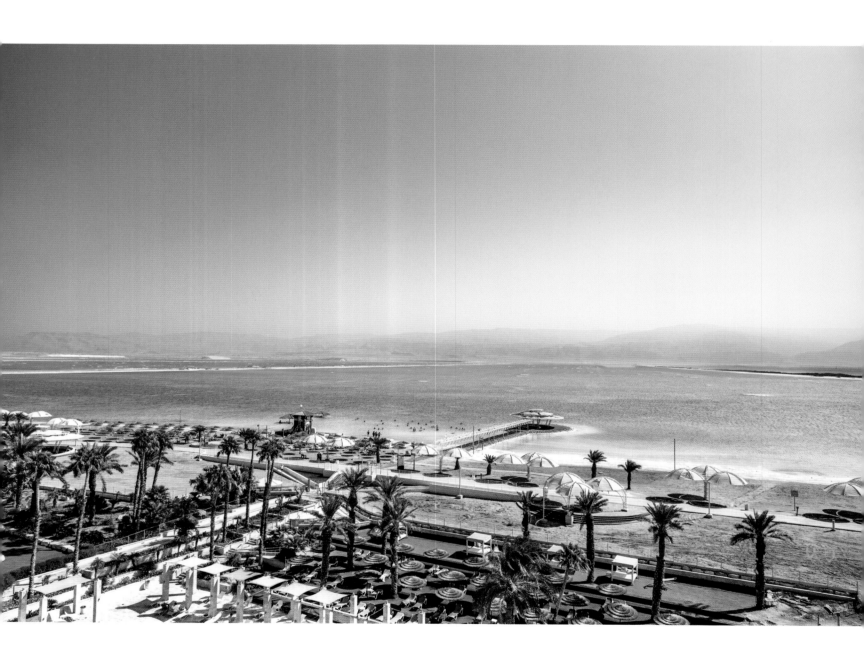

PEACE BE WITHIN YOUR
WALLS AND SECURITY
WITHIN YOUR TOWERS!

PSALM 122:7

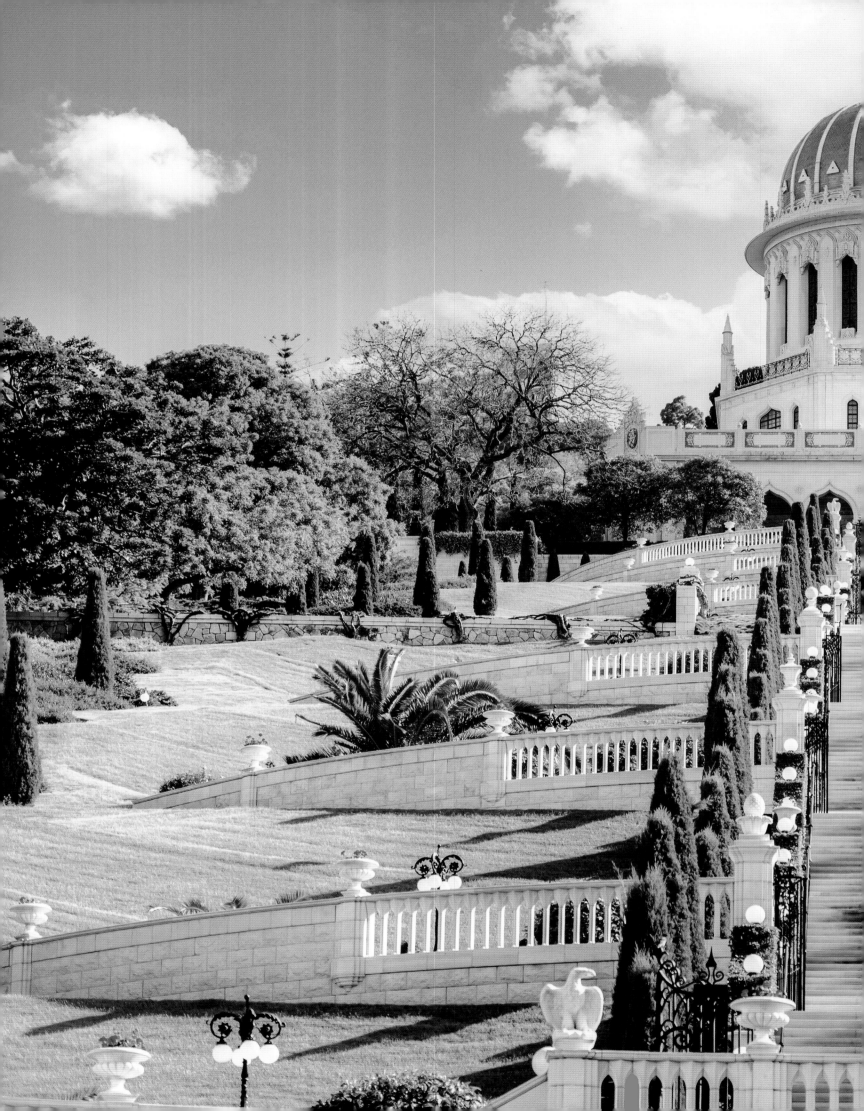

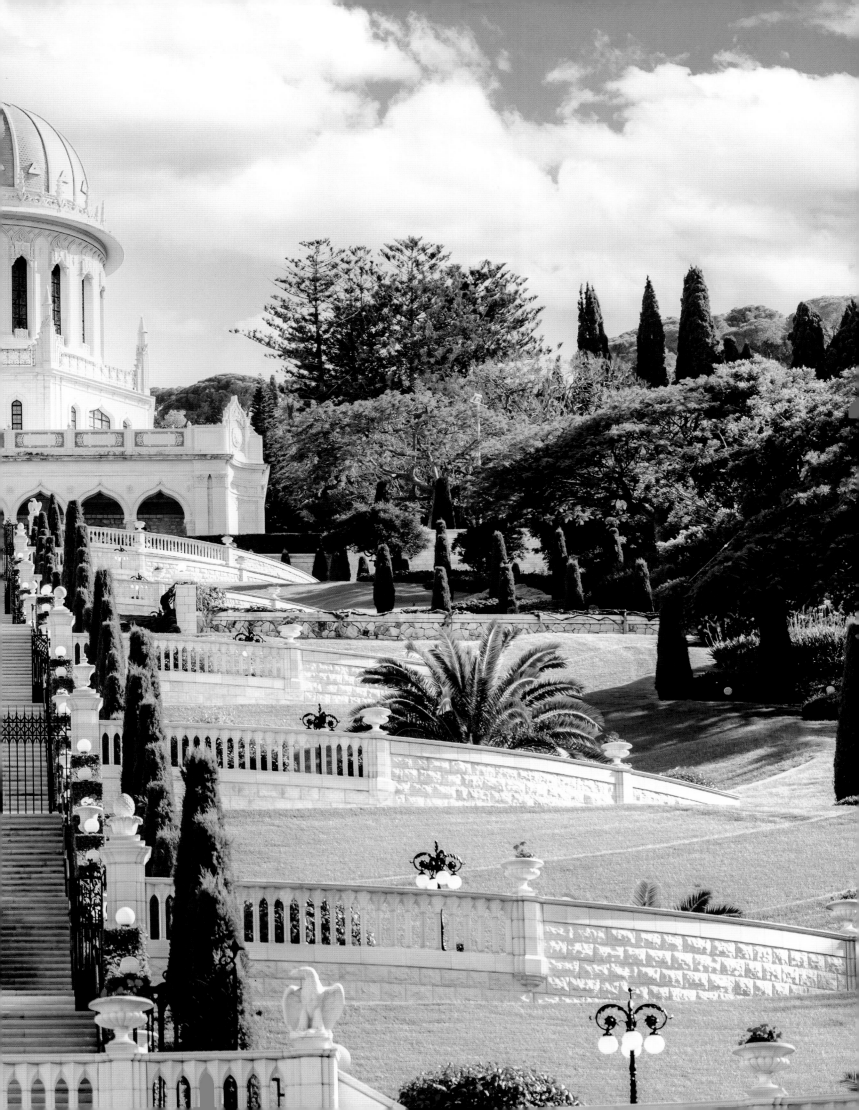

Homes in the Desert

Jeremiah 17:5–8

Cursed is the man who trusts in man and makes flesh his strength, whose heart turns away from the LORD. He is like a shrub in the desert, and shall not see any good come. He shall dwell in the parched places of the wilderness, in an uninhabited salt land.

Blessed is the man who trusts in the LORD, whose trust is the LORD. He is like a tree planted by water, that sends out its roots by the stream, and does not fear when heat comes, for its leaves remain green, and is not anxious in the year of drought, for it does not cease to bear fruit.

—JEREMIAH 17:5–8

IN THE JUDEAN WILDERNESS, not too far from each other, we find two very different homes with two very different functions: Masada, Herod's desert fortress, and Engedi, where David and his men lived. This passage in Jeremiah reveals what it looks like to follow God, but the verses also seem to offer a description of both of these desert homes—with verses 5–6 painting a picture of Herod and Masada, and verses 7–8 showing us David at Engedi. May we be the well-watered land. May we trust the Lord.

THEY FOUND RICH, GOOD PASTURE,
AND THE LAND WAS VERY BROAD,
QUIET, AND PEACEFUL.

1 CHRONICLES 4:40

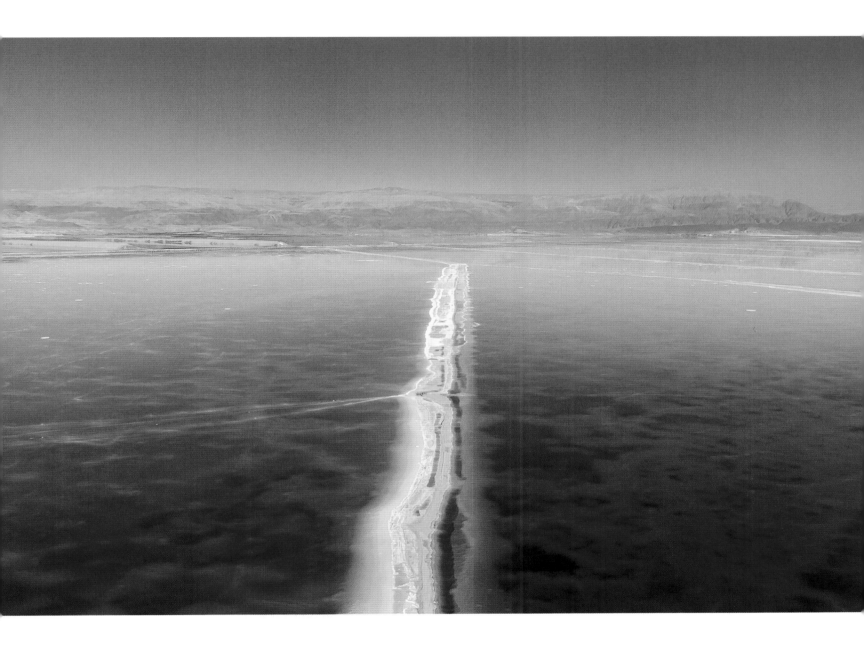

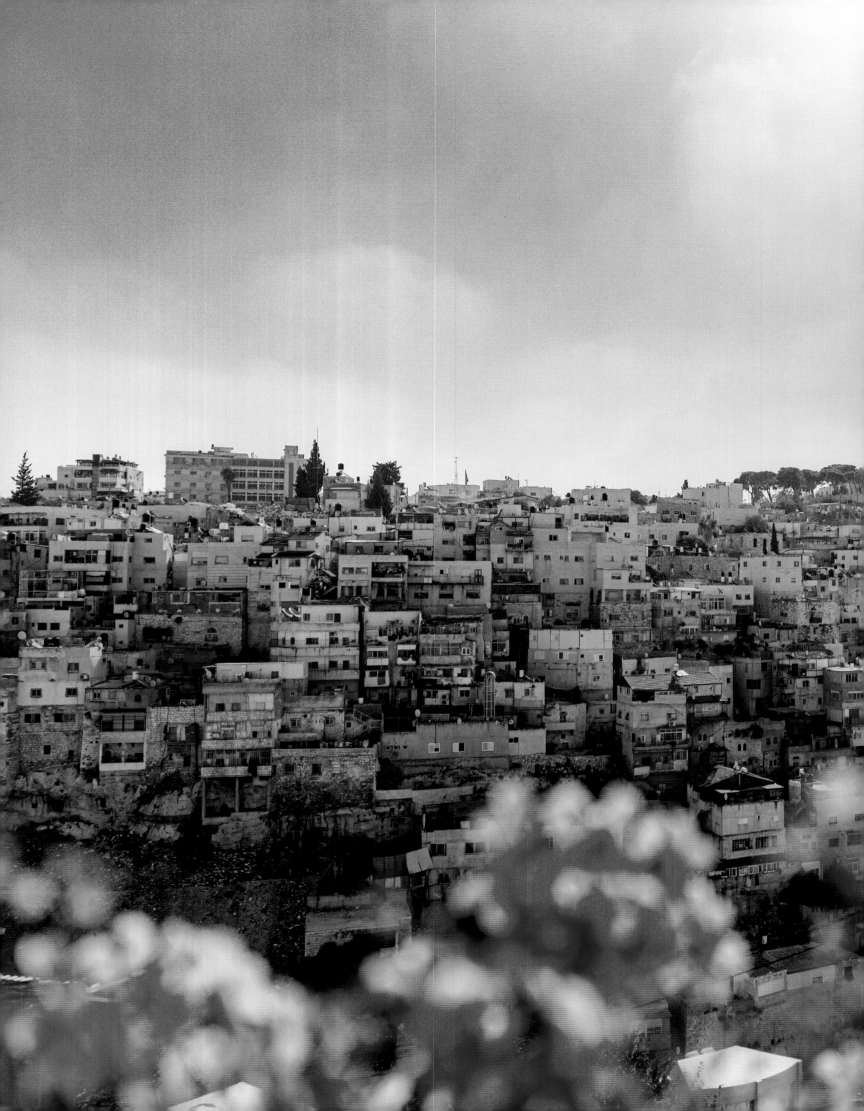

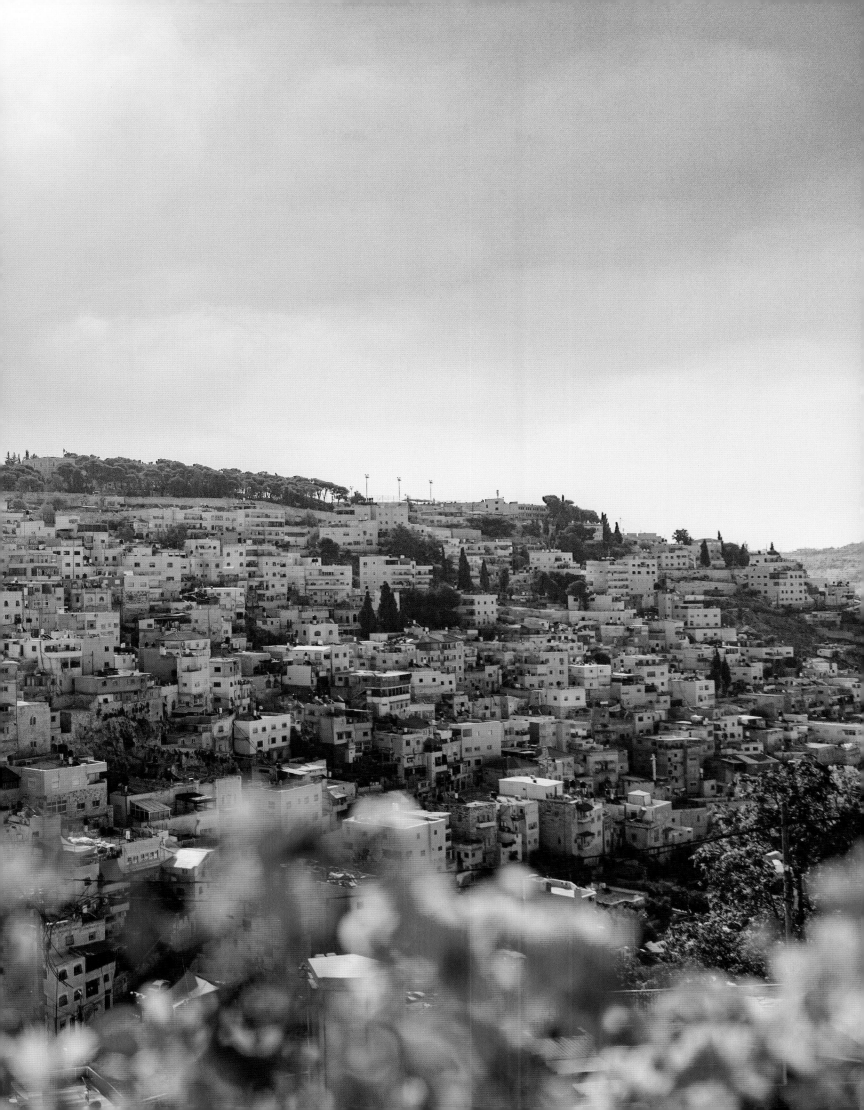

Mount Scopus

Psalm 122

I have chosen Jerusalem that my name may be there.
—2 CHRONICLES 6:6

GOD HAS A UNIQUE LOVE for Jerusalem. He chose it for Himself. He put His name there. And we have reason to believe this is more than just a metaphor. In the Hebrew language, the letter *shin* is regarded as the first letter of God's name, Shaddai. In its ancient form, the letter *shin* closely resembled a *W*.

An aerial picture of the topography of Jerusalem reveals that the city is surrounded by three valleys that form the letter *shin* around it. It appears that God has stamped His name on this city—like a monogram. We monogram things we own and love, things we plan to always keep.

Some physicians have also pointed out that the major arteries of the human heart also form the letter *shin*. The God who formed the mountains around Jerusalem and who formed your heart has stamped His image on His city and on His creation. Just like the city of Jerusalem, you are known and loved by the God who made you.

The Old City of Jerusalem covers only 0.35 square miles, but it's one of the most coveted pieces of real estate in the world. Jews regard it as their holiest site, and Muslims view it as their third holiest.

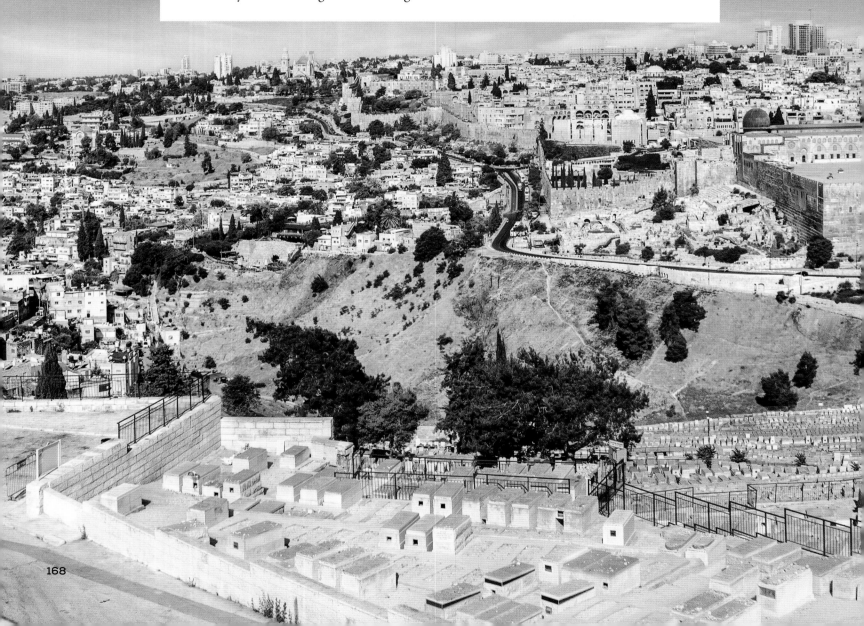

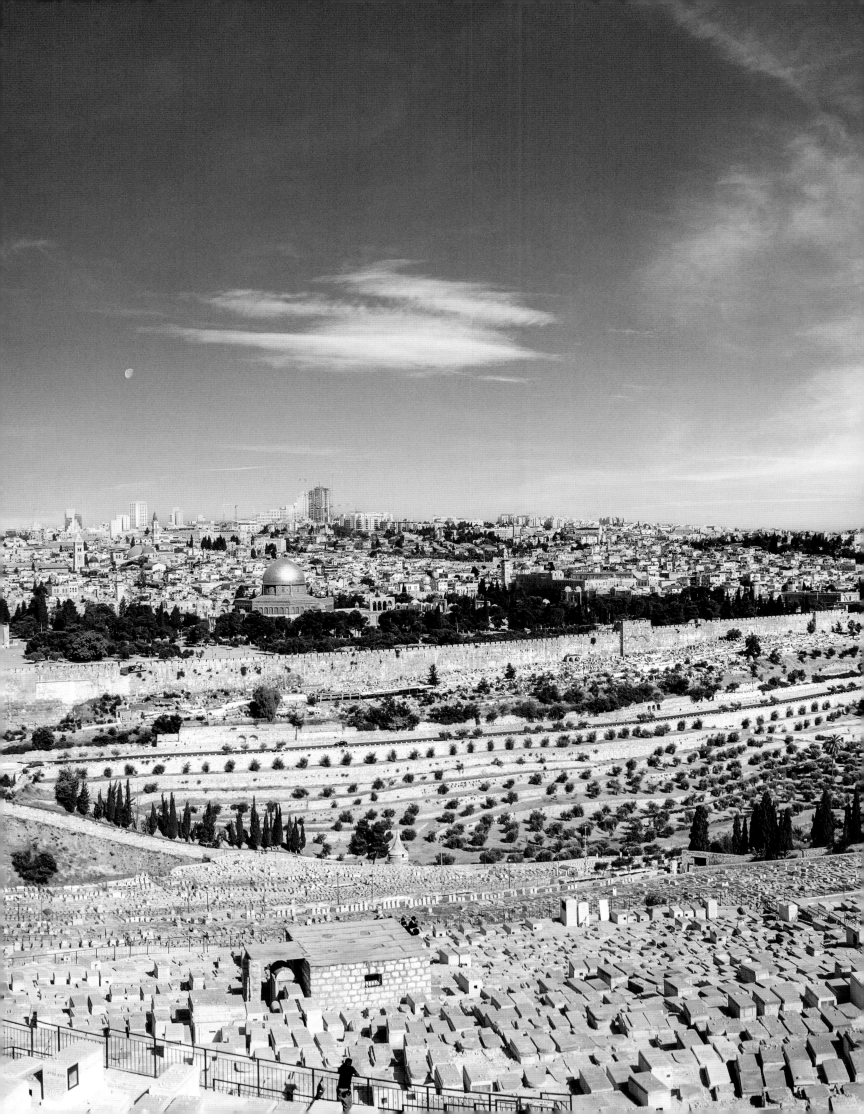

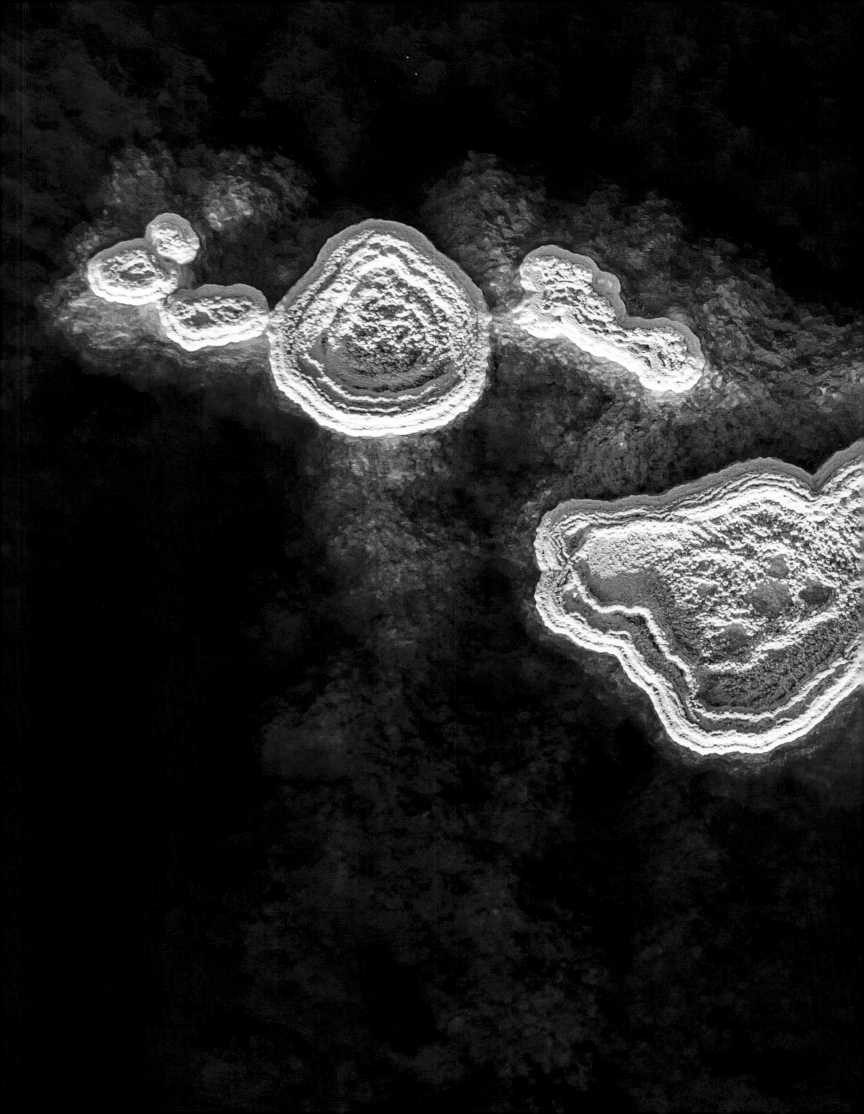

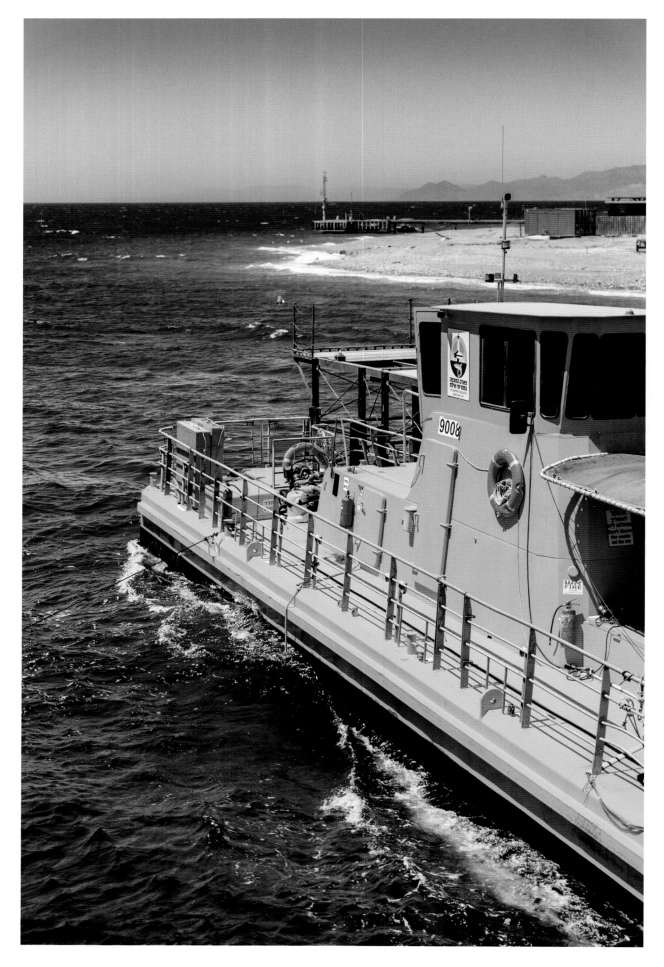

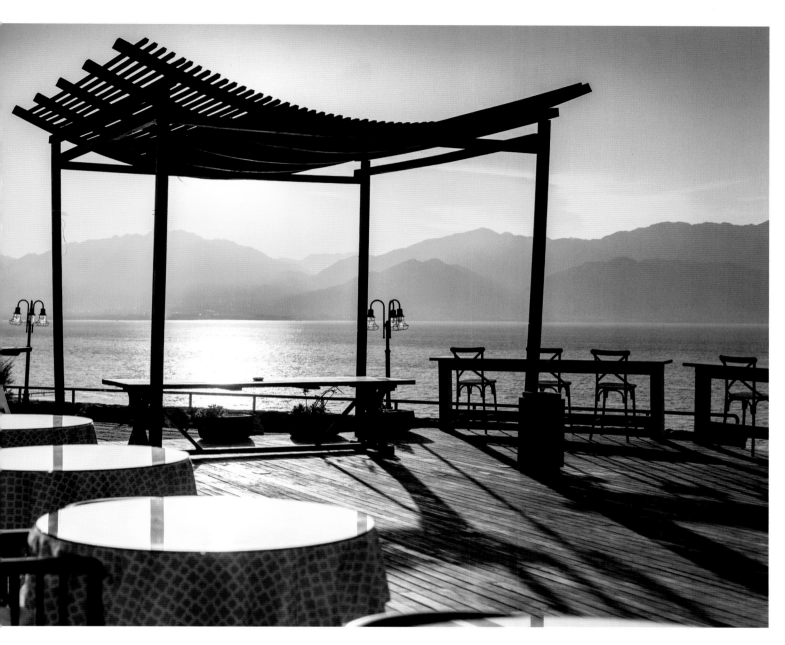

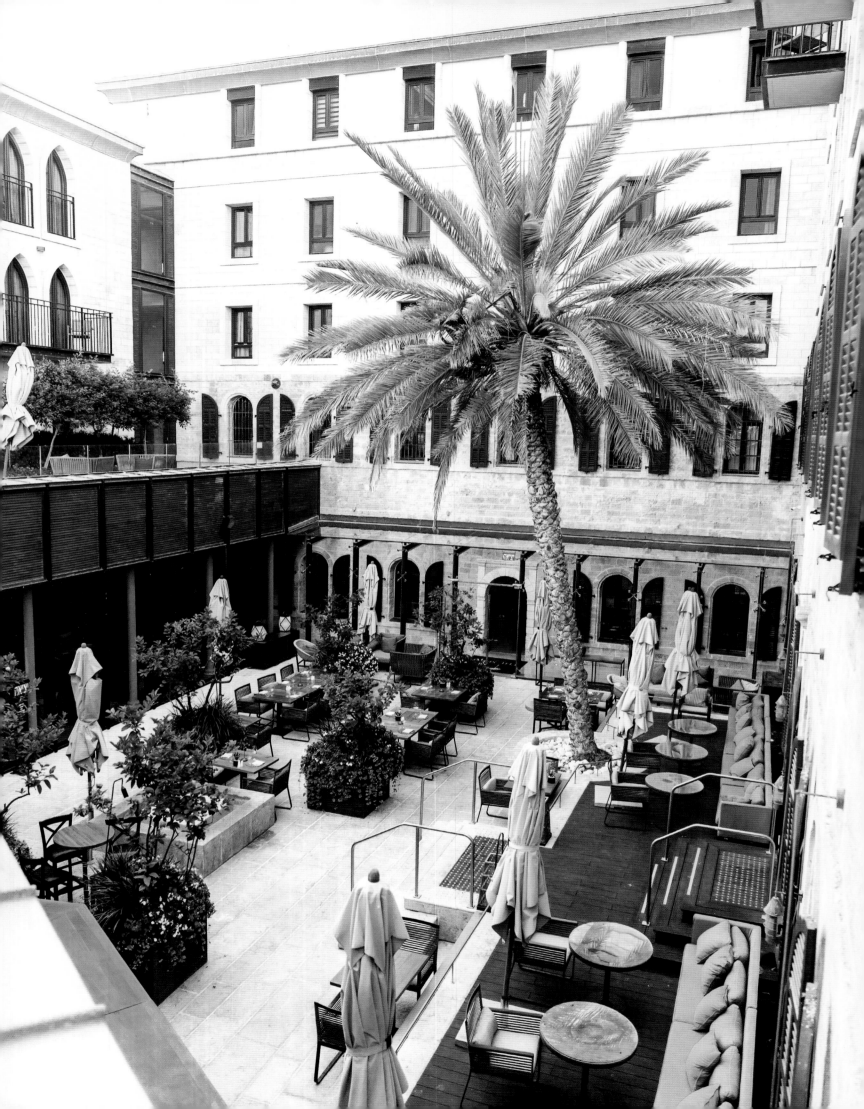

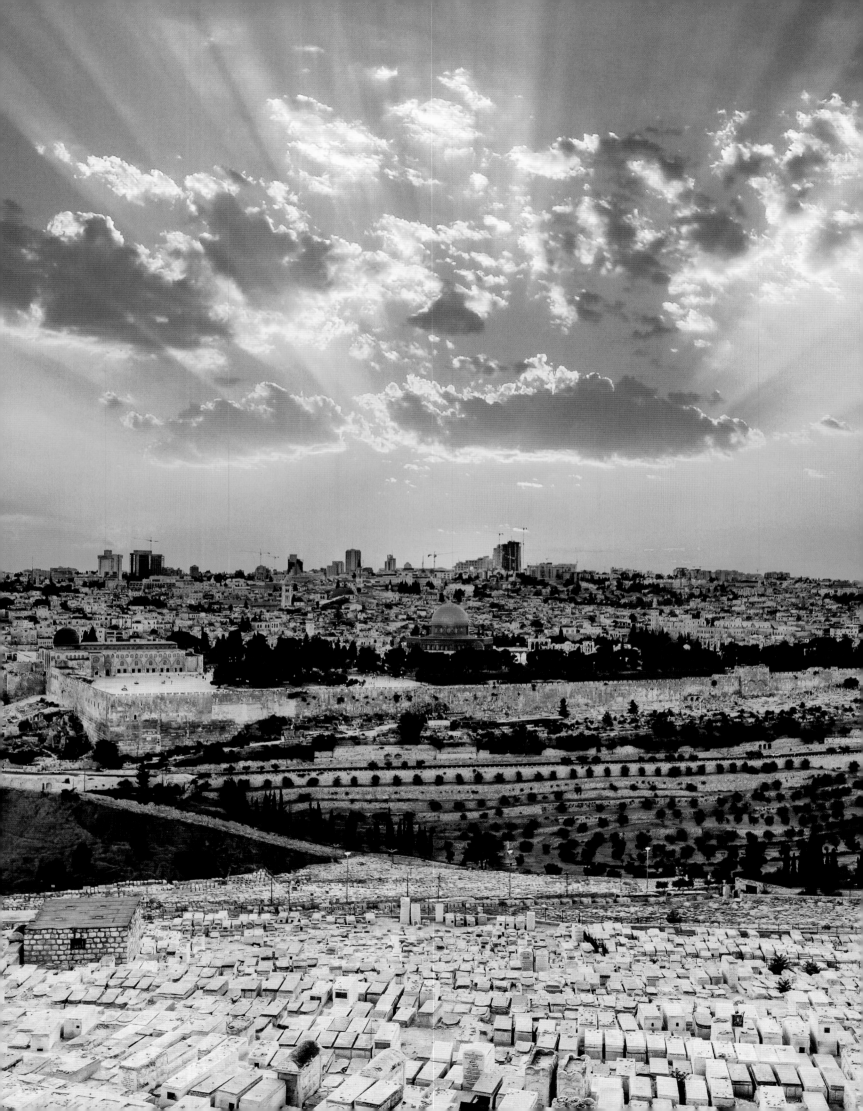

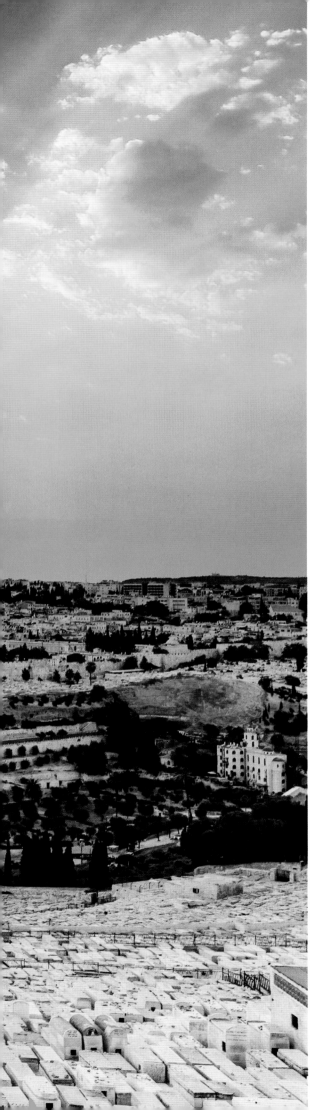

Mount Olives

Zechariah 14:1, 4; Ezekiel 43:1–4

Then the LORD my God will come, and all the holy
ones with him.
—ZECHARIAH 14:5

MOUNT OLIVES PLAYS an important role in the reign of Jesus.
It stands across the Kidron Valley from the city of Jerusalem, in
close proximity. This is the hill Jesus rode down on Palm Sunday
as the people cried, "Hosanna!" (Matthew 21:1–11). And the
Garden of Gethsemane, where He prayed the night before He
died, is at the base of the hill.

According to the prophet Zechariah, when Jesus comes back,
He will return on this mountain and it will split. Then He will enter
the city walls through the Eastern Gate. At present, the Eastern
Gate is walled off with cement. This was done in an effort to defy
the prophecy foretelling the return of Jesus. A graveyard outside
the gate is meant to deter Him as well, since a law-abiding Jewish
rabbi would never walk through a cemetery because He'd become
"unclean."

Rest assured, nothing will threaten the return of King Jesus! If
His own grave cannot stop Him, neither can the graves of others!
If death can't hold Him back, cement offers no threat!

Visitors to Jerusalem are often surprised to see how small the Old City of Jerusalem is.
It's possible to walk to all the locations of the accounts of Jesus's time in Jerusalem in a
few hours.

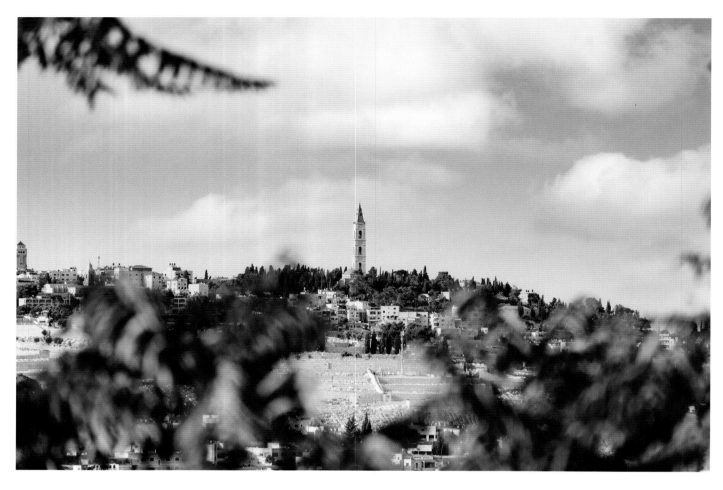

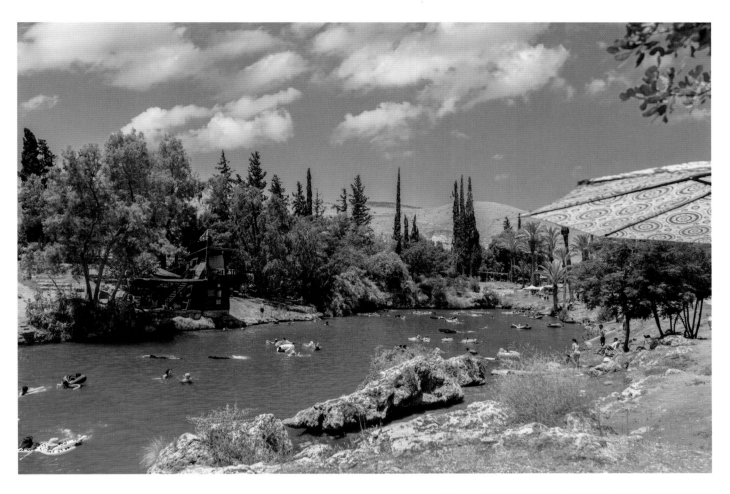

THE RIGHTEOUS
FLOURISH LIKE THE
PALM TREE. . . . THEY
ARE PLANTED IN THE
HOUSE OF THE LORD;
THEY FLOURISH IN THE
COURTS OF OUR GOD.

PSALM 92:12–13

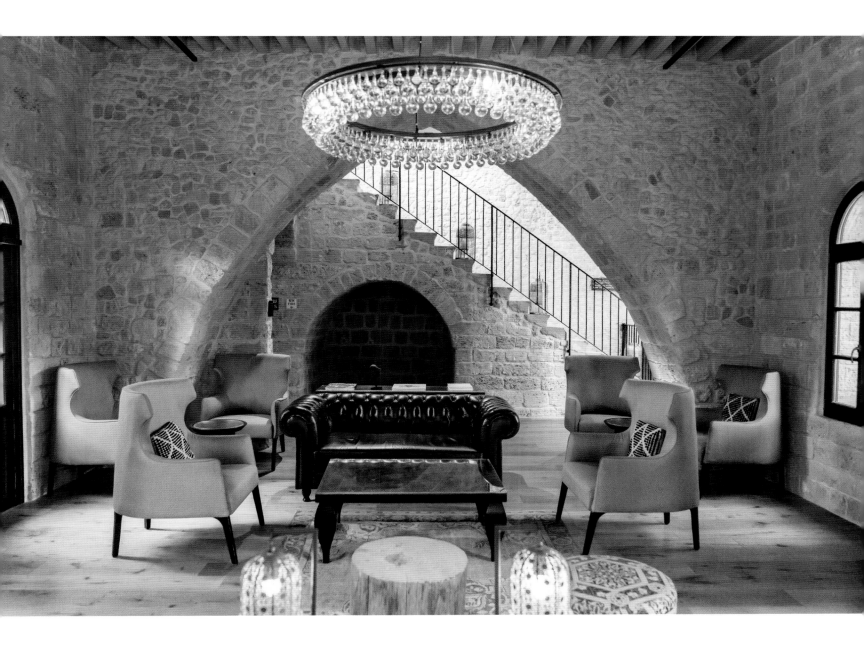

Palm Sunday Prophecy

Luke 13:31–35

JESUS KNEW ALL He would endure. It didn't surprise Him. He even prophesied Palm Sunday. Many times prior to His death, He explained to His disciples that He'd be killed and would rise again. Despite all His foretelling, no one grasped what would happen. But He knew, and He faced it willingly. He wasn't murdered against His will. He laid down His life intentionally as a part of the Father's plan for redemption and restoration (John 10:18).

What an incredible demonstration of love, that Jesus would die on a tree He made to save a people He made (John 1:3, Colossians 1:16). It's possible that, during His trips to Jerusalem through the years, He walked past the very tree He would die on. He may have even spoken with the people who crucified Him.

And as He walked down Mount Olives on Palm Sunday, He knew that the people crying, "Hosanna! Blessed is He who comes in the name of the Lord!" would be crying, "Crucify Him!" a week later. He knew all He'd endure, yet He willingly gave His life to redeem those who have committed treason against Him and His kingdom. What mercy! What grace!

Because Jesus is God, He can see the hidden things—He has a special lens on the future. He foretold His death many times, knowing all He would endure on the cross. Here, a hole in the wall around Palm Sunday Road reveals the Old City view Jesus would've had as He moved toward his death.

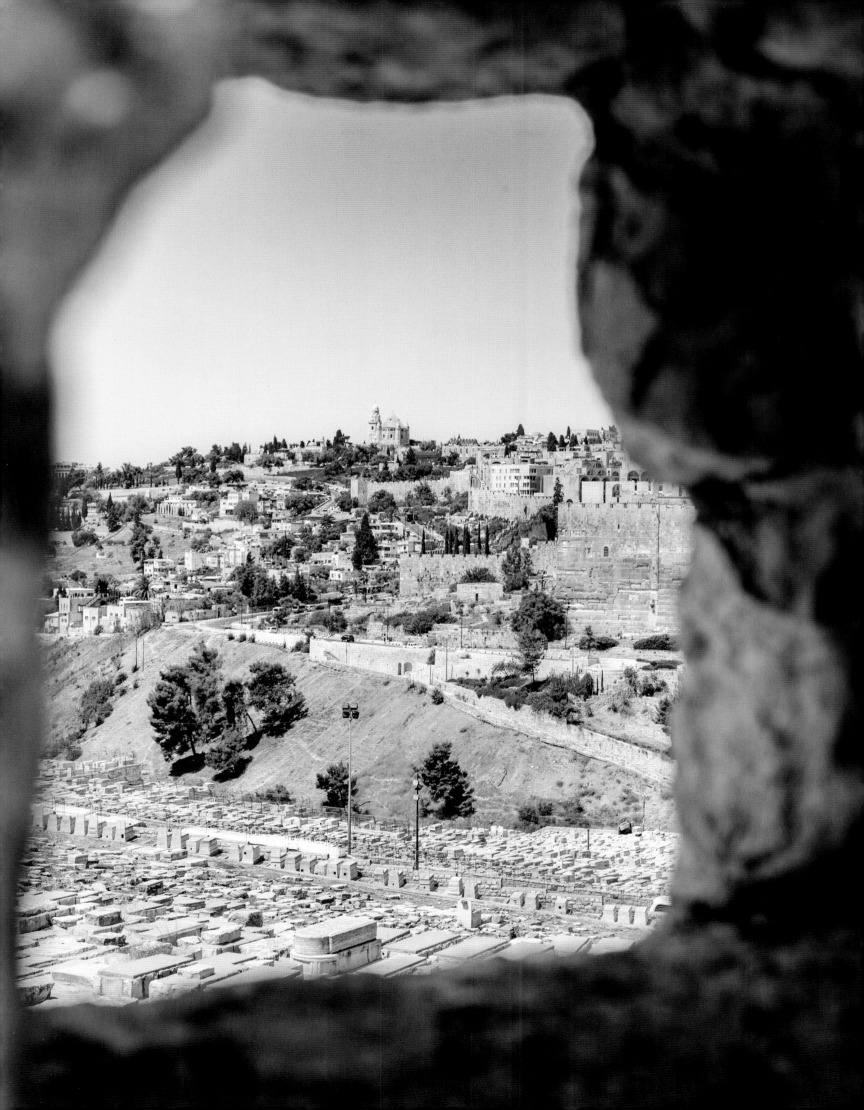

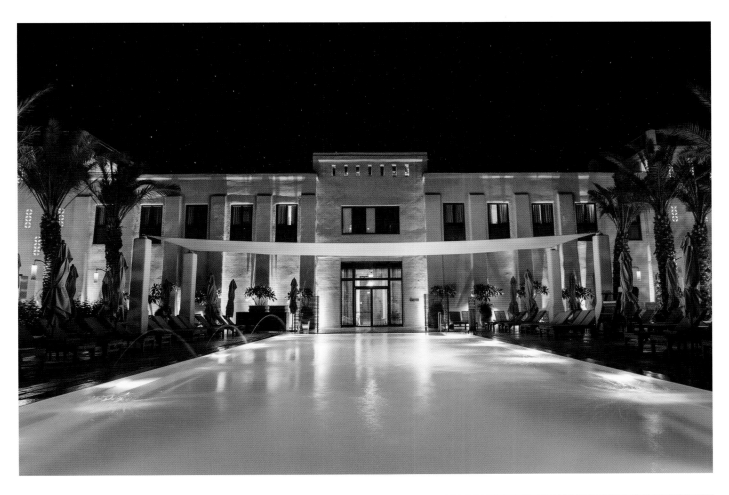

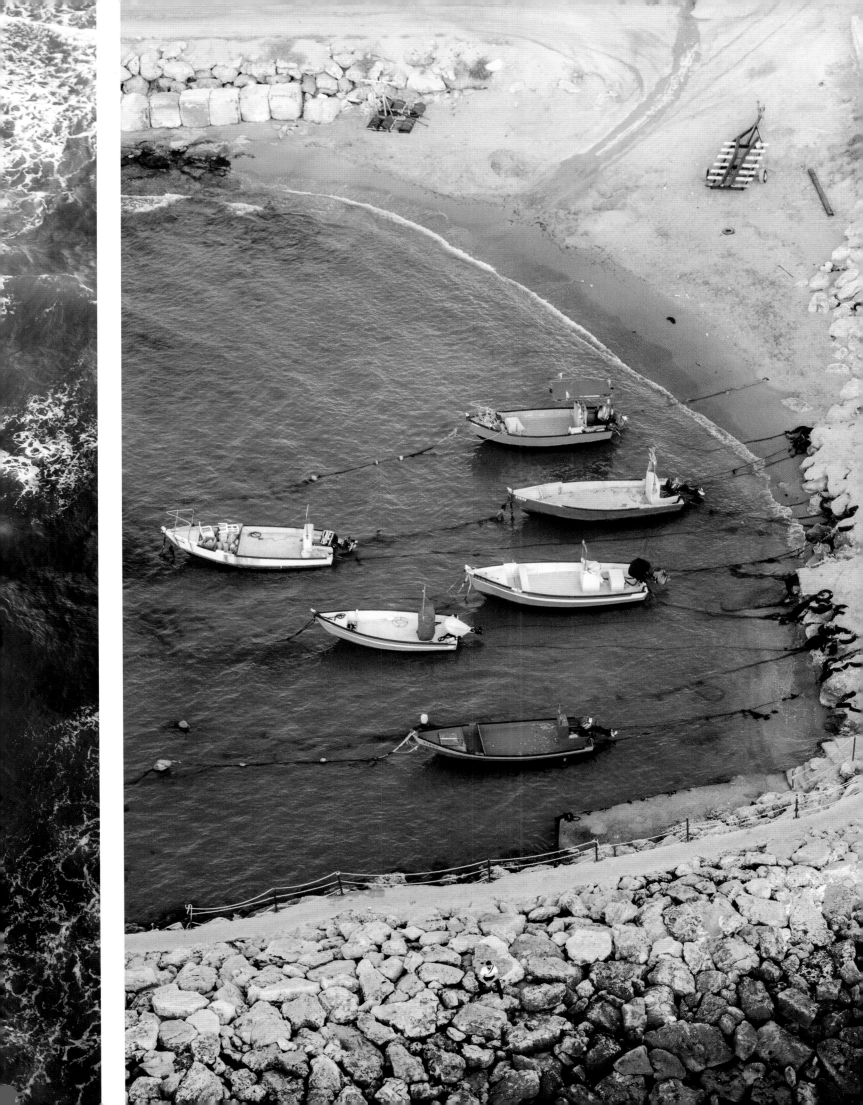

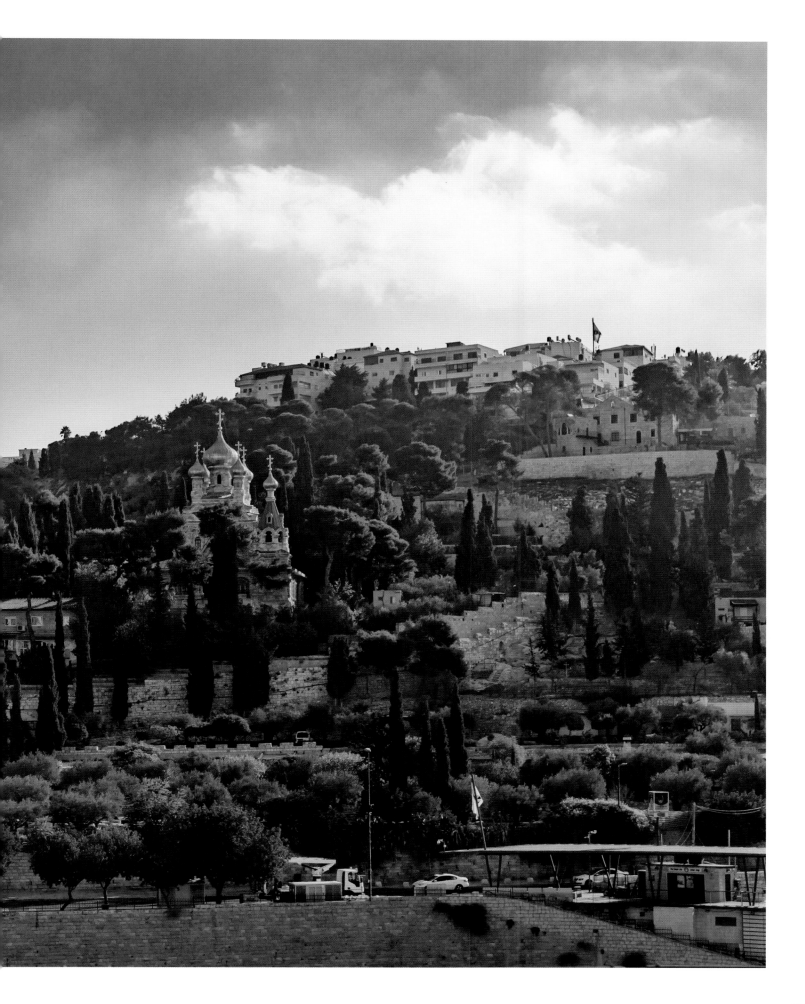

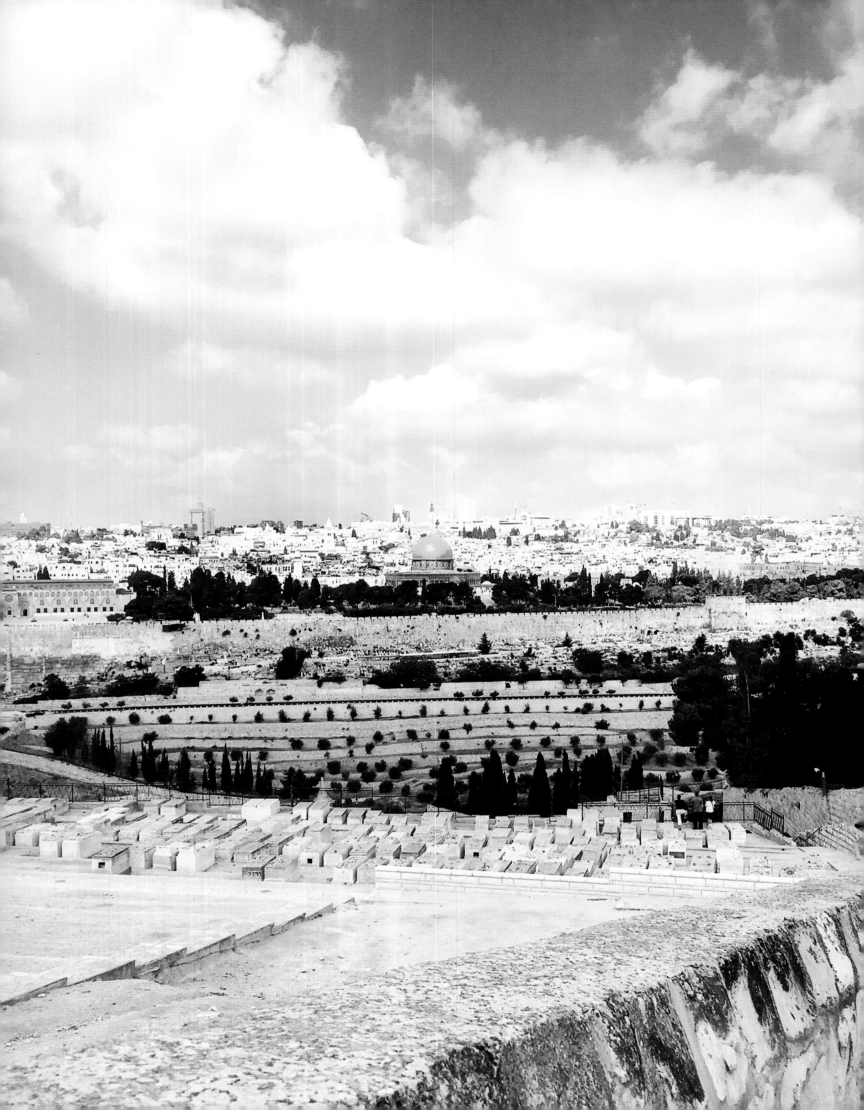

Palm Sunday Road

Luke 19:28–40

Some of the Pharisees in the crowd said to him, "Teacher, rebuke your disciples." He answered, "I tell you, if these were silent, the very stones would cry out."

—LUKE 19:39–40

FOR THOUSANDS OF YEARS, Mount Olives has been covered in both olive trees and burial plots. There are tens of thousands of graves, all marked by stones. The Pharisees didn't like the fact that the people were praising Jesus, so they told Him to rebuke His disciples, but He said that if they were silent, the very stones would cry out.

While it's impossible to know for certain, this may be a reference to the gravestones, which was likely His way of pointing to the souls of those who had passed through death already.

It may be that He was saying something along these lines: "If you try to stop the living from praising Me, the eternal souls of the dead will do it instead. My praise will echo through the universe regardless!" Nothing can stop our Savior, and nothing can stop His creation from praising Him!

Those who walk the traditional Palm Sunday Road can see the ancient graveyard, the Garden of Gethsemane, the Old City Walls, and the Southern Steps.

ALL NATIONS WILL CALL YOU
BLESSED, FOR YOU WILL BE
A LAND OF DELIGHT.

MALACHI 3:12

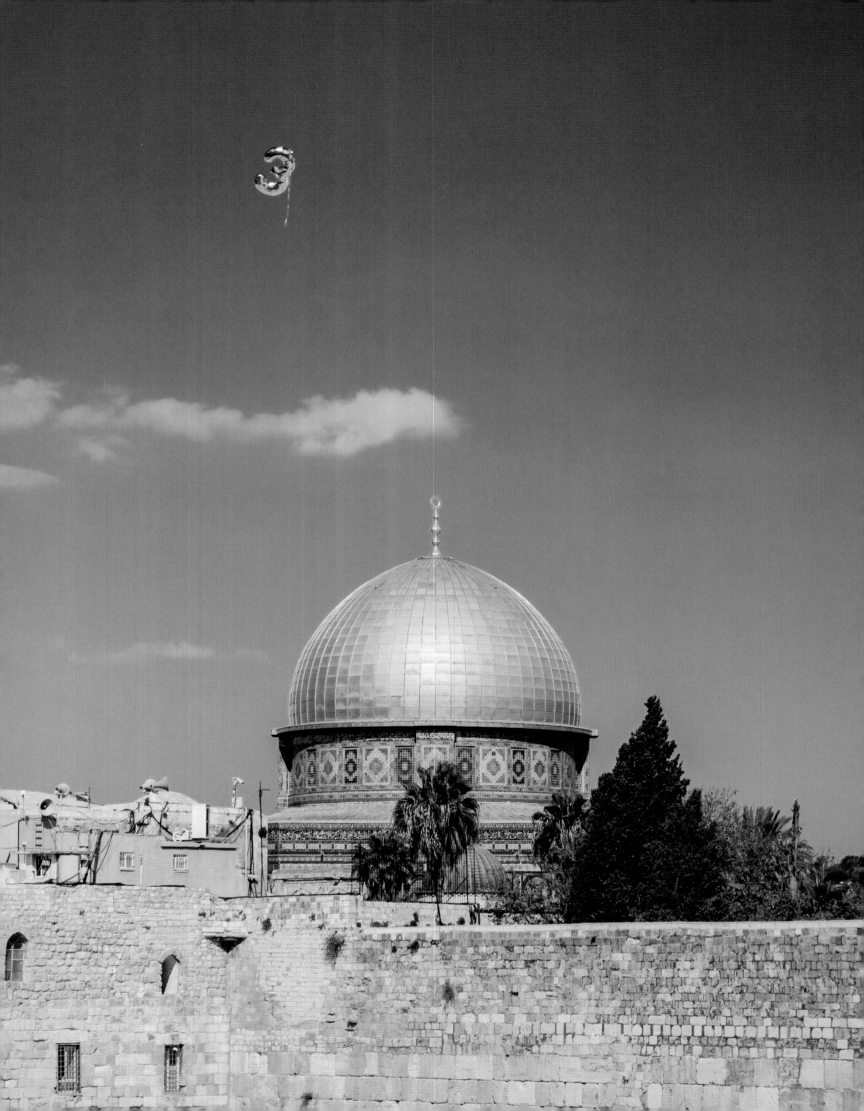

DO GOOD TO ZION IN
YOUR GOOD PLEASURE;
BUILD UP THE WALLS
OF JERUSALEM.

PSALM 51:18

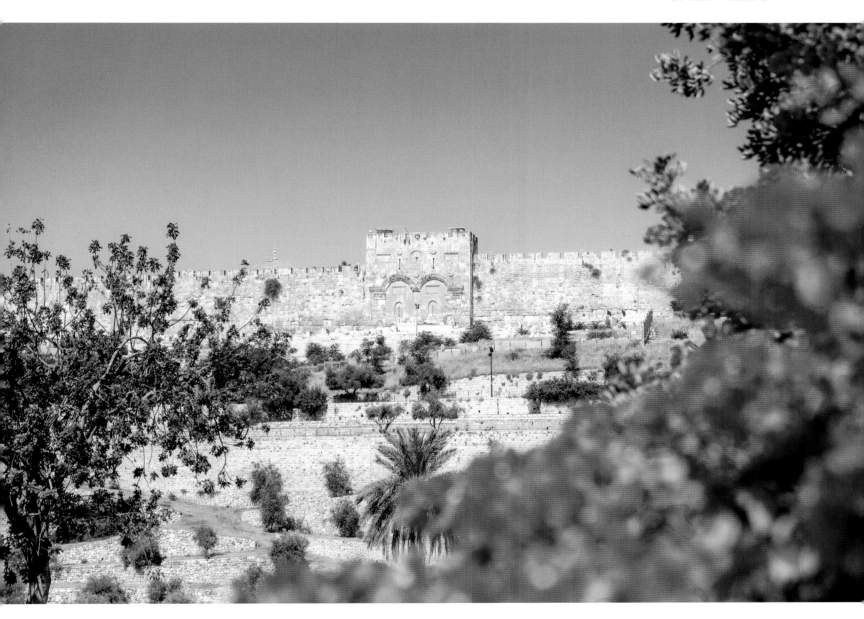

Jesus Wept Church

Luke 19:41–43

JESUS LOVED JERUSALEM and its people, but they didn't love Him back. And He wept over it. This church was built in memory of that moment of grief and heartache.

Jesus prophesied the destruction of the city He loved, which happened approximately forty years later—after His death, resurrection, and ascension.

As heartbreaking and painful as it was for Him, He knew these were all necessary steps in advancing His return to establish His kingdom on earth, where He will reign as King forever!

Antonio Barluzzi designed this teardrop-shaped church in memory of the site where Jesus wept over Jerusalem. It is formally known as Dominus Flevit Church.

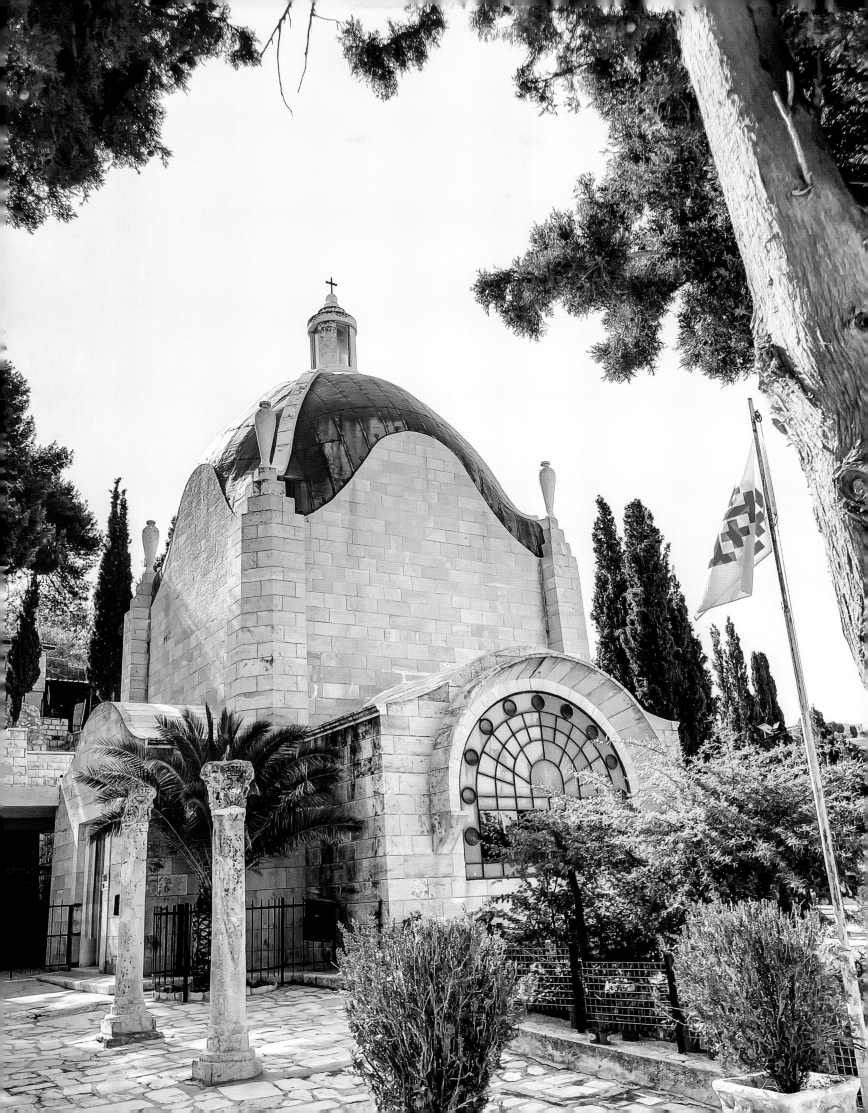

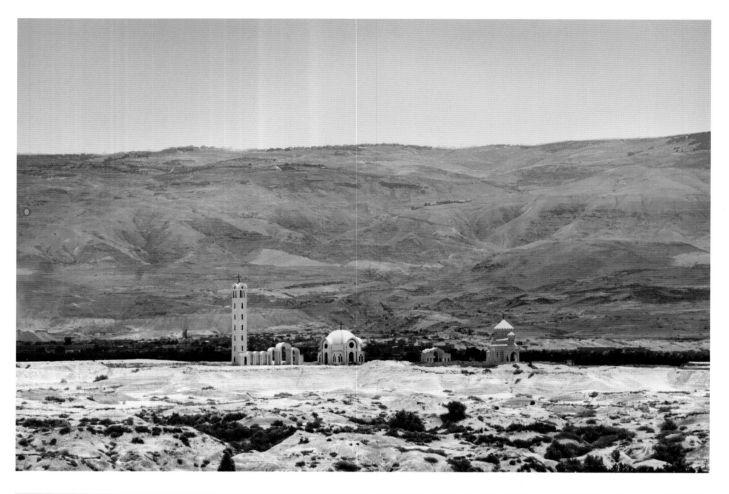

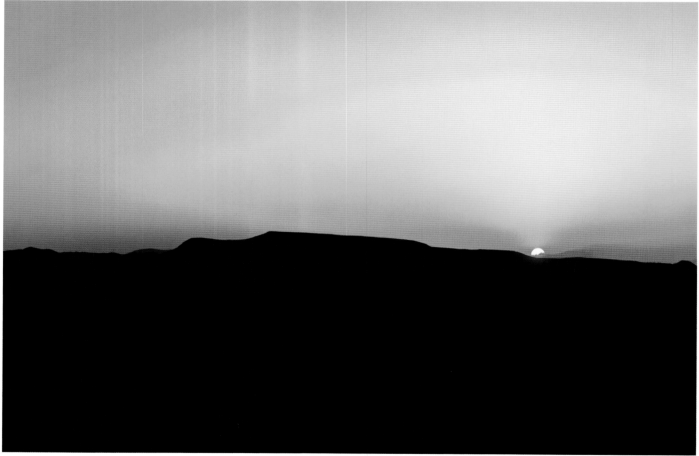

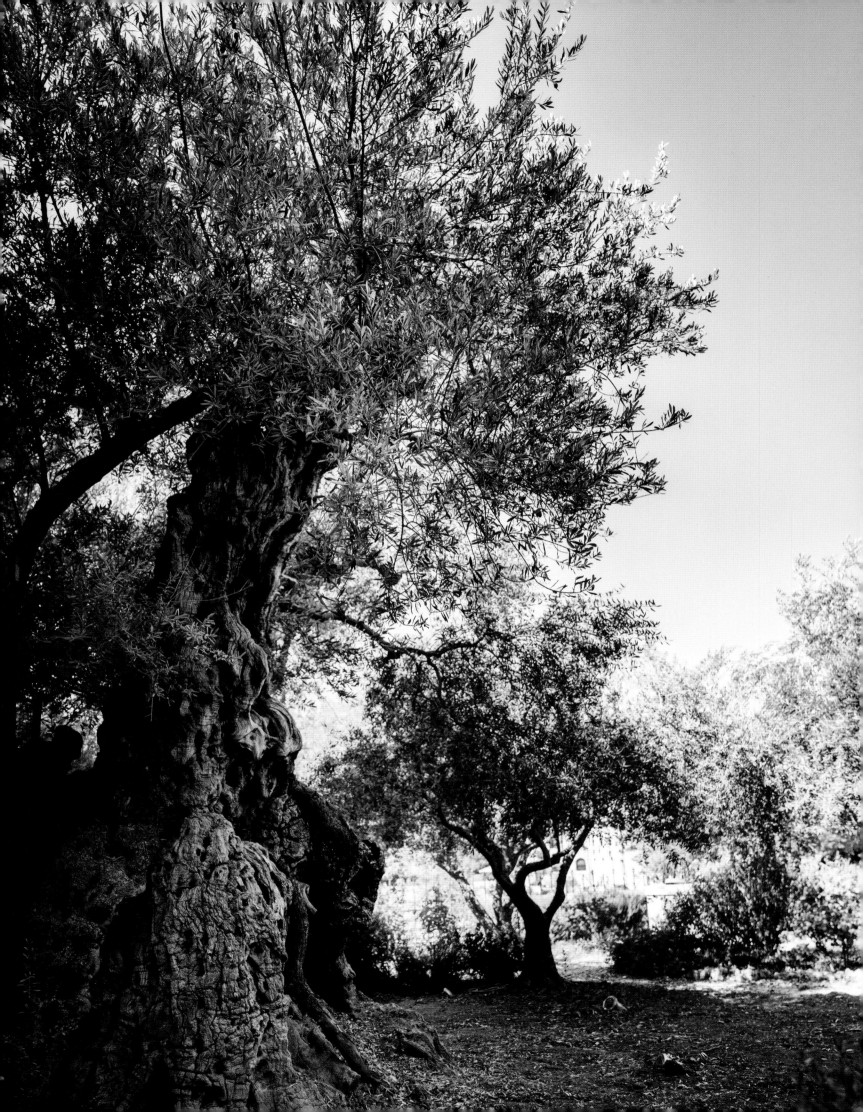

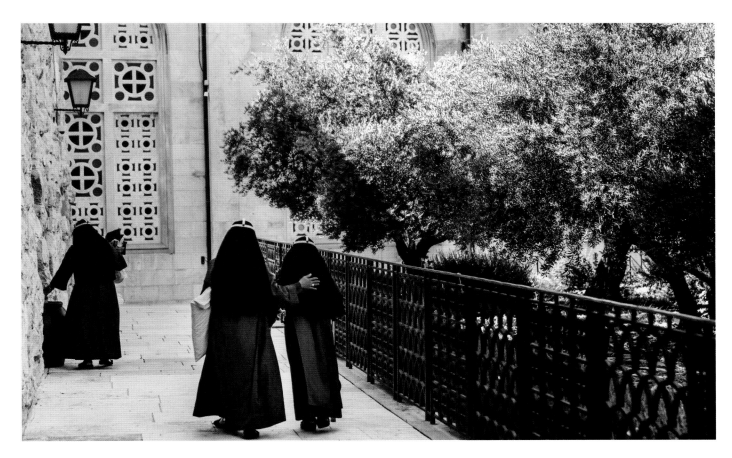

Garden of Gethsemane

Matthew 26:30–56

JESUS SPENT A CRUSHING NIGHT in this garden among the olive trees. It was His final night on earth prior to His crucifixion. He nestled in between these olive branches to cry out to the Father. He grieved. He prayed. He gathered His friends around Him. But His path had been planned from before the earth was formed: He was about to be crushed.

This garden was a fitting location for Jesus's struggles because olives go through a similar process. The way to get the most valuable thing out of an olive is to crush it. Crushing is necessary to get what lasts. This was true for Jesus, and it's true for us too. Life will crush us at times, but through it all, we are being turned into people with softer hearts, more resilient and compassionate. Through your crushing, may you look to Christ, who was crushed for you like the olives in this garden to give you what is most valuable on an eternal scale.

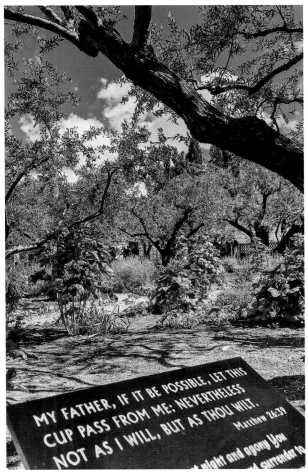

There are two trees in the Garden of Gethsemane that some believe may be two thousand years old. If that's true, it's possible they were there on the night our Savior cried and prayed before He was sentenced to die.

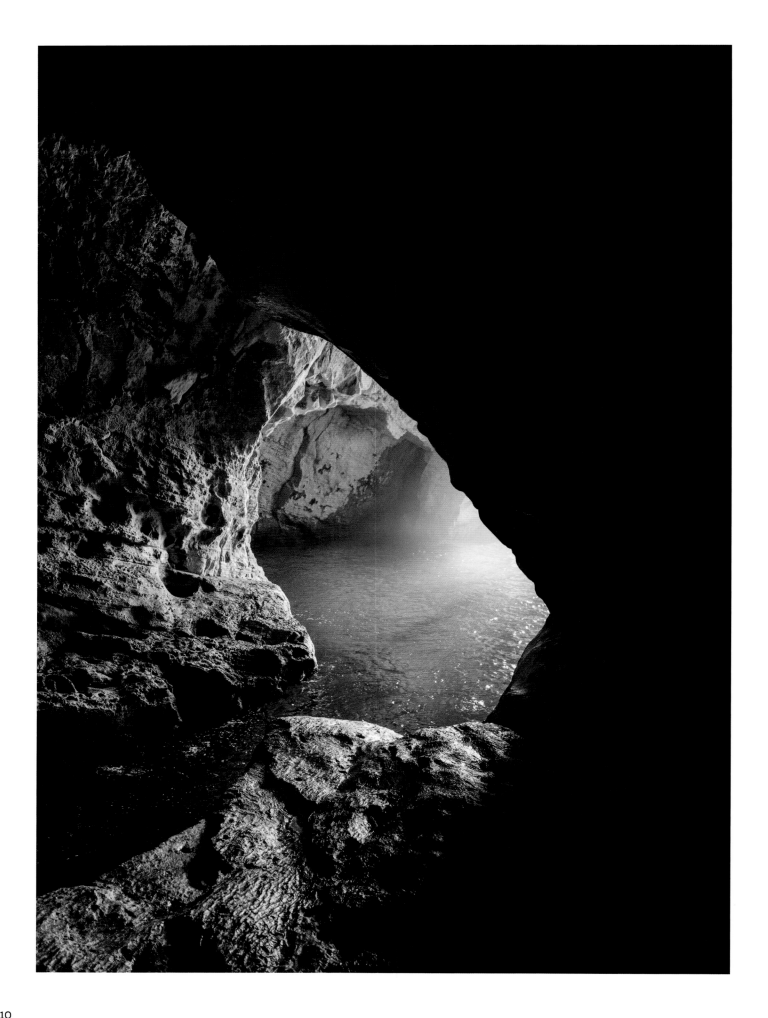

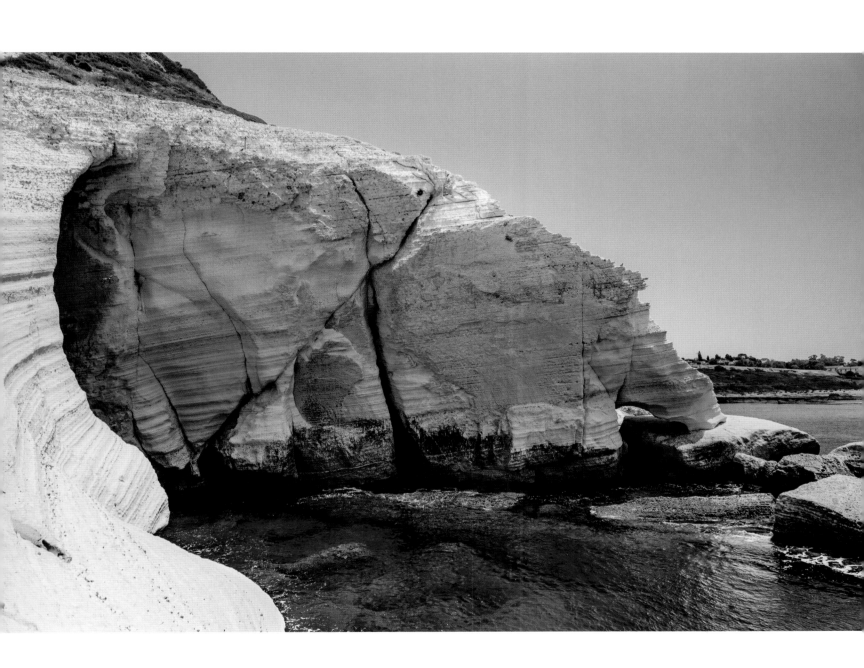

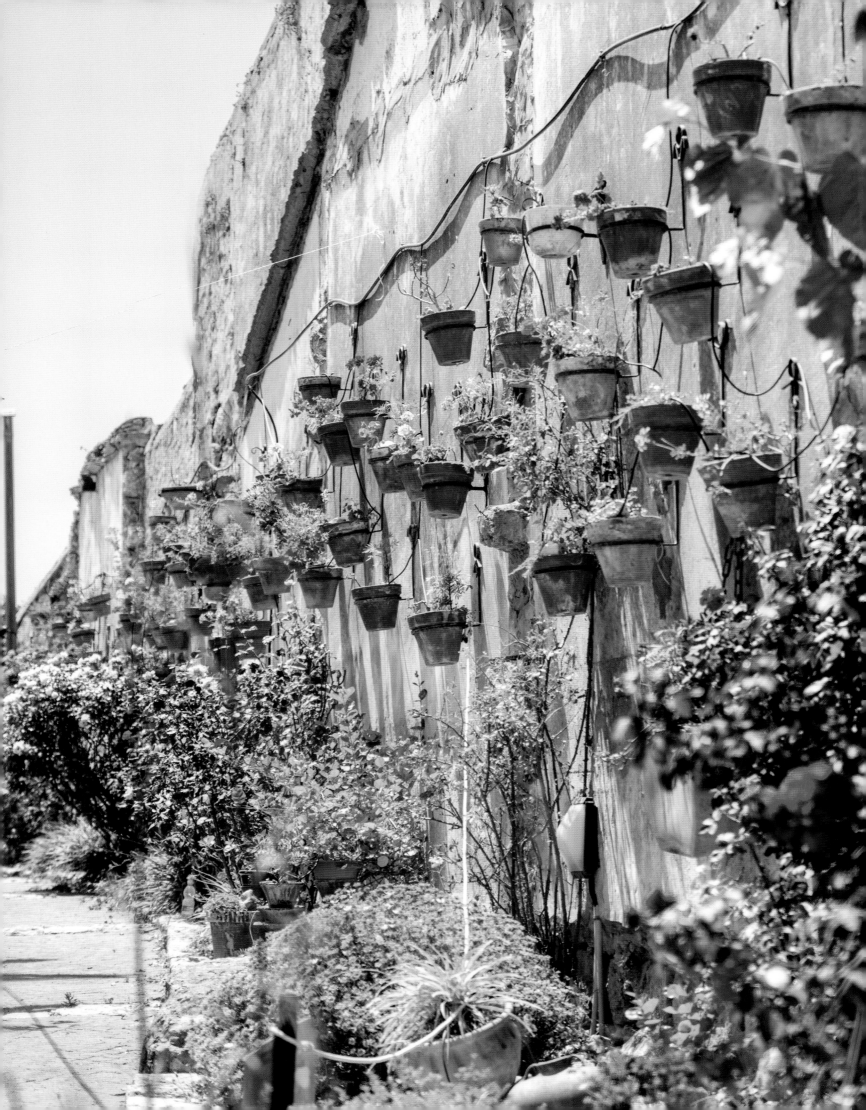

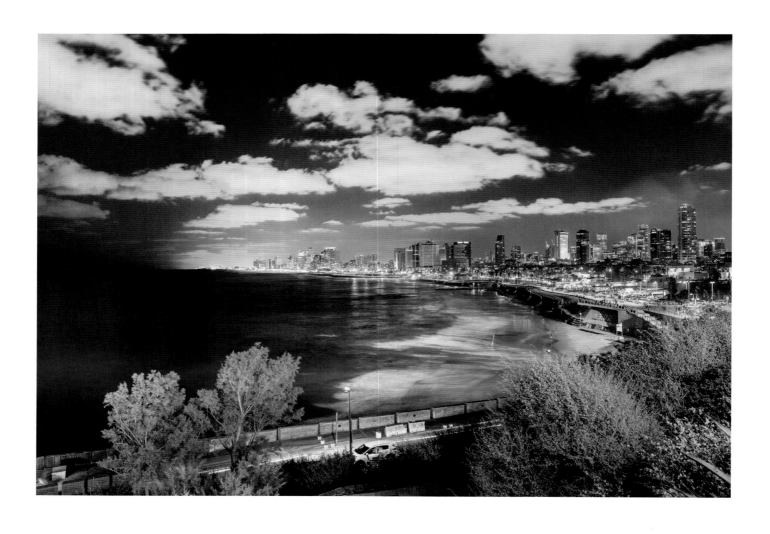

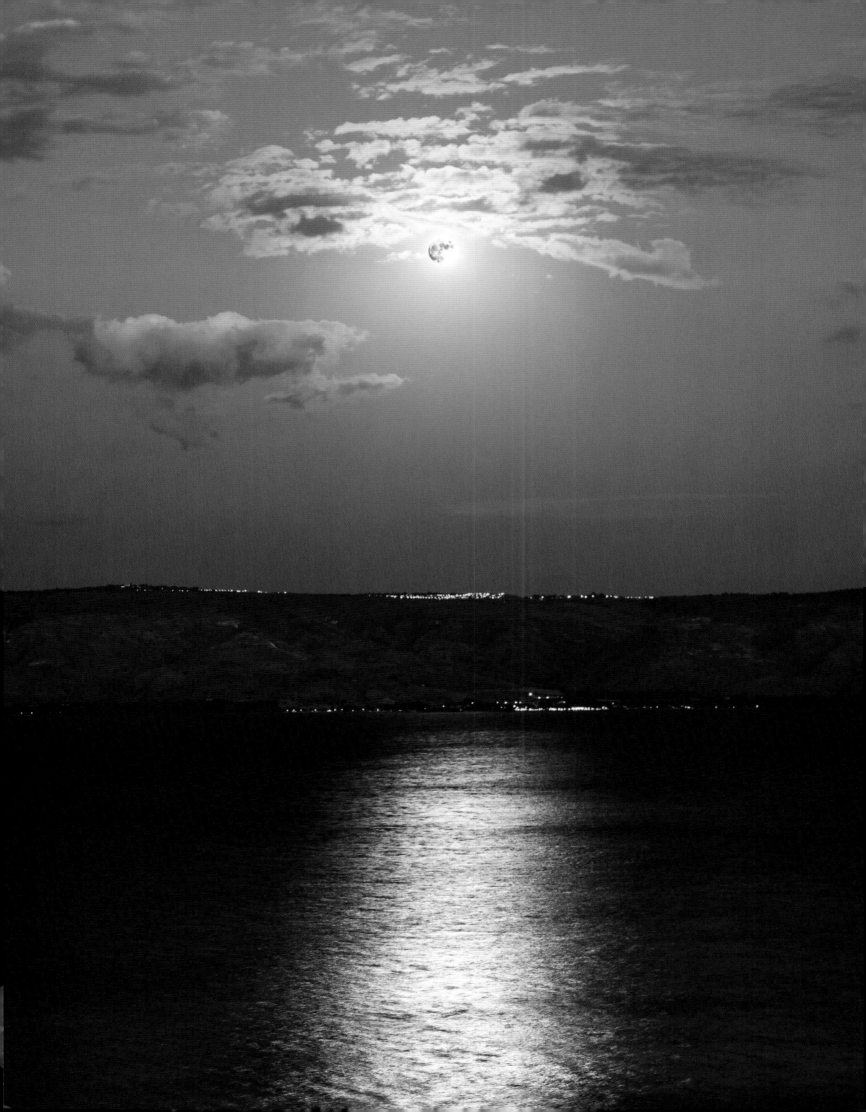

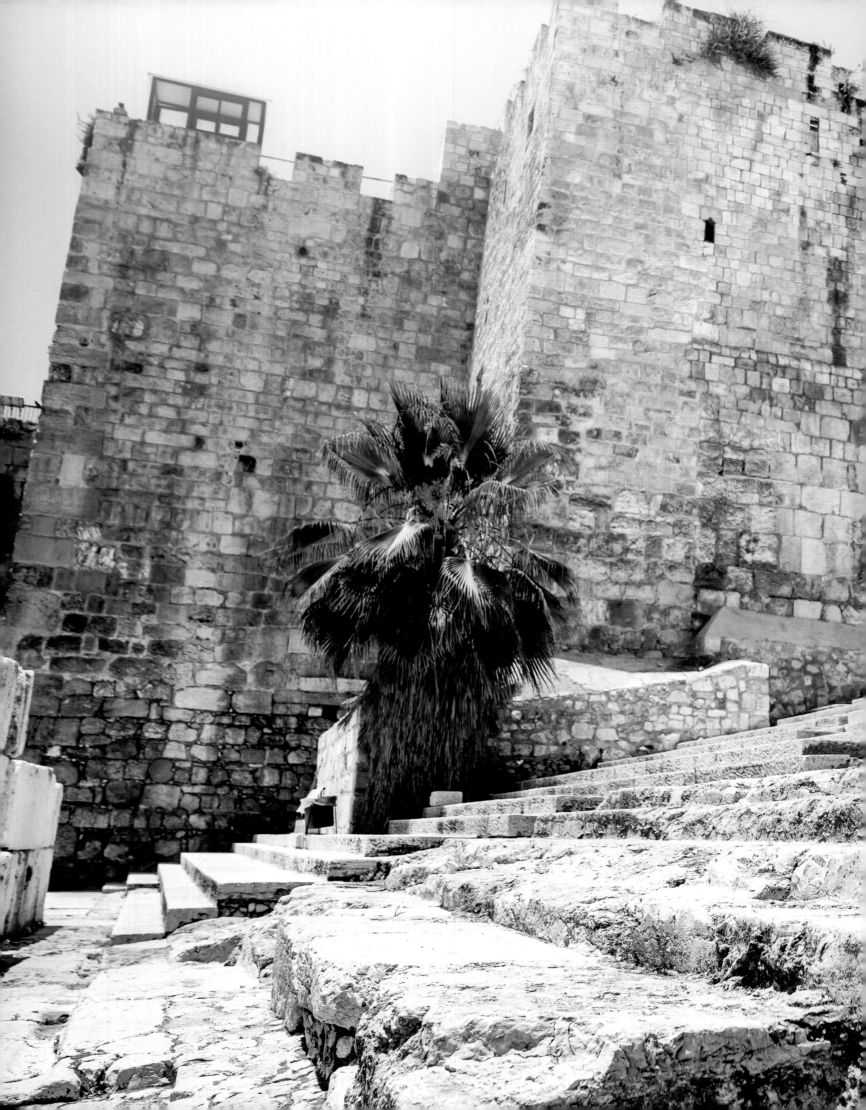

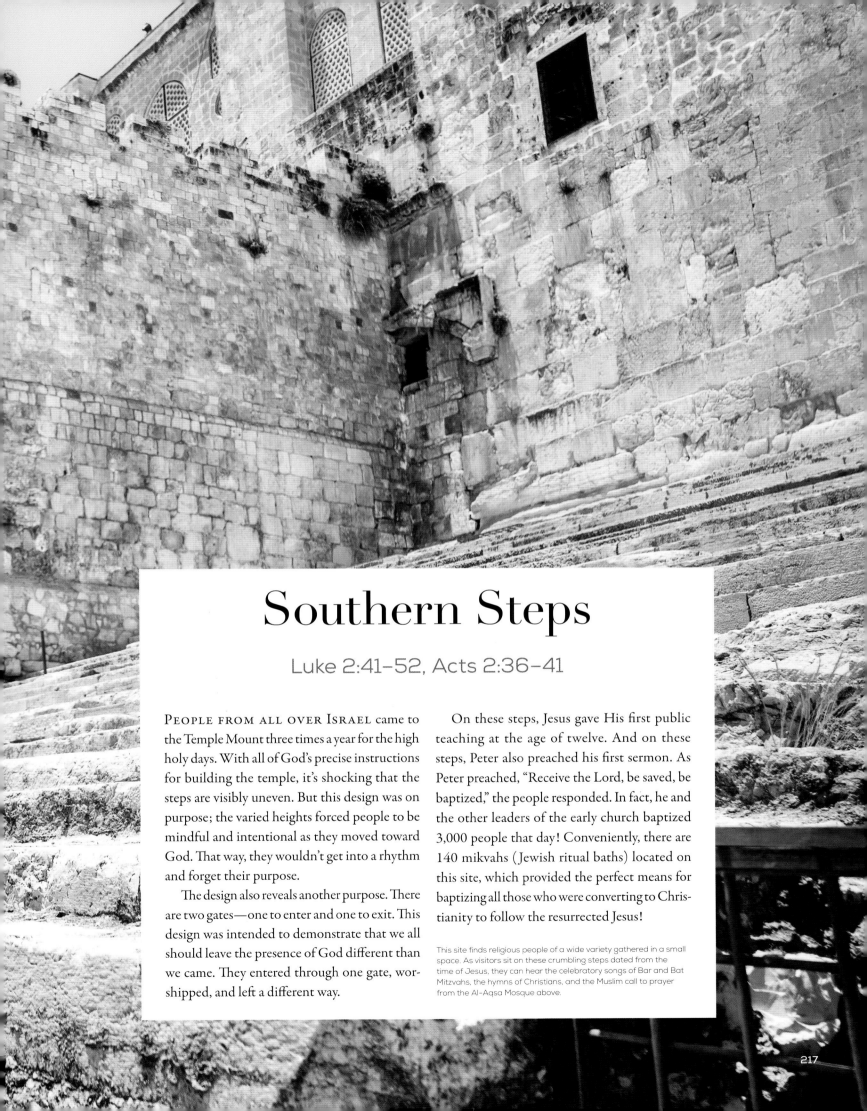

Southern Steps

Luke 2:41–52, Acts 2:36–41

PEOPLE FROM ALL OVER ISRAEL came to the Temple Mount three times a year for the high holy days. With all of God's precise instructions for building the temple, it's shocking that the steps are visibly uneven. But this design was on purpose; the varied heights forced people to be mindful and intentional as they moved toward God. That way, they wouldn't get into a rhythm and forget their purpose.

The design also reveals another purpose. There are two gates—one to enter and one to exit. This design was intended to demonstrate that we all should leave the presence of God different than we came. They entered through one gate, worshipped, and left a different way.

On these steps, Jesus gave His first public teaching at the age of twelve. And on these steps, Peter also preached his first sermon. As Peter preached, "Receive the Lord, be saved, be baptized," the people responded. In fact, he and the other leaders of the early church baptized 3,000 people that day! Conveniently, there are 140 mikvahs (Jewish ritual baths) located on this site, which provided the perfect means for baptizing all those who were converting to Christianity to follow the resurrected Jesus!

This site finds religious people of a wide variety gathered in a small space. As visitors sit on these crumbling steps dated from the time of Jesus, they can hear the celebratory songs of Bar and Bat Mitzvahs, the hymns of Christians, and the Muslim call to prayer from the Al-Aqsa Mosque above.

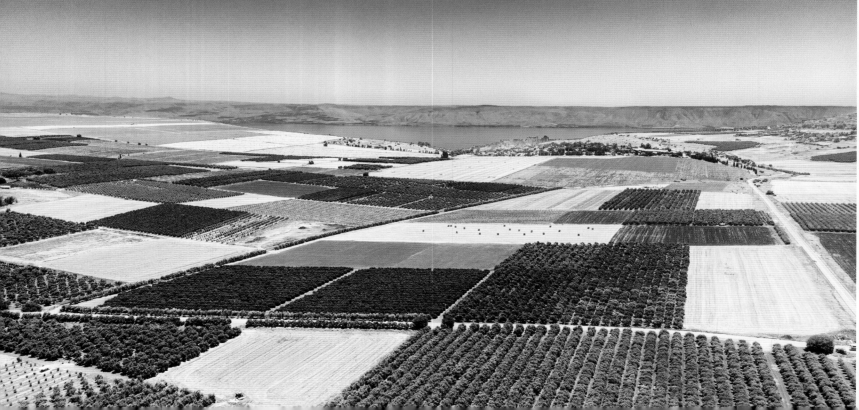

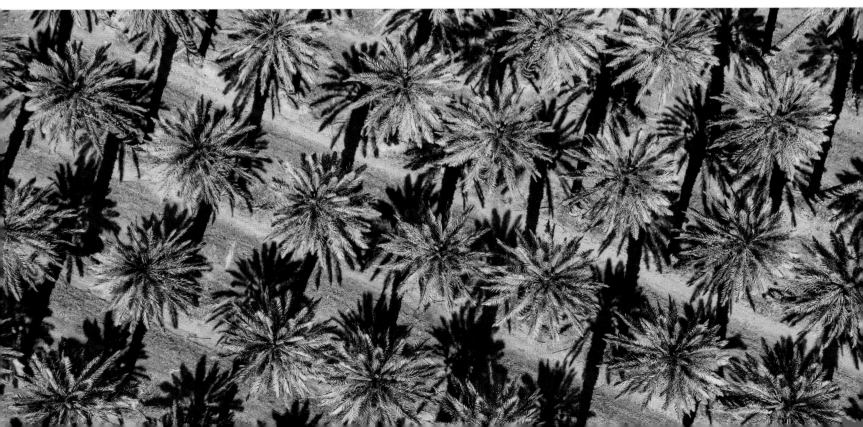

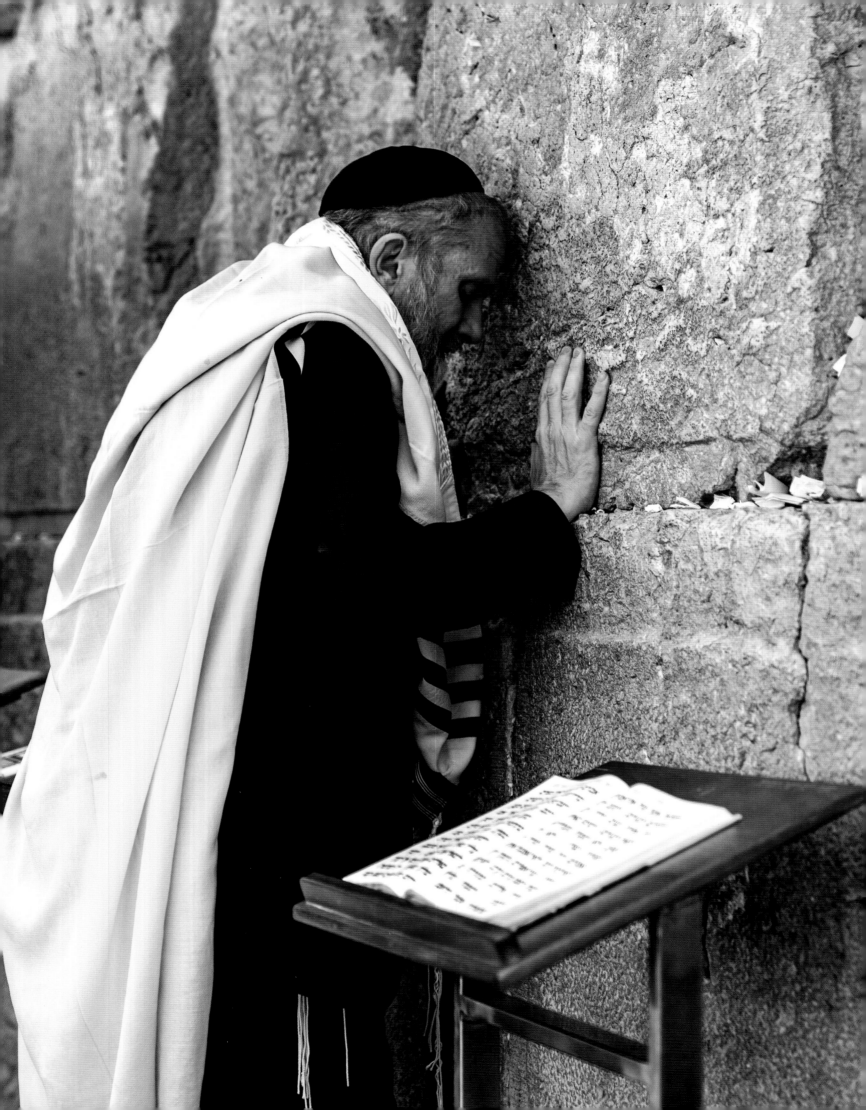

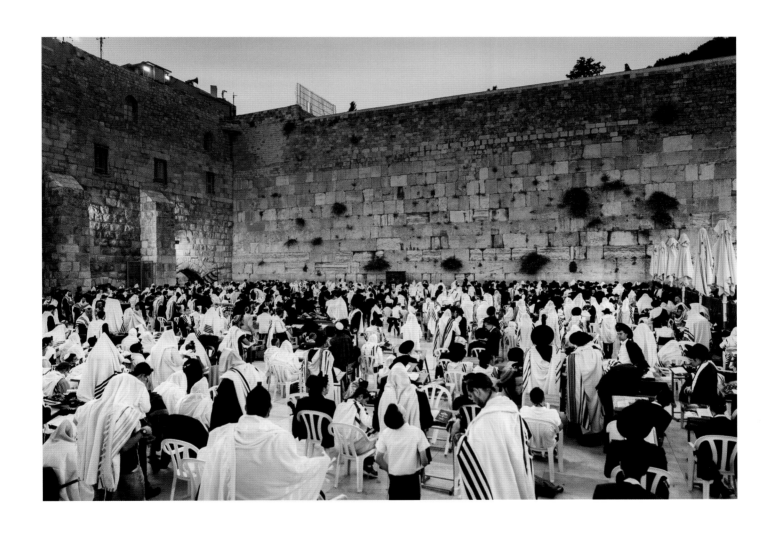

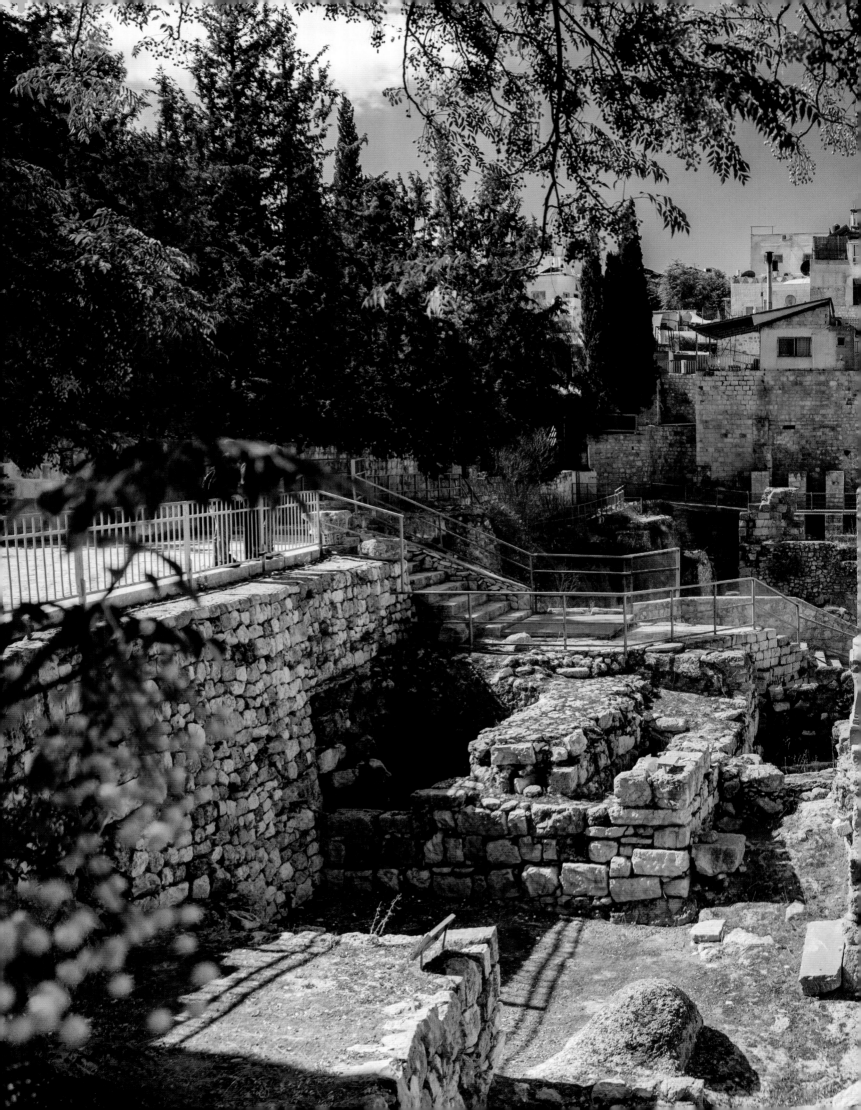

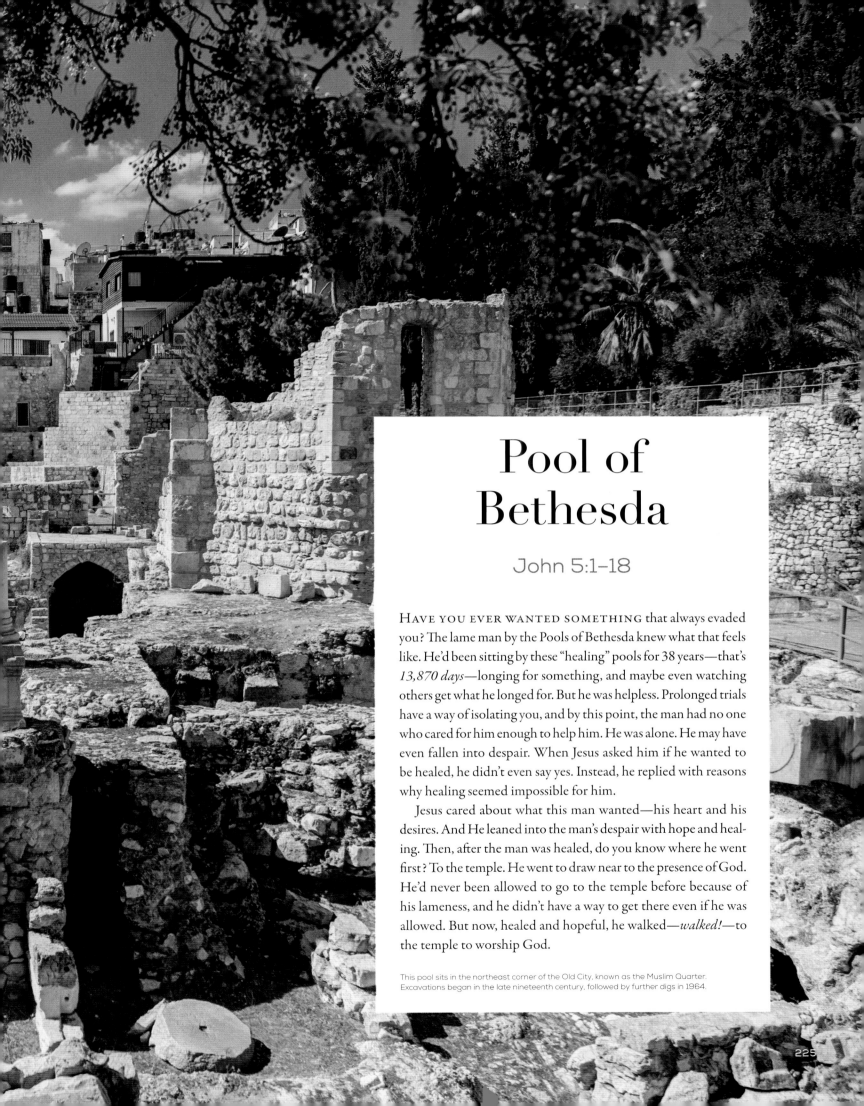

Pool of Bethesda

John 5:1–18

HAVE YOU EVER WANTED SOMETHING that always evaded you? The lame man by the Pools of Bethesda knew what that feels like. He'd been sitting by these "healing" pools for 38 years—that's *13,870 days*—longing for something, and maybe even watching others get what he longed for. But he was helpless. Prolonged trials have a way of isolating you, and by this point, the man had no one who cared for him enough to help him. He was alone. He may have even fallen into despair. When Jesus asked him if he wanted to be healed, he didn't even say yes. Instead, he replied with reasons why healing seemed impossible for him.

Jesus cared about what this man wanted—his heart and his desires. And He leaned into the man's despair with hope and healing. Then, after the man was healed, do you know where he went first? To the temple. He went to draw near to the presence of God. He'd never been allowed to go to the temple before because of his lameness, and he didn't have a way to get there even if he was allowed. But now, healed and hopeful, he walked—*walked!*—to the temple to worship God.

This pool sits in the northeast corner of the Old City, known as the Muslim Quarter. Excavations began in the late nineteenth century, followed by further digs in 1964.

I WILL RESTORE THE
FORTUNES OF MY
PEOPLE ISRAEL, AND
THEY SHALL REBUILD
THE RUINED CITIES
AND INHABIT THEM.

AMOS 9:14

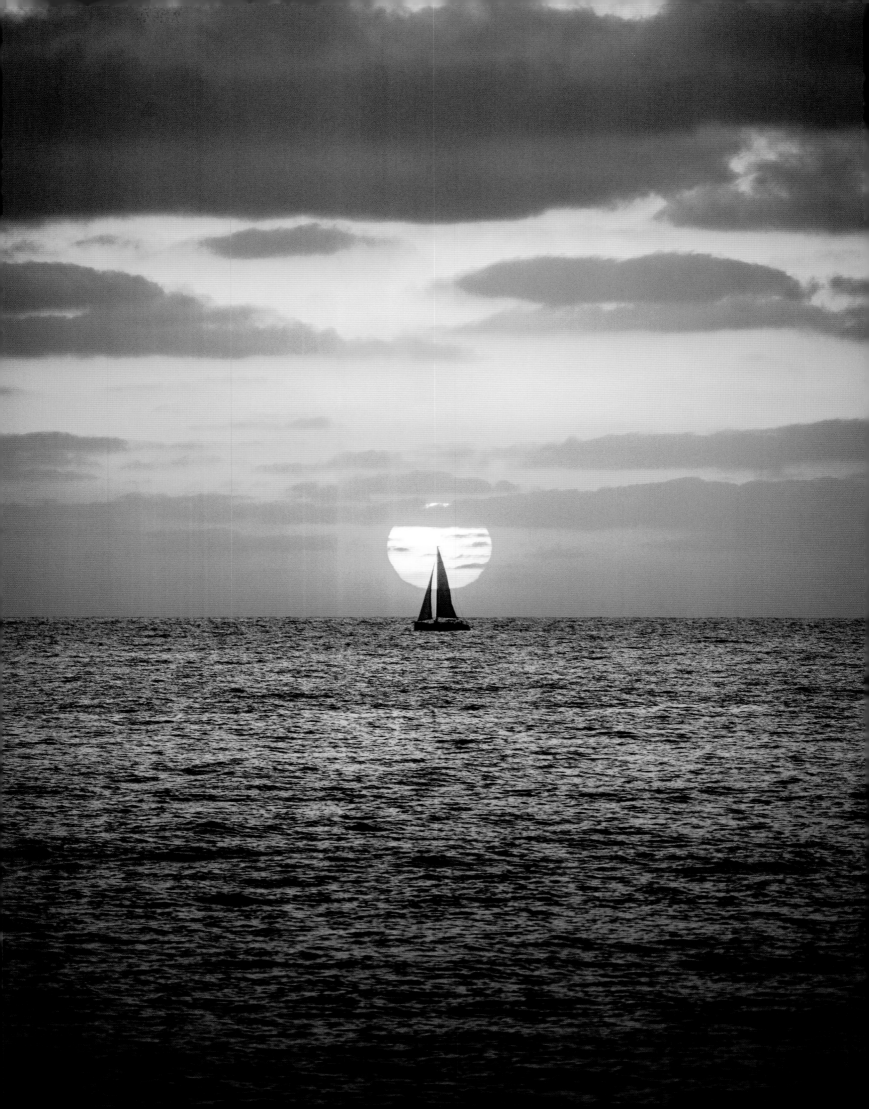

THE WHOLE EARTH
IS AT REST AND QUIET;
THEY BREAK FORTH
INTO SINGING.

ISAIAH 14:7

Pool of Siloam

John 9

THIS IS THE EDGE OF A POOL that was a major gathering place in ancient times. In this very public place, Jesus performed an astonishing miracle—but He did it on the Sabbath, which was a violation of the religious laws of the Pharisees, the ruling class. Their rabbis had created additional laws on top of God's law and had begun to treat them with the same weight as God's law. Jesus never broke God's law; He only broke the laws of the Pharisees.

To His own detriment, Jesus pursued this blind man to heal him. He knew it would prompt the Pharisees to hate Him all the more. He knew that revealing His power and doing it on the Sabbath would put Him one step closer to His own death at the hands of the religious leaders.

To His own detriment, Jesus pursued you too. He willingly gave His life, paid your sin debt, and lived a perfectly righteous, law-abiding life that is credited to your account.

The Pool of Siloam was first constructed during the reign of King Hezekiah, seven hundred years prior to the birth of Christ. A second version of the pool was constructed a few hundred years later. It was eventually destroyed during the First Jewish–Roman War (AD 70) and discovered during a 2004 excavation directed by archaeologist Eli Shukron.

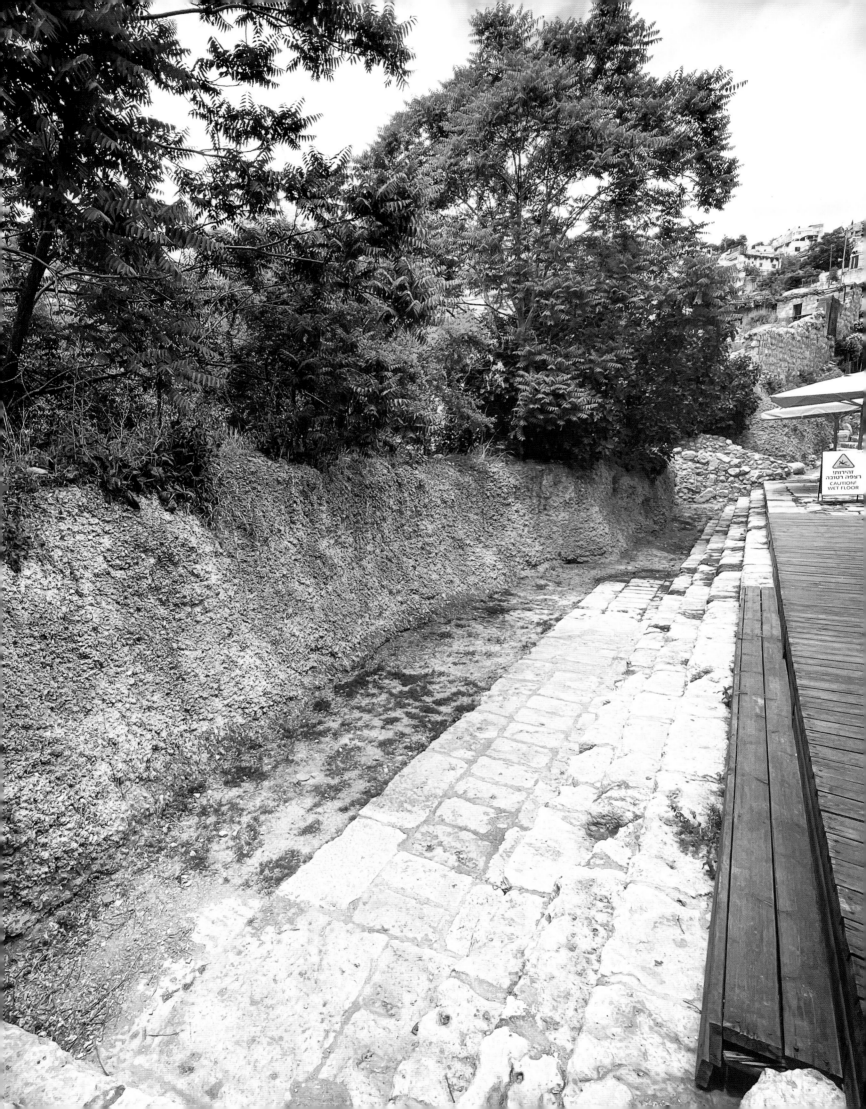

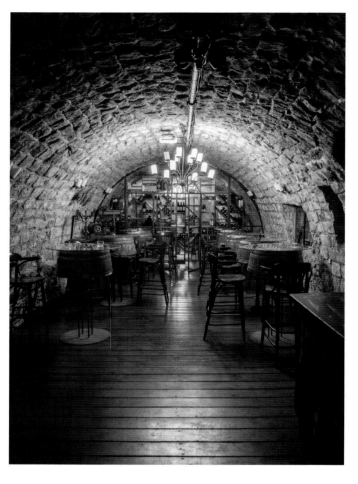

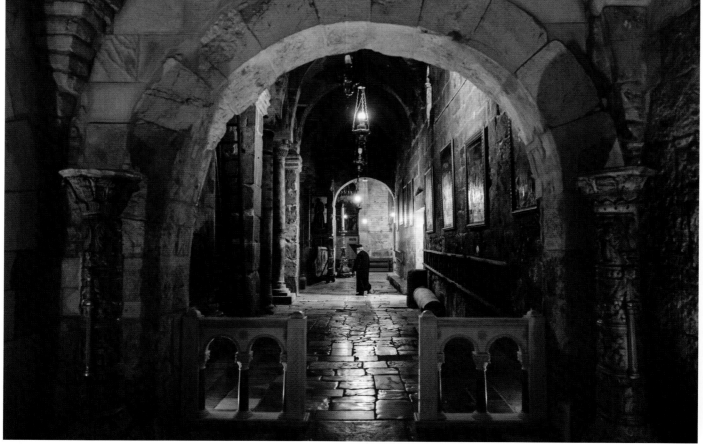

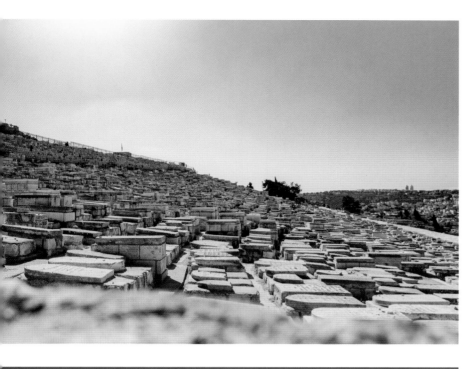

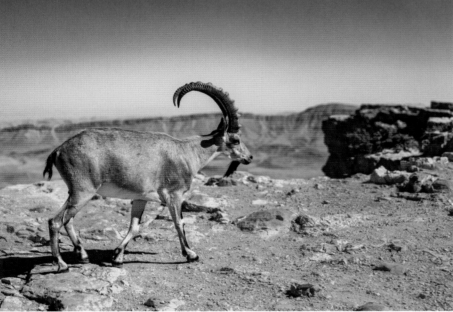

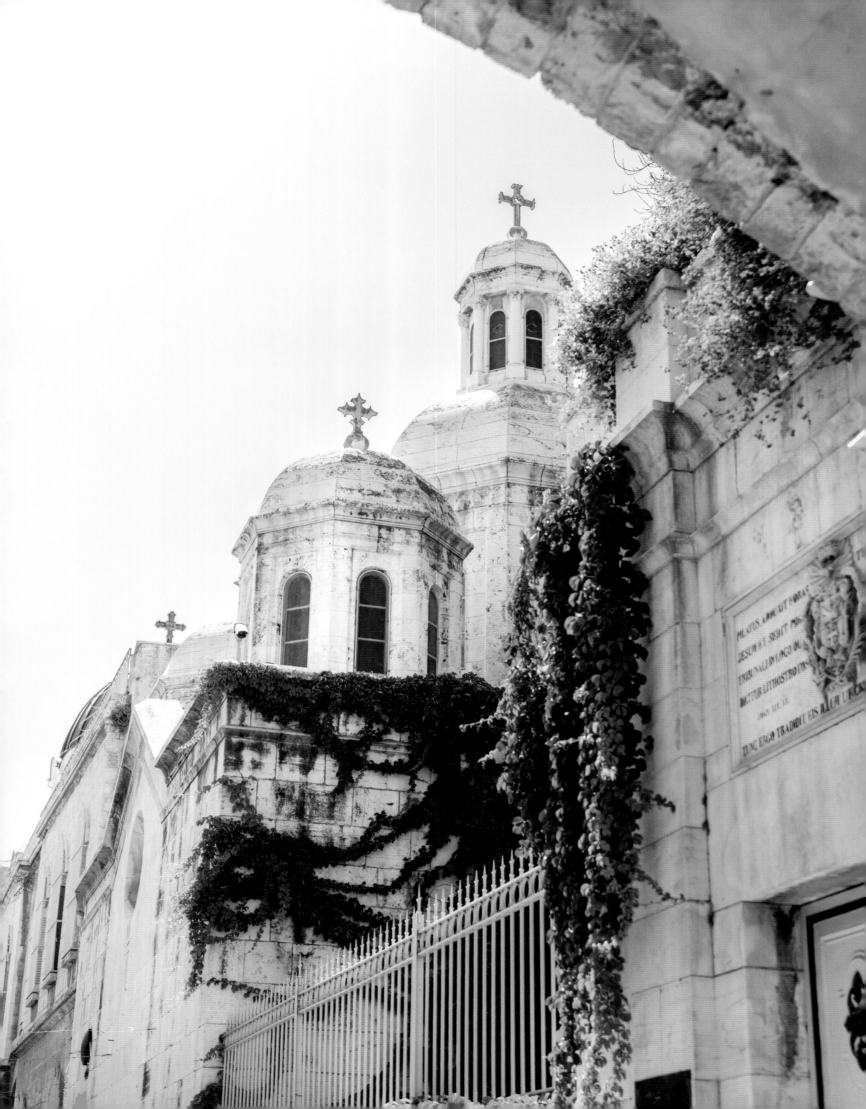

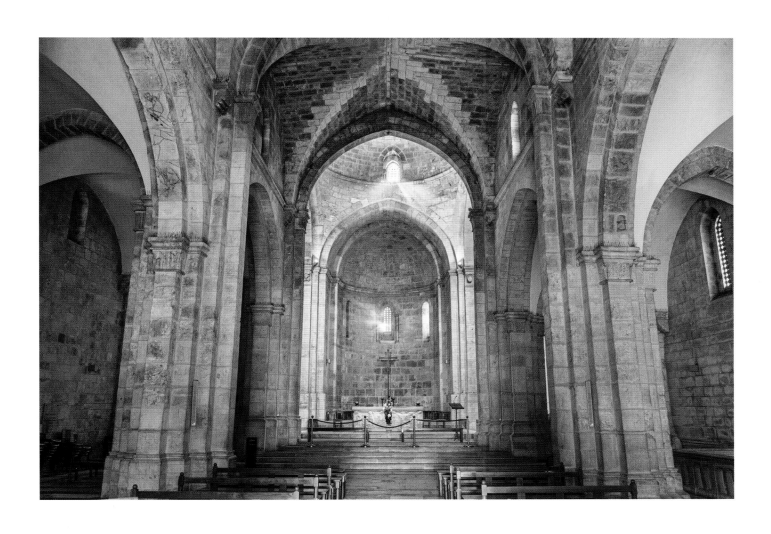

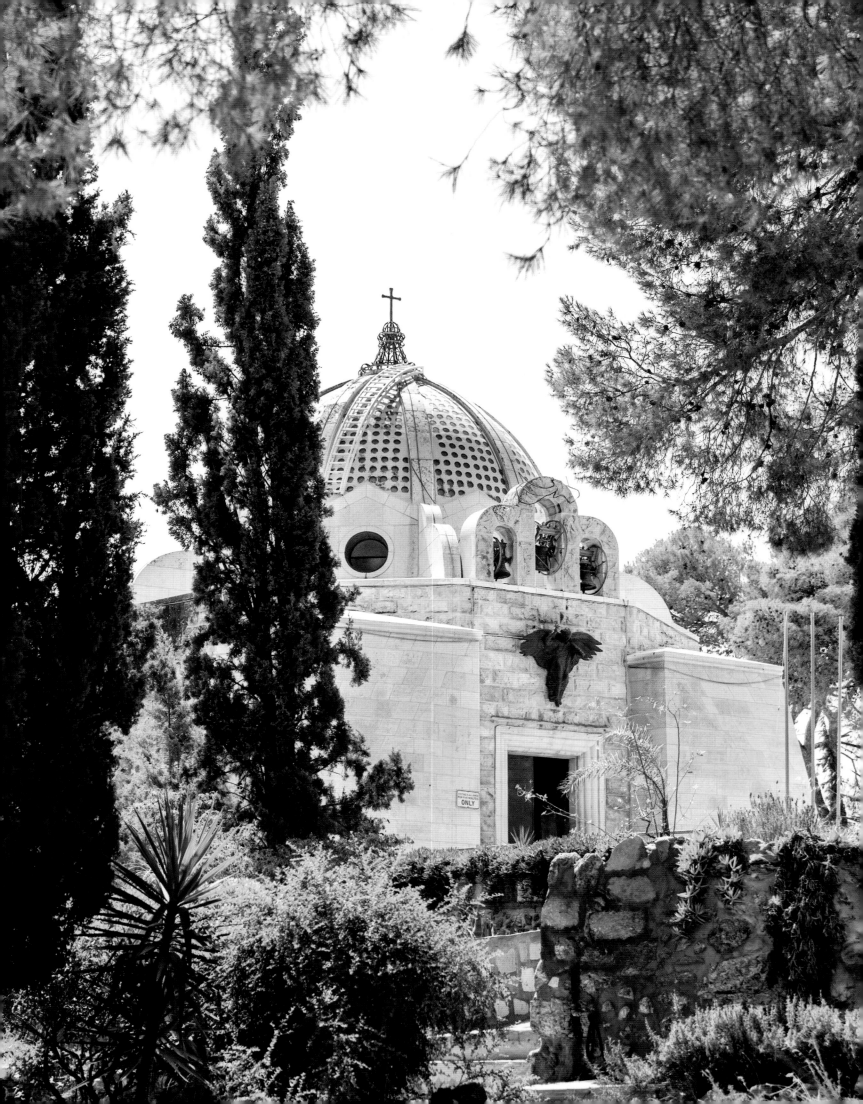

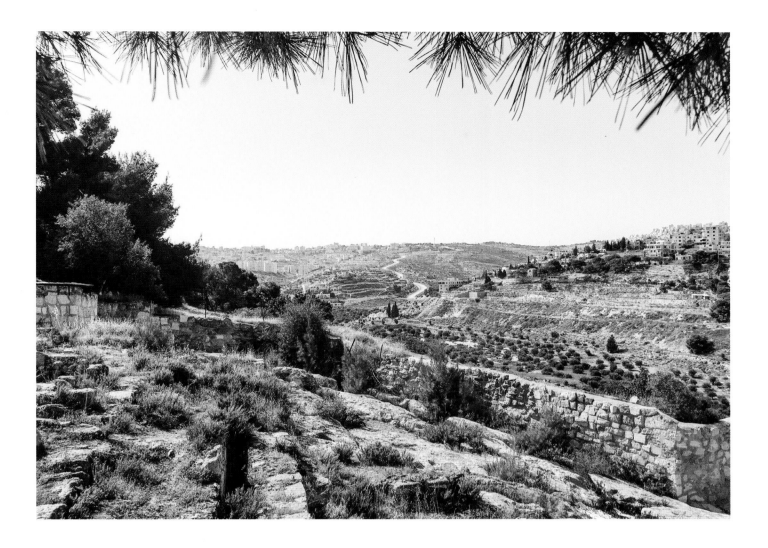

Beit Sahour / Bethlehem

Luke 2:1–20

KATALUMA IS THE GREEK WORD for the place where Jesus was born. Many homes were built on top of caves, and this word refers to the cave basement area that served as a holding pen for livestock at night. During the winter months, people often lit a fire in the doorway at night to keep the animals warm and prevent them from escaping.

Though we celebrate Jesus's birth in December, He was born in the summer—likely between June and September, when the census was taken (2:1). This was also the time of year when shepherds kept their flocks in the field overnight (2:8), which conveniently left the kataluma vacant for an out-of-town family. So Jesus was likely born in a kataluma like this, and probably laid in a stone manger, because that's what most mangers were made of at the time.

Meanwhile, in a nearby field, angels appeared to the shepherds telling them the Messiah had been born.

> Fear not . . . I bring you good news of great joy that will be for all the people. For unto you is born this day in the city of David a Savior, who is Christ the Lord.
>
> —Luke 2:10–11

From this vantage point, visitors can see the rocky hills of the outskirts of Bethlehem. However, there is one flat field in the valley, and shepherds still keep their flocks there today. Because of its uniqueness among the rest of the landscape, it's widely believed to be not only the site where the angels appeared to herald the birth of Jesus, but also where David kept his sheep when he lived in Bethlehem and where Ruth gleaned in Boaz's field.

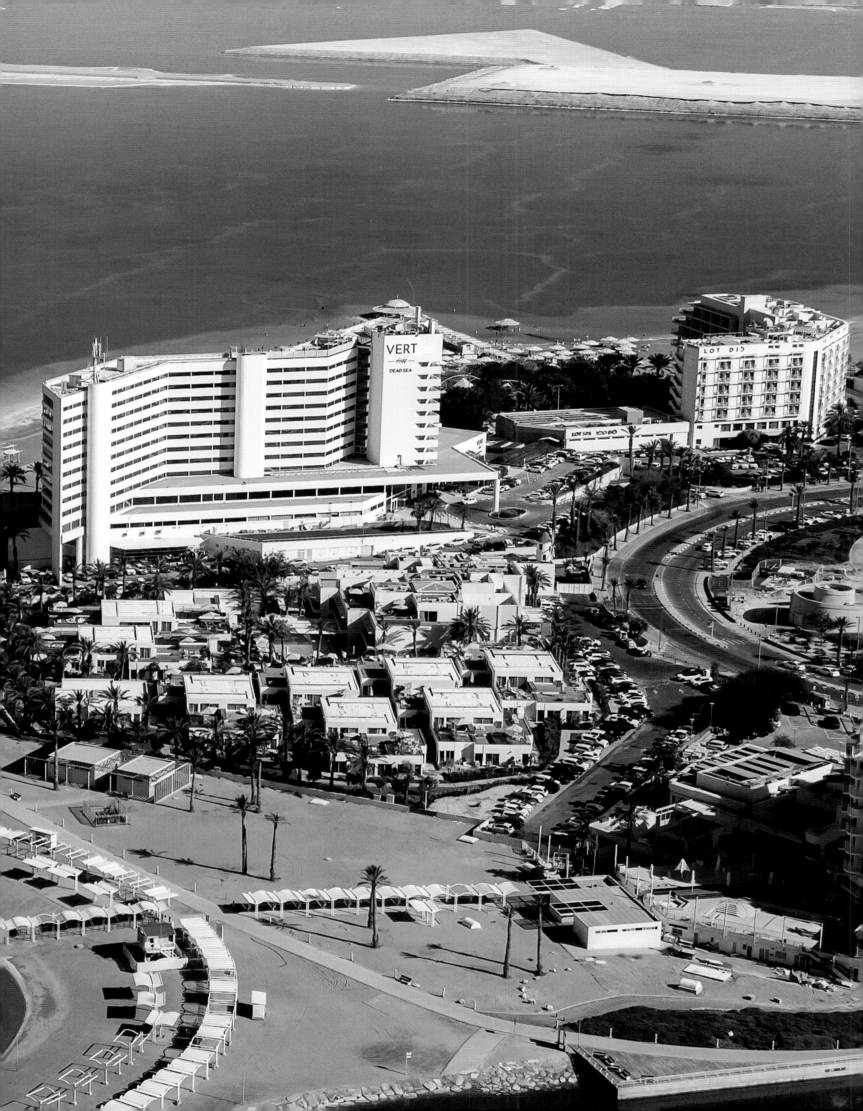

FEAR NOT, O LAND;
BE GLAD AND
REJOICE, FOR THE
LORD HAS DONE
GREAT THINGS!

JOEL 2:21

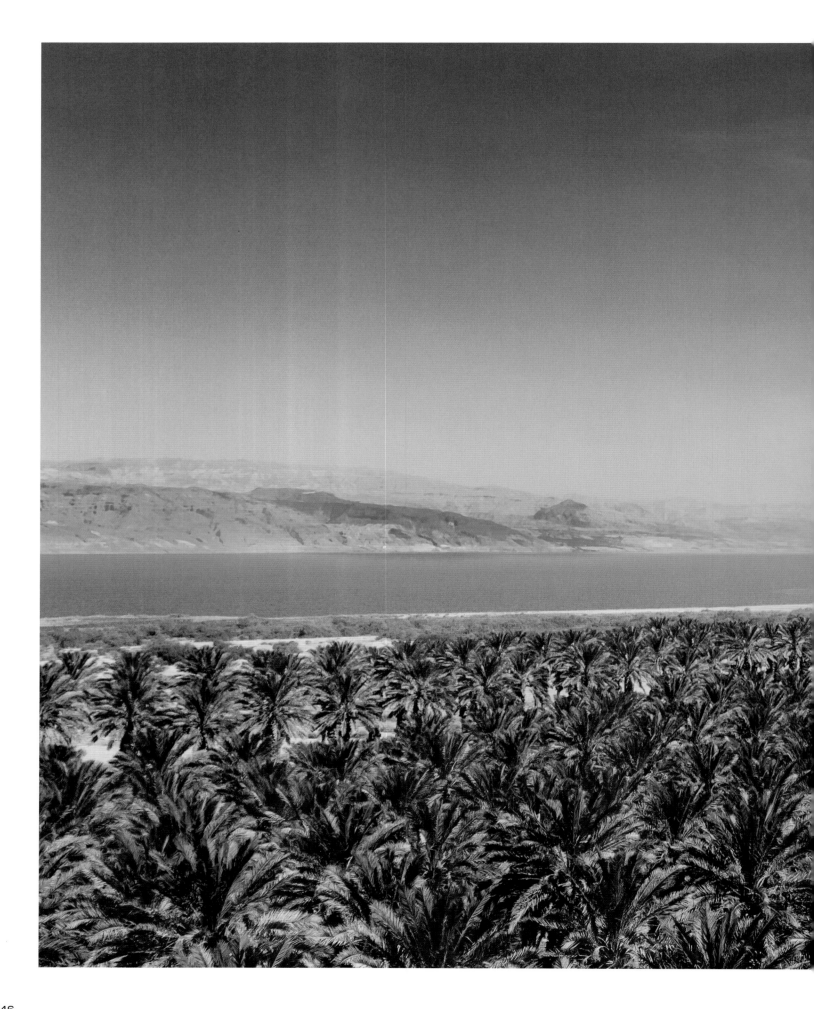

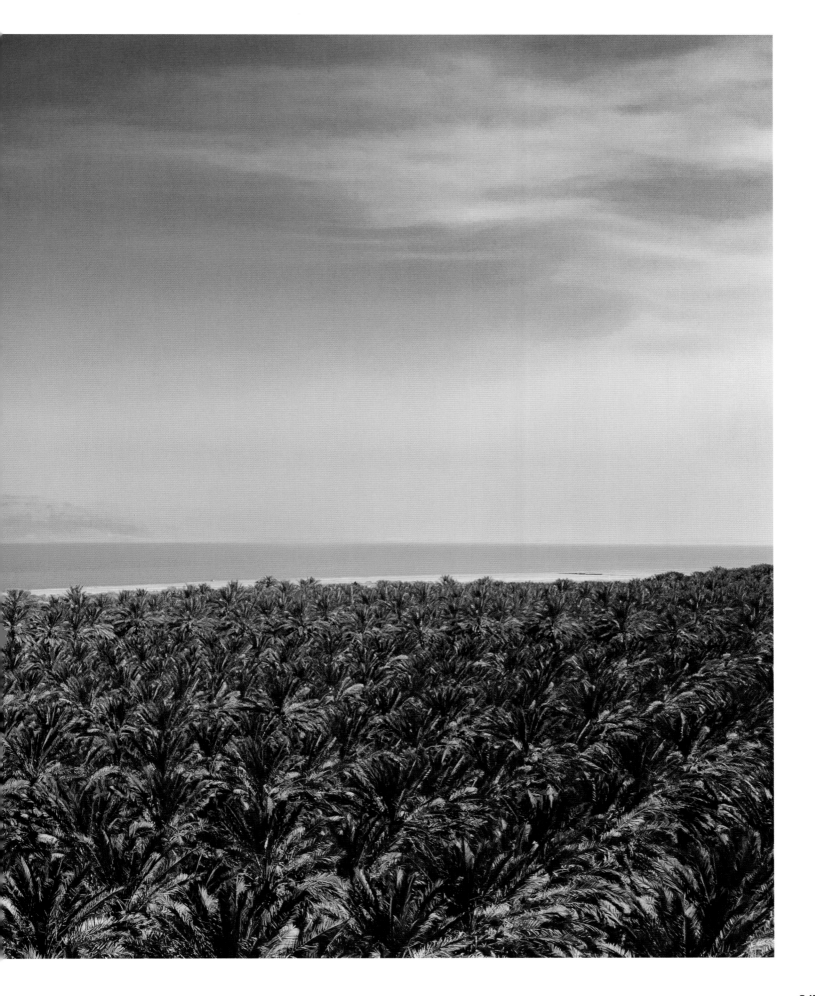

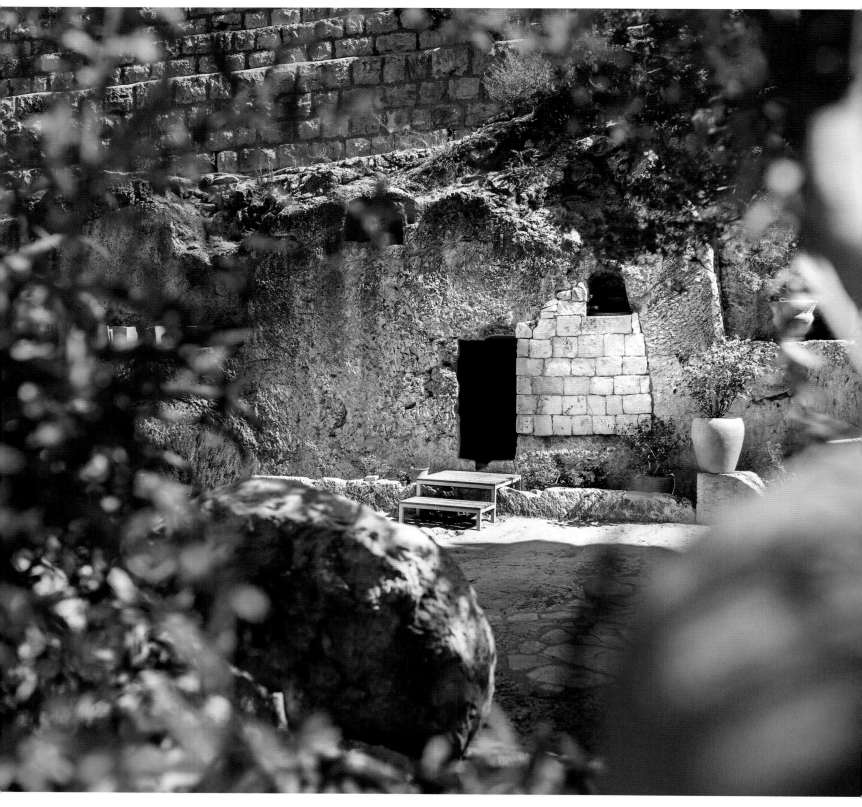

REGARDLESS OF *WHERE* IT HAPPENED, *WHAT* HAPPENED AT THAT SITE SERVES AS THE HINGE POINT OF HISTORY.

The location of Jesus's death, burial, and resurrection is contested, with the dividing lines often falling between various denominations. This site is positioned just outside the northern gate of the city and the temple. This location lends credence to the site based on its alignment with Leviticus 1:11, which says the spotless lamb will be sacrificed "on the north side of the altar before the LORD."

Garden Tomb

John 19–20, Leviticus 1:11

SCRIPTURE OFFERS a few helpful details about the place where Jesus was crucified, died, was buried, and rose again. While we don't know for certain which is the exact spot, there are a few unique details about the Garden Tomb that make it a worthy consideration.

Positioned on a major highway at the time (the Damascus Road), it was a popular site for Roman crucifixion due to its visibility. It was outside the city walls, as Scripture requires; and while the walls have been rebuilt and relocated many times over the years, this northern wall has remained fixed because it is built into the existing rock face. Nearby is an old first-century quarry that resembles a skull, an echo of the name Golgotha, which means "Place of the Skull."

Just a few steps away is a garden with a first-century winepress and a rich man's tomb that matches the descriptions of Scripture. There are first-century Christian symbols etched on the outside of the tomb, marking it as a place of worship. But regardless of *where* it happened, *what* happened at that site serves as the hinge point of history. It changed eternity. Has it changed yours?

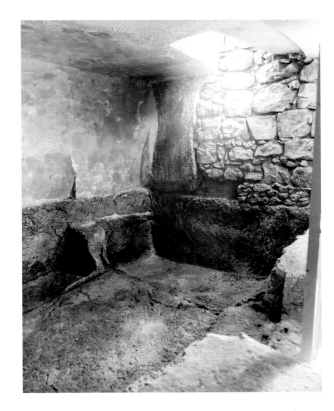

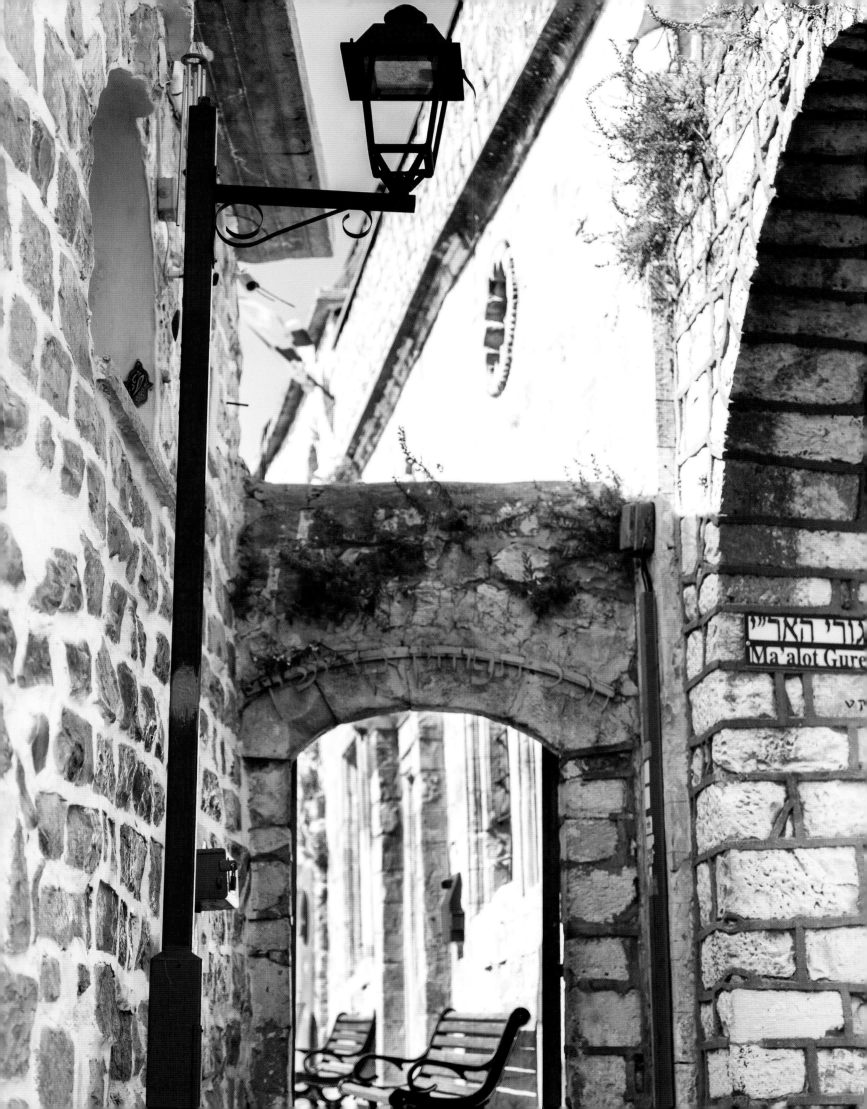

PHOTO INDEX

The following photos were taken by Tara-Leigh Cobble:

ABOUT *the* AUTHOR

TARA-LEIGH COBBLE is passionate about helping people read, understand, and love the Bible. Since 2014, she's been leading teaching trips to Israel through Israelux, specializing in luxury pilgrimage tours where travelers study the Bible on-site. She loves to watch others be

awed by the story of Scripture through firsthand experience. She is the creator and host of the daily podcast *The Bible Recap*, designed to walk listeners through the Bible in a year, and the author of the book with the same name. The podcast garnered over 100 million downloads in its first three years, and more than twenty thousand churches around the world have joined the reading plan. She also created an international network of discipleship communities called D-Group; hundreds of men's and women's D-Groups meet in homes and churches around the world to study Scripture.

Tara-Leigh's favorite things include sparkling water and days that are 72 degrees with 55 percent humidity. She thinks every meal tastes better when eaten outside. She lives in a concrete box in the skies of Dallas, Texas, where she has no pets, children, or anything that might die if she forgets to feed it.

For more information about Tara-Leigh and her ministry, you can visit her online:

Websites: taraleighcobble.com | israelux.com | thebiblerecap.com | mydgroup.org
Social media: @taraleighcobble | @israeluxtours | @thebiblerecap | @mydgroup

ABOUT *the* PHOTOGRAPHER

For more information about **RICHARD VAN DE WATER**, visit him at richardvandewater .com.

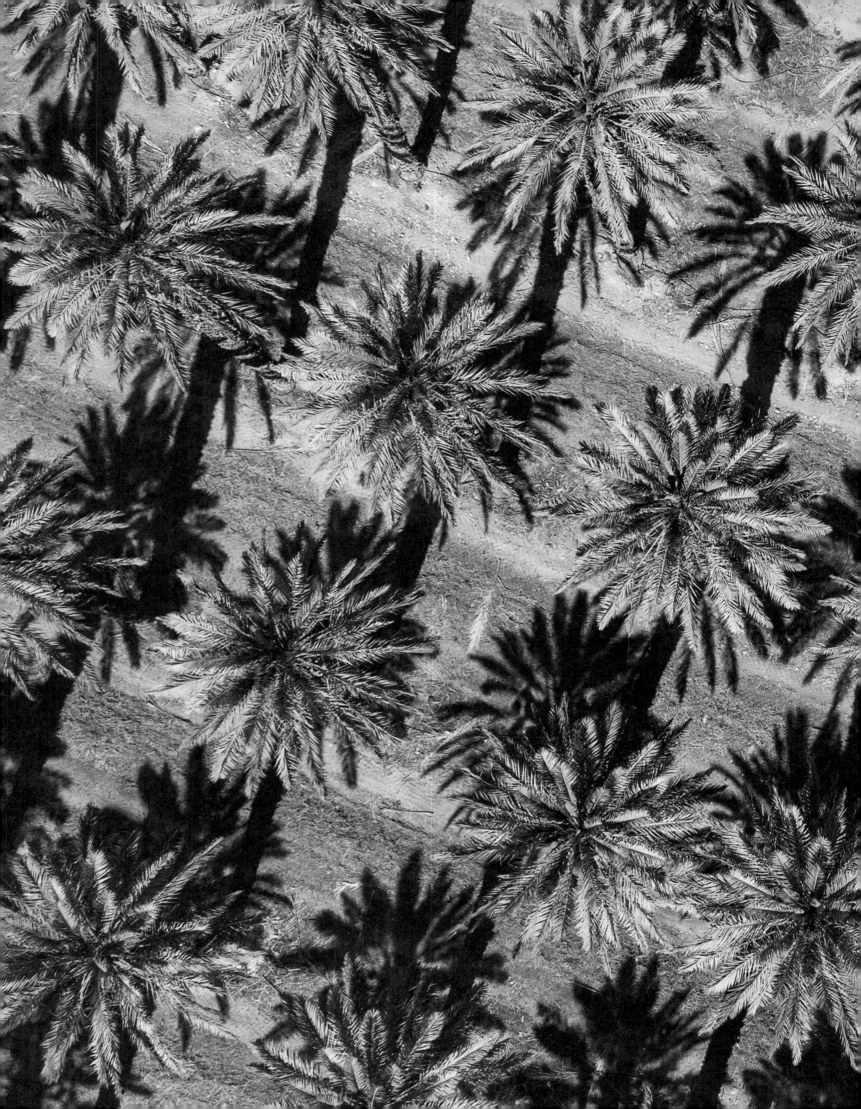